FIFTY YEARS OF FASHION

14.00

D1344067

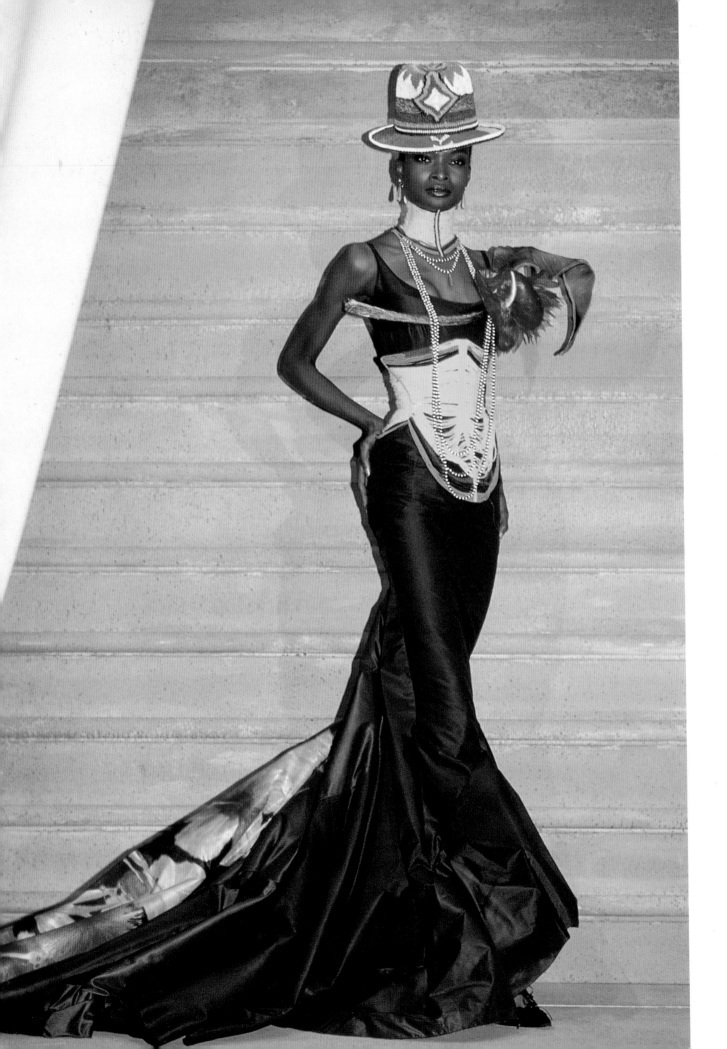

FIFTY YEARS OF FASHION

NEW LOOK TO NOW

VALERIE STEELE

PHOTOGRAPHS FROM

THE MUSEUM AT THE FASHION INSTITUTE OF TECHNOLOGY, NEW YORK

BY IRVING SOLERO

YALE UNIVERSITY PRESS

NEW HAVEN AND LONDON

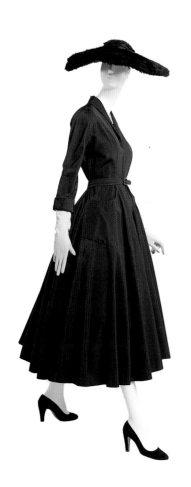

© Société nouvelle Adam Biro, 28 rue de Sévigné, 75004 Paris, France.
Original French title: *Se vêtir au XXe siècle (1945–1990)*.
English edition copyright © 1997 by Yale University
Third printing, 2006

Designed by Gillian Malpass

Printed in Singapore

Library of Congress Cataloging-in-Publication Data

Steele, Valerie.
 Fifty years of fashion : new look to now / Valerie Steele
 p. cm.
 Includes bibliographical references and index.
 ISBN 0-300-07132-9 (cloth)
 ISBN 0-300-08738-1 (paper)
 1. Costume – United States – History – 20th century.
 2. Fashion – United States – History – 20th century. I. Title.
GT615.S74 1997
391′.00973′0904–dc21 97-26413
 CIP

A catalogue record for this book is available from
The British Library

Frontispiece Kitu dress by Christian Dior,
Spring–Summer 1997. Photograph
Courtesy of Christian Dior Couture.

CONTENTS

FOREWORD

THE MUSEUM AT THE FASHION INSTITUTE OF TECHNOLOGY has one of the world's largest and most important collections of costumes and textiles, with particular strength in twentieth-century fashion. With the publication of this book, the museum presents a complementary exhibition which explores how and why fashion has changed over the past half-century. From magnificent Balenciagas to practical denims, the exhibition demonstrates how fashion affects everyone, men and women, whether they admit it or not.

One of the biggest myths about fashion is that it refers only to haute couture. This misconception has been reinforced in recent years, as fashion has become an ever more popular "spectator sport." High-style dresses are now high-priced collectibles and Oscar night has become a fashion show! *Fifty Years of Fashion: New Look to Now* challenges this perception by considering fashion in a broader sense.

Fashion is not only a noun referring to clothing but a verb meaning "to give shape or form, to alter or transform." It is in this sense that The Fashion Institute of Technology trains students for the fashion industries. Supporting the academic programs of the college, The Museum at the F.I.T. provides a unique design resource for students as well as scholars and design professionals.

The exhibition that complements this book has been made possible in part through the generosity of The Sara Lee Corporation. The J.M. Kaplan Fund's publication program, "Furthermore . . . ," has underwritten an exhibition brochure. With *Fifty Years of Fashion: New Look to Now*, the museum is pleased to share with the public some of its greatest treasures.

Dorothy Twining Globus
Director
The Museum at the Fashion Institute of Technology

ACKNOWLEDGEMENTS

Many people helped turn my manuscript into a book and an exhibition. I would especially like to thank Gillian Malpass, Editor at Yale University Press, and Dorothy Twining Globus, Director of The Museum at the Fashion Institute of Technology. Everyone at the museum has participated in this project, but I am especially grateful to Irving Solero, whose photographs contributed so much to the book, and to my colleagues in the Costume Department, particularly Laird Borrelli, Fred Dennis, Lynn Sallaberry, and Ellen Shanley. Grateful acknowledgements are made to everyone who shared visual material; they are listed in the captions, but I must single out for special thanks Michael Schulman of Archive Photos and, of course, Roxanne Lowit and her assistant, Jamie Cabreza. Most of all, thanks to my family.

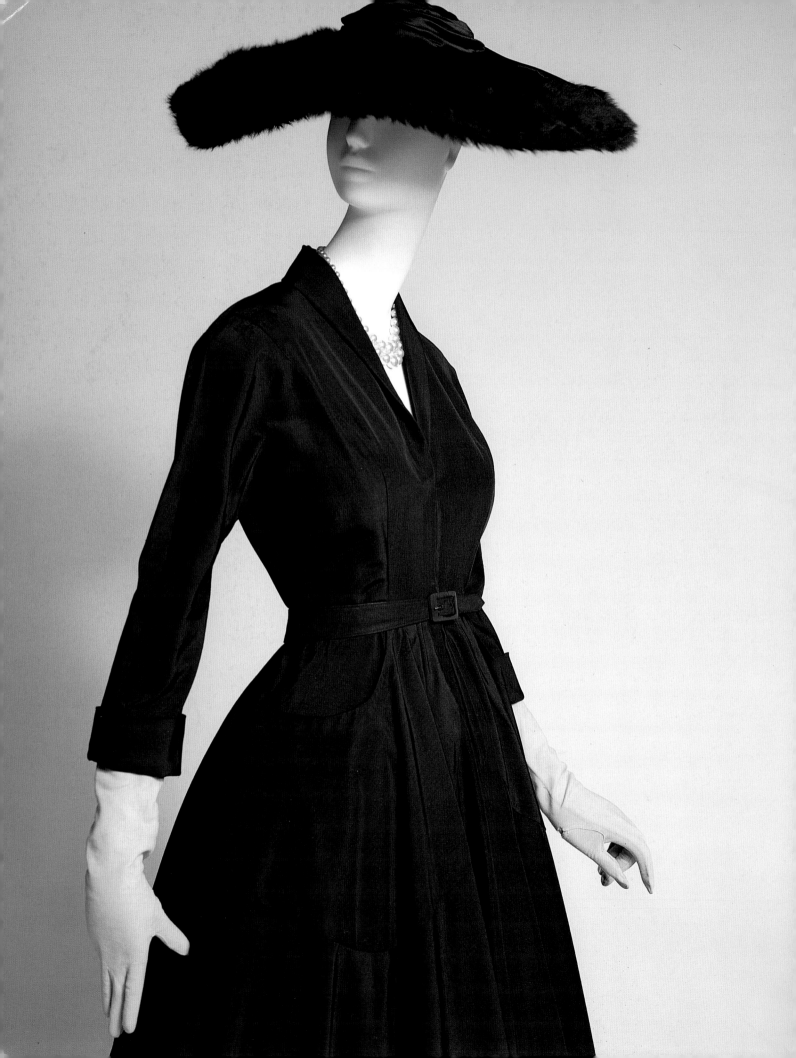

ONE THE NEW LOOK:
 FASHION AFTER THE WAR

"THIS YEAR BEGINS A NEW ERA and it follows as the peace the war, that men want women beautiful, romantic . . . birds of paradise instead of hurrying brown hens," predicted *Harper's Bazaar* in October 1945. Looking back on the postwar period, the great couturier Christian Dior agreed: "We were emerging from a period of war, of uniforms, of women-soldiers built like boxers. I drew women-flowers, soft shoulders, flowing busts, fine waists like liana and wide skirts like corolla." The postwar era would, indeed, be characterized by an extravagantly romantic and ultrafeminine fashion that differed dramatically from wartime attire. Yet it is also true that the fashionable silhouette epitomized by Dior's New Look actually began *before* the war. During the war years this image of lush femininity was essentially "put on ice;" it was only after the war that the freeze melted and the rhythm of fashion burst out again in the work of many designers, of whom Dior was only the most famous.

To understand the fashions of the past fifty years – from the New Look to now – it will be necessary to review what happened earlier in the century, and to focus, in particular, on the years between 1939 and 1944. Moreover, it will be crucial to analyze the culture of fashion from several perspectives, not limiting ourselves to a narrative account of the creations of "the great designers." In recent years scholars and costume curators have increasingly realized that fashion must be placed firmly within its cultural and historical context; the study of dress cannot be separated from women's history, for example. Furthermore, the focus is no longer on the haute couture, or even solely on women's fashion, today there are exhibitions on subjects such as street style and denim.

Many people mistakenly believe that the term "fashion" refers only to high fashion. This misconception is reinforced by the publicity surrounding the expensive creations of a handful of famous fashion designers. Yet high fashion is only a small part of the fashion system, of which the couture is an even smaller subcategory. It may be useful, therefore, to review certain key terms in the vocabulary of fashion.

The haute couture (literally "high [-quality] sewing") refers to the exclusive creations of a relatively small number of designers. Paris has been the

1 Detail of "New Look" dress, after Christian Dior, by Nettie Rosenstein, 1947 (plate 10). Photograph by Irving Solero.

center of the couture since the nineteenth century, when Charles Frederick Worth reorganized the practice of dressmaking, transforming it from a craft to big business and high art. By asserting his creative authority and proposing that women choose from a series of models, Worth achieved greater fame than other dressmakers. Among the most important couturiers of the twentieth century were Coco Chanel and Christian Dior. Although both of them are long dead, their couture houses live on, with Karl Lagerfeld designing for Chanel and John Galliano for Dior.

Couture dresses can cost $40,000; not surprisingly, there are very few clients, and the couture business usually loses money. However, since the 1970s most couturiers have also designed ready-to-wear collections, which are produced in standard sizes and can be bought "off the rack" at department stores and boutiques. A ready-to-wear Chanel suit might cost $4,000. Although only a fraction of the cost of a couture ensemble, this is still expensive, yet at some boutiques there are waiting lists for Chanel suits. The real money, however, is in perfumes and cosmetics, since many thousands of women can afford to pay $20 for a lipstick. In economic terms, then, the couture functions as an advertisement to promote a particular brand, in this case "Chanel." In creative terms, however, the couture often functions as a laboratory to explore new design ideas.

The fashion industry developed very differently in America, and as a result most American fashion designers create ready-to-wear. Contrary to popular belief, famous designers such as Calvin Klein and Donna Karan are not couturiers, although the clothes from their top collections can be expensive. (An outfit might cost $2,000.) Typically, these designers also have less expensive lines of clothing, and license a range of products, such as blue jeans, underwear, pantyhose, and perfume. Again, the less expensive products usually produce the most revenue. Meanwhile in Italy there exists a number of couture houses, mostly in Rome, but the ready-to-wear business, based in Milan, is much more lucrative and influential. Top fashion designers who head their own companies include Giorgio Armani and Gianni Versace. Since the 1960s there has also existed a thriving French ready-to-wear industry. At the top end are designers such as Jean-Paul Gaultier and Thierry Mugler, who are known as *créateurs* (as opposed to "couturiers"), and show their collections in March and October, whereas couturiers show their collections in January and July.

The history of menswear has followed a different trajectory. Throughout most of world history men's clothing has been at least as modish and extravagant as women's clothing. As late as the eighteenth century, men in the ruling class wore fashionable clothing made of such luxurious materials as silk and velvet, in bright and light colors (including pink), decorated with embroidery, gold, and lace. From the end of the eighteenth century sobriety began to creep in and western men experienced a change that has been called

"the great masculine renunciation." The rise of capitalism, together with the democratization of society, caused men's clothing to become more sober and uniform. The production of men's clothing also changed. Traditionally, tailors cut and sewed men's clothing, just as dressmakers made women's clothing. Fashion innovations usually originated from a collaboration between the tailor and his client. By the nineteenth century, however, many men had ceased to go to custom tailors, and, instead, bought ready-to-wear clothing. (It was only in the twentieth century that most women began to buy their clothes ready-made.) Modern menswear is relatively plain and mostly mass-produced.

The idea that men wear functional clothing, while women wear frivolous fashion, is simply wrong. Clothing is the general and inclusive term for all the various coverings and articles of dress designed to be worn on the human body. Fashion is a particular kind of clothing that is "in style" at a given time. The concept of fashion therefore implies a process of style change. It is true that men's clothing fashions change more slowly and less dramatically than women's, but they do change. This is more obvious at the top levels of fashion, where designers such as Calvin Klein create clothing lines for men as well as women, but fashion influences even clothing produced for the mass market. Contrary to popular opinion, neither the business suit nor sportswear separates exist outside the realm of fashion; to give an example, there are fashions in running shoes. Nevertheless, we do tend to distinguish, however imprecisely, between basic or classic clothing (blue jeans, parkas) and the latest trendy fashions.

Shakespeare observed that "the fashion wears out more apparel than the man." In other words, long before a person's clothing has worn out, it has become unfashionable. In Shakespeare's day only members of the ruling class dressed fashionably; the mass of the rural peasantry wore simple clothes that hardly changed over generations. Today, however, the vast majority of people around the world are affected by the fashion system – even if they are unwilling to admit this. Designers are sometimes described as "dictators" who capriciously create new styles and hoodwink gullible consumers into buying them. This was a gross exaggeration even in the past, when couturiers like Christian Dior were at the height of their fame. Trendsetters have always been equally influential in launching new fashions.

In *The Autobiography of Malcolm X*, the black radical described how, in the early 1940s, he was initiated into the hipster look then common in Harlem:

> I was measured, and the young salesman picked off a rack a zoot suit that was just wild: sky-blue pants thirty inches in the knee and angle-narrowed down to twelve inches at the bottom, and a long coat that pinched my waist and flared out below my knees. As a gift, the salesman said the store would give me a narrow belt with my initial "L" on it. Then he said I

ought to also buy a hat, and I did – blue, with a feather in the four-inch brim. Then the store gave me another present: a long, thick-linked, gold-plated chain that swung down lower than my coat hem . . . I took three of those twenty-five cent sepia-toned, while-you-wait pictures of myself, posed the way "hipsters" wearing their zoots would "cool it" – hat angled, knees drawn close together, feet wide apart, both index fingers jabbed toward the floor.

It is common knowledge that youth subcultures, which are often associated with particular styles of music, frequently beget clothing styles. Yet most research on subcultural styles has focused on the 1960s and after. By the late 1930s, however, the zoot suit had already become a popular style among urban African-American men.

By 1943 the zoot suit was as famous (or, perhaps one should say, as no-torious) as the New Look would be in 1947. Like the New Look, the zoot suit was characterized by exaggeration. Both the New Look and the zoot suit caused controversy, and in both cases the state attempted to restrict or prohibit the style, which was associated with the violation of wartime cloth restrictions. There were also, of course, important differences between the two styles. The New Look was promulgated by the highest echelons of the French couture, from whence it "trickled down" to the masses. By contrast, the zoot suit, which first appeared at Harlem nightclubs like the Savoy, was an early example of street style.

In 1941 the *New Yorker* (a periodical geared toward upper-class whites) jok-ingly submitted "a preview of men's Easter fashions from the world's least inhibited fashion center, Harlem." Obviously, the magazine's editors did not expect that white men would adopt the clothing worn by jazz musicians like Cab Calloway and aspiring hipsters like the future Malcolm X. The zoot suit was adopted by Mexican-American youths in California, but problems began in March 1942, when the War Production Board ruled that the wool used in men's suits must be reduced by 26 percent, thereby defining the zoot suit as unpatriotic, even quasi-illegal. In 1943 race riots erupted in several American cities. These were sometimes referred to in

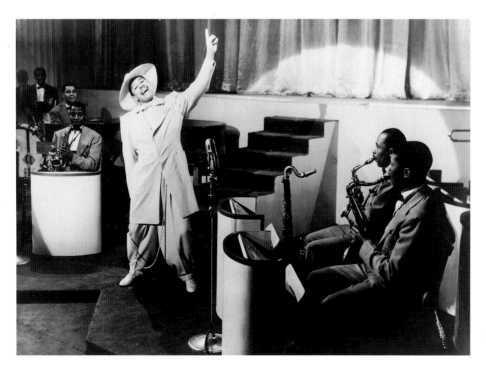

2 Cab Calloway in a zoot suit. Still from the film Stormy Weather, 1943.

the press as "Zoot Suit Riots." Although Malcolm X later referred to the zootie as a "clown," some fashion historians have interpreted the style as a badge of ethnic defiance.

Without minimizing the significance of "style warfare," it is also true that the zoot suit was primarily associated with jazz. In France the popularity of "swing" resulted in the rise of a similar subculture; young men known as zazous adopted huge zoot jackets, short pants, and elaborately styled hair. Although there were probably only a few hundred zazous in Paris, their emulation of the zoot-suiters' style created controversy in Nazi-occupied Paris. In 1942 the collaborationist youth group Jeunesse Populaire Française decided to "scalp the Zazous," and went out armed with scissors to cut off their trademark hairstyle. A year later in Los Angeles white servicemen attacked and stripped the clothes off Mexican-American zoot-suiters.

A famous photograph of 1947 taken on the street in France shows an angry crowd of women tearing a New Look dress off a young woman. Although the response to the New Look seldom reached the stage of assault and battery, we must remember that this fashion, too, was extremely controversial in its day. To understand why, however, we must go back in time.

The 1930s were an uneasy period, "the hollow years" the historian Eugene Weber has called them. When war finally exploded in western Europe in 1939, it had been presaged by the invasions of Ethiopia, Manchuria, and Czechoslovakia, and by the Civil War in Spain. Can we say that fashion "reflected" the political situation? In addition to the romantic escapism of 1930s high fashion, there were various practical styles, such as trousers suitable for bicycling, as well as tailored suits and hats influenced by military uniforms.

However, it would not be wise to exaggerate the direct influence of politics on design. Broad shoulders had formed part of the fashionable look from about 1935, and this line was further exaggerated over the next few years until it reminded some observers of the padded shoulders of American football players. There is no evidence, however, that broad shoulders were originally intended to look either masculine or military – like woman soldiers or boxers. Quite the reverse: the discourse in the fashion press emphasized how an exaggerated shoulder line made the waist look small by comparison.

The Nazi Occupation of Paris began in June 1940. The Germans initially intended to move the entire Paris couture industry to Berlin or Vienna, and it was only with great difficulty that Lucien Lelong, president of the Chambre Syndicale de la Couture Parisienne, was able to prevent the implementation of the German agenda. Even so, the Nazis exerted a strict control over the French fashion industry, shutting down many fashion houses, censoring fashion magazines, and forcing many workers into war-related industries. Nevertheless, some twenty couture houses continued to produce about a hundred models a year, fashions designed primarily for wealthy collaborators and for export to Germany. The wives and mistresses of Nazi dignitaries and

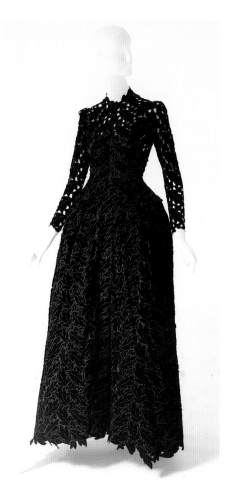

3 Balenciaga court-style evening dress with matching jacket in black velvet with openwork leaf pattern, 1938. The Museum at F.I.T., New York, Gift from The Estate of Tina Chow, 91.255.2. Photograph by Irving Solero.

4 Fashion at Auteuil, 1941. Photograph © Lapi-Viollet.

Axis leaders still bought couture dresses, as did those who enriched themselves on the black market, but the international clientele from the Allied nations no longer came to Paris.

Accustomed to imitating French fashion, designers in the Allied countries were at a loss when Paris fell. Indeed, the entire international fashion system was thrown into a crisis, because ever since the seventeenth century Paris had been the world capital of fashion. Even during the First World War fashion news continued to come out of France, but when German tanks rolled into Paris the international trade in French fashion was severely curtailed. In its issue of September 1, 1940, American *Vogue* noted,

> This is the issue of Vogue that, in other years, was called "Paris Openings." But this year, the needles of Paris have been suspended, temporarily we hope, by the fortunes of war. And for the first time in memory, an autumn mode is born without the direct inspiration of Paris. For the first time, the fashion center of the world is here – in America. Into every mind concerned with clothes, the question repeatedly arises, "What will America do without Paris fashion?"

The fashion world eventually coped with the situation in two ways. To some extent designers were able to develop their own indigenous styles of dress; in America, for example, the most creative designers, such as Claire McCardell, focused on sportswear, thus inaugurating the beginning of what came to be known as the American Look. Equally important was the institution of government regulations that pushed fashion in the direction of wartime uniformity.

Clothes rationing began in Great Britain in June 1941; coupons were distributed, with a garment costing a certain number of coupons. So-called "utility" clothes, which met government standards were sold at fixed prices. In 1942 additional Restriction Orders were imposed, limiting the yardage and controlling the styles that could be produced. The number of buttons, pleats, and pockets were all regulated to save both labor and materials. Artificial silk was no longer available for anything but parachutes. The United States followed suit with its L85 restrictions, although the approved style was given the more triumphant name, the "Victory Suit."

"Il faut skimp, pour être chic," declared British *Vogue*, in pidgin French, explaining that "The progress of the war has made it necessary to prohibit all superfluous material and superfluous labour." The resulting dresses had short, narrow skirts and no excess trimmings. The fashions of the 1940s are often perceived now as "practical," but they were promoted at the time as patriotic. (In addition, many women began wearing uniforms to work.) Everything saved in material and manpower went into the war effort.

There was no comparable incentive for the French designers to skimp, since anything saved went to help the Nazi war machine. As a result, French

5 Detail of Balenciaga court-style evening dress, 1938 (plate 3). Photograph by Irving Solero.

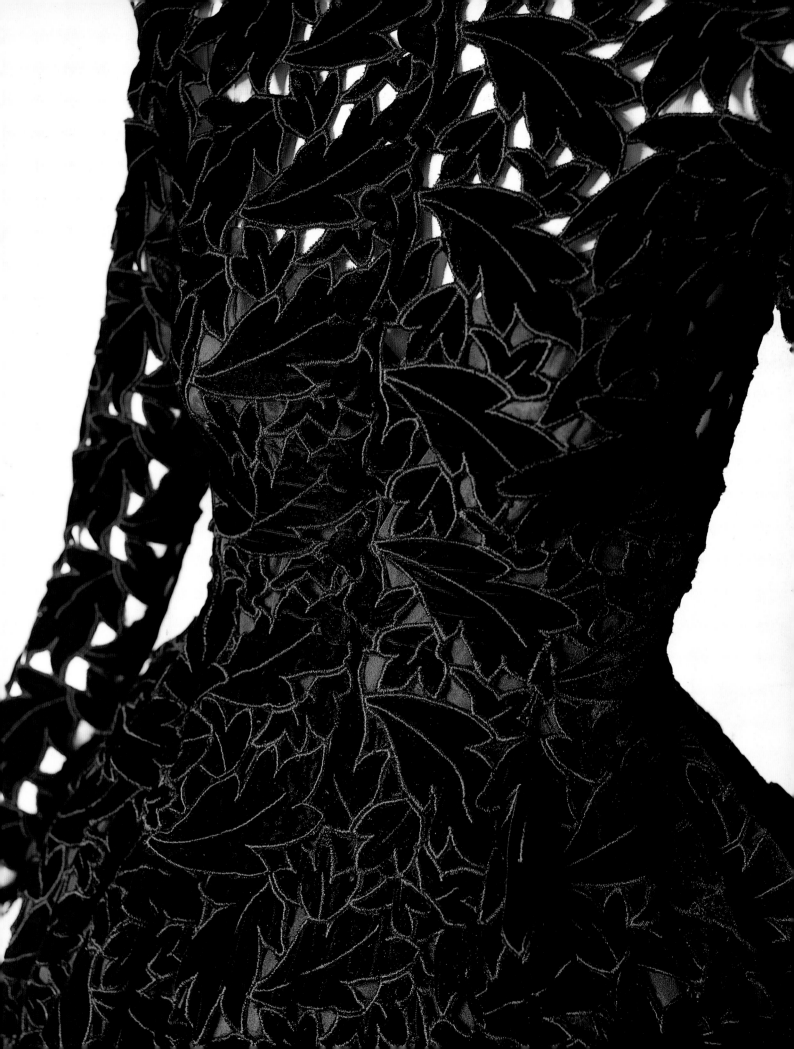

couturiers tended to emphasize extravagantly flamboyant styles, created (they argued later) "in deliberate defiance of the Germans." Some couturiers even claimed afterward that they were trying to make the Germans look absurd. This argument is difficult to accept, and English fashion historian James Laver reproached the French "for having invented this argument after the fact in order to justify themselves in the eyes of history."

More credibly, other French observers have suggested that the Paris couture coped with difficulties such as fabric shortages by making fewer dresses, rather than by limiting the yardage or workmanship in each individual garment. This would later cause difficulties with the Allies after the Liberation of Paris. Certainly, during the Occupation, fantasy and extravagance dominated the French couture. Evening dresses often looked as though they had been designed for romantic films, with cinched waists and long, full skirts. (Shoulders, however, remained broad.) It may be relevant that historical costume drama was one of the few film genres permitted in occupied France.

The dominant daytime silhouette, on the other hand, consisted of a boxy torso and a short skirt. This was true in both France and the Allied nations, although for different reasons: government directives in the case of Britain and America, and a combination of fashion and personal economy in France. Ordinary French women were economically constrained, especially after 1941 when there were severe shortages. Lacking leather, people made platform shoes out of wood and cork. As private automobiles disappeared, women took to bicycling, and purses were increasingly replaced by shoulder bags. Men's suits were recut to fit the women left behind. The exigencies of warfare meant that for most women fashion was of minor importance.

Yet there is also evidence that French women expressed their patriotism through the creation and appreciation of elegant fashion. "I tell myself I must save this diary," wrote Colette,

> to be reopened again at a later date when it will bear witness that in February 1941, between standing in line for milk, rutabagas and mayonnaise with no oil or eggs, Candlemas with no crêpes, and shoes with no leather, Paris brought forth its most characteristic feats, producing *a figured velvet dress* [and] *a very dressy pink lamé blouse . . . (Paris de ma fenêtre,* 1942)

6 Wartime fashions of the 1940s had broad shoulders and short skirts. Photograph © Lapi-Viollet.

Perhaps fashion was a way of denying, even resisting, the humiliation of defeat and occupation. Certainly creativity was employed in the face of shortages. Hats were made "of scraps that could not be used for anything else," recalled Dior, defying "both the period's woes and plain common sense."

Meanwhile, the Vichy regime adopted a fashion discourse similar to that in Fascist Italy and Nazi Germany, stressing nationalism and conservative social values. Fashion designers were encouraged to draw inspiration from regional or "folk" costumes; Jacques Fath, for example, designed dresses inspired by peasant costume. Fashion magazines were also encouraged to extol the traditional Frenchwoman, as opposed to the cosmopolitan Parisienne. This official discourse seems, however, to have had little impact on most French people: women were not supposed to wear trousers, for example, but there is evidence that many did nevertheless.

When Paris was liberated in August 1944, the Allies were horrified to see what the American War Production Board described as "a flagrant violation of the imposed wartime silhouette." Lelong was now forced to justify the Paris couture, this time to the Allies. He issued a statement in American *Vogue* (December 15, 1944), in which he denied any knowledge of the existence of clothing restrictions in other countries: "I have only just received copies of English and American clothing restictions and now understand why certain journalists found Paris collections exaggerated." He vowed to bring French fashion in line with Allied requirements, and also defended the importance of fashion for France:

> From the smallest apprentice to the greatest designer, the Parisian couture in a supreme effort managed to overcome all obstacles to present this first collection of liberation. For four years, we have fought to keep couture alive because it represents a Parisian industry of prime importance and because it was a means of avoiding unemployment for workers and consequent forced labor in Germany, and lastly to preserve for *la haute couture parisienne* the place it has always had in the eyes of the world.

It was necessary to emphasize that Paris fashion had not been irrevocably contaminated by collaboration with the Nazis. Hence the defensive argument that, during the war, Paris fashions had "comforted the French [and] discomfited the Germans." It was also necessary to promote the importance of Paris – after several years of foreign fashion independence. The French couture devised a brilliant public relations coup that would simultaneously disarm hostile foreign critics and actively promote the revival of Paris fashion.

The *Théâtre de la Mode* was an exhibition of dolls dressed by the leading Parisian couturiers in miniature fashions, complete with tiny shoes and hats, posed within delightful sets depicting Parisian life, which were created by artists such as Jean Cocteau and Christian Bérard. Created during the winter of 1944–5, the exhibition was first shown at the Pavillon Marsan, where it

was seen by nearly 100,000 visitors. It then toured internationally in 1945–6, reminding viewers of the glory of French fashion; the profits went to French war relief. Among those represented were Balenciaga, Jean Dessès, Jacques Fath, Madame Grès, Lanvin, Lucien Lelong, Patou, and the House of Worth.

"Words almost fail us in describing the beauty and exquisiteness of this exhibit," wrote New York fashion consultant Tobe in her influential newsletter. "Certainly it is something that everyone in the retail and fashion business should see . . . Make no mistake about it – Paris is still the magic five-letter word."

"We see a new look ahead," predicted *Glamour* in January 1945, although the magazine's editors were as yet unsure what that look would be. Indeed, the remark referred only to the latest trends in hats, although elsewhere in the same issue there were references to dresses with "very full skirts" and new coats "featuring the hour-glass waist, made tinier by voluminous sleeves and great bell-shaped skirts." In fact, the styles of 1945 and 1946 marked an uneasy compromise between the recent history of French design and the exigencies of a new political situation. There were lower hemlines, fuller skirts, and higher heels; waists were cinched, but shoulders remained heavily padded. In short, the look was still transitional.

By 1946 fashion professionals like Bettina Ballard had become curious about the new designer working for the House of Lucien Lelong, who had given a "fresh and tempting look to clothes in the lethargic postwar fashion atmosphere." She decided to ask Lelong. "Let me introduce you, Bettina, to someone who I think has great talent," he said proudly. "This is Christian Dior."

"By the summer collections of 1946, Christian Dior was a much talked-about personality owing to the extraordinary news that Marcel Boussac, the cotton king of France . . . was to back him in a couture house of his own that would open next season," Ballard continued. "The smell of fame was strong, attracting not only friends, but workers who felt the stir of something happening in the couture and who were willing to take a chance on this lucky man." Soon Dior's friend, the artist Bébé Béraud, was leaking details of the forthcoming collection: "You'll see, Christian Dior is going to change the whole fashion look. He's making huge pleated skirts . . . " As Ballard observed, "Paris always takes its fashion news seriously, and fashion since the war had been stale and tepid. Everyone hoped that Christian Dior would breathe life and some fire into this picture. The Cinderella story behind the house of Dior had created great publicity and speculation." When Ballard arrived at the entrance to 30 avenue Montaigne for the opening show the morning of February 12, 1947, there was an immense crowd.

Once inside,

I was conscious of an electric tension that I had never before felt in the couture . . . The first girl came out, stepping fast, switching with a provoca-

tive swinging movement, whirling in the close-packed room, knocking over ashtrays with the strong flare of her pleated skirt, and bringing everyone to the edge of their seats . . . After a few more costumes had passed, all at the same exciting tempo, the audience knew that Dior had created a new look . . . We were witness to a revolution in fashion and to a revolution in showing fashion as well.

Ballard immediately ordered the dress called "1947". On her return to New York, even the taxi drivers asked, "Is this the 'new look'?"

The term "New Look" was actually the brainchild of another fashion editor, the redoubtable Mrs. Carmel Snow of *Harper's Bazaar*, who greeted Dior's first collection as "a sensational success." Dior himself had described his first line as the "Corolla," a botanical term describing opening petals, which referred to his ideal of women as *femmes-fleurs*. Soon even the French were referring to "le New Look." Everyone was. When Sally Kirkland moved from *Vogue* to covering fashion for *Life*, "The guys would say, 'What's the new look *this* week, Sally?' The idea of an overnight shift, absolutely putting your whole wardrobe out of style, was definitely news — and, to some, upsetting."

Another American living in Paris, the future Susan Mary Alsop, has also left a record of the New Look. Her account is valuable, because it is the naive expression of a young woman writing to a friend at home:

[February 15, 1947] The girl friends say I must have a look at a man named Christian Dior, no one ever heard of him before but there is something called "The New Look" which he has invented. Apparently Mrs. Snow of *Harper's Bazaar*, who is here, says that this man Dior has saved the French fashion industry . . .

[February 23, 1947] I did go to Dior's first collection, fighting my way through hundreds of richly dressed ladies clamoring to get in. It is impossible to exaggerate the prettiness of "The New Look." We are saved, becoming clothes are back, gone the stern padded shoulders, *in* are soft rounded shoulders without padding, nipped in waists, wide, wide skirts about four inches below the knee. And such well-made armor inside the dress that one doesn't need underclothes; a tight bodice keeps bust and waist as small as small; then a crinoline-like underskirt of tulle, stiffened, keeps the skirt to the ballet tutu effect that Mr. Dior wants to set off the tiny waist.

Prices were high, even for a wealthy debutante, but fortunately Dior asked her to wear his clothes that season — free — as "publicity and bait for other customers."

Among the best-selling items in Dior's first collection was "Le Bar," a calf-length black wool skirt with innumerable deep knife-pleats that consumed many yards of fabric, worn with a pale silk shantung jacket fitted to the

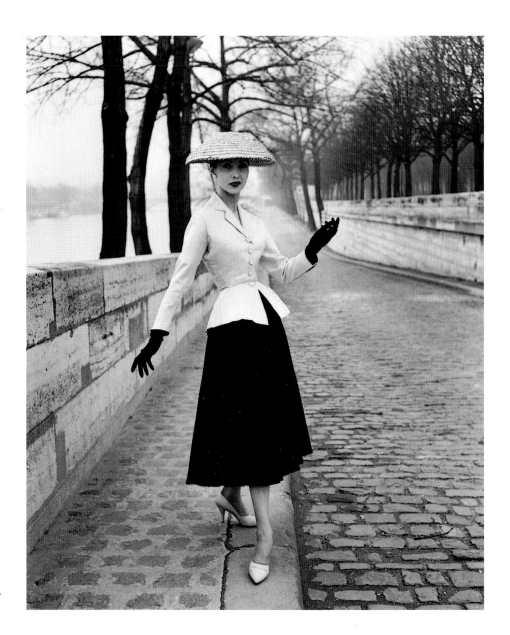

7 "Le Bar" by Christian Dior, 1947.
Photograph by Willy Maywald. © Assoc.
Willy Maywald/ADAGP.

bust and discreetly padded over the hips with sculpted basques, the better to emphasize a slender waist. High-heeled pumps, a broad-brimmed hat, gloves, and a purse completed the ensemble. Foundation garments also became increasingly important, especially new corsets and "waspie" girdles.

Contemporary reactions to the New Look varied. Not surprisingly, the French were delighted, since so much of the French economy was based on fashion, but the American and English response was conflicting. Since the long skirt was the most conspicuous feature of the New Look, attention focused there. "The New Look wins – by a length," claimed one English journalist. Conversely, a group of American women banded together to form something called "A Little Below the Knee Club," which was dedicated to maintaining the relatively short skirts of the early 1940s. Labour Party politi-

cian Bessie Braddock fumed, "The longer skirt is the ridiculous whim of idle people . . . who . . . might do something more useful with their time."

Dior's second collection in September further emphasized the drop in hemlines. In some cases, hemlines grazed the ankles. Marjorie Becket of *Picture Post* (September 27, 1947) complained bitterly:

> Straight from the indolent and wealthy years before the 1914 war come this year's much discussed Paris fashions. They are launched upon a world which has not the material to copy them, and whose women have neither the money to buy, the leisure to copy, nor in some designs even the strength to support, these masses of elaborate material . . . We are back to the days when fashion was the prerogative of the leisured wealthy woman, and not the everyday concern of the typist, saleswoman or housewife.

Even if one discounts English animus and appeals to class warfare, it is true that middle-class Frenchwomen also had reservations. The magazine *Marie-France* (September 30, 1947) published a referendum "for or against long skirts." As the editors put it, "Everyone of you is wondering: Why? What will be the consequences? How can we adapt?" But they concluded predictably that "everyone feels powerless when it comes to anything as mysterious as fashion."

How *would* women adapt to long skirts when the economic situation was still so dire? English fashion journalist Alison Settle went to Sir Stafford Cripps, President of the Board of Trade, to try to get the clothing ration increased, since it would exceed a woman's entire clothing ration to make a single New Look dress. "What New Look?" Cripps demanded. Informed of the latest developments in fashion, he snapped, "Out of the question." Later he complained, "There should be a law" – against the New Look. But the obedience to government regulations regarding clothing broke down after the war had ended.

Some women sewed strips of fabric onto their hems. Fashion historian Avril Lansdell helped her mother make a New Look skirt out of black-out curtains; then they ripped apart two dresses and remade them as a single New Look style. Ordered to the principal's office at school to explain her appearance, Avril sweetly explained, "I've grown three inches since last summer, and this was the best my Mother could do as she has no coupons to spare."

The longing for elegance and luxury had been suppressed for the years of war, and the New Look promised to gratify it. Princess Elizabeth of England herself attended a private showing of Dior gowns at the French Embassy, and Princess Margaret was soon wearing the New Look. More importantly, so were a host of ordinary women. Those who could not afford couture originals bought ready-to-wear versions of the New Look, some of which were produced on license from the House of Dior, and others that were pirated copies and adaptations. The Museum at the Fashion Institute of Technology,

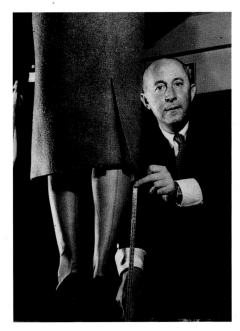

8 Christian Dior measuring the new, low hemline. Photograph: Archive Photos.

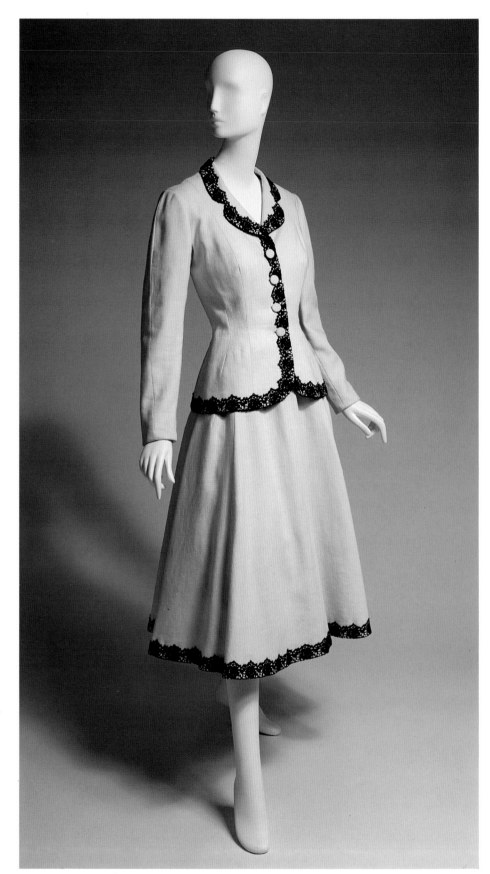

9 Balenciaga white linen suit trimmed with black lace, 1948. The Museum at F.I.T., New York, Gift of Doris Duke, 72.81.20. Photograph by Irving Solero.

10 (*facing page*) "New Look" dress, after Christian Dior, by Nettie Rosenstein, in black wool/silk faille with matching contour belt and horsehair petticoat, 1947. The Museum at F.I.T., New York, Gift of Janet Chatfield-Taylor Braguin, 74.135.8. Christian Dior cartwheel hat in black fur felt with scalloped brim and satin crown, 1954. The Museum at F.I.T., New York, Gift of Sally Cary Iselin, 71.213.32. Photograph by Irving Solero.

for example, has a nice copy of a New Look dress made in New York by Nettie Rosenstein.

As Dior himself explained, "No one person can change fashion – a big fashion change imposes itself. It was because women longed to look like women again that they adopted the New Look." Even if Dior had never been born, other designers such as Jacques Fath, Pierre Balmain, and Jean Dessès were moving in the same direction. "Together, without a doubt, they would have produced a New Look," argued English designer Victor Stiebel in 1949. "It might have taken a little longer, but a violent change was inevitable." According to Steibel,

> The fact that Dior was a new French name, a name dusted with magic before he ever opened his house; the fact that for his opening he cocked a snook at compromise and produced superlative clothes that were a couple of jumps ahead of anything seen since the war – and the fact that the whole thing was timed with the precision of a military operation – meant that Dior grabbed the credit and today is known as the couturier responsible for the New Look.
>
> He wasn't. The New Look was inevitable.

A word like "inevitable" may be too strong. Yet, with hindsight, the success of the New Look is probably not surprising.

"After the narrow mingy styles of the war, the New Look came as an explosion of fabric and petticoats, everything everybody had been denied all those years," recalled Babs Simpson, who had been in 1947 an editor at *Harper's Bazaar*. Women were "starved for luxury," agreed Diana Vreeland, and Dior "gave them plenty." The New Look "was a sociological phenomenon that went far beyond fashion," said Françoise Giroud, former editor-in-chief of *Elle*. "Coming after so long a period of restriction, it was a kind of *volupté*."

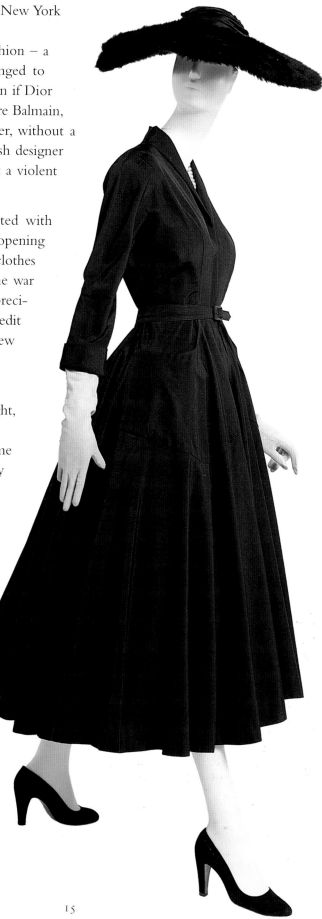

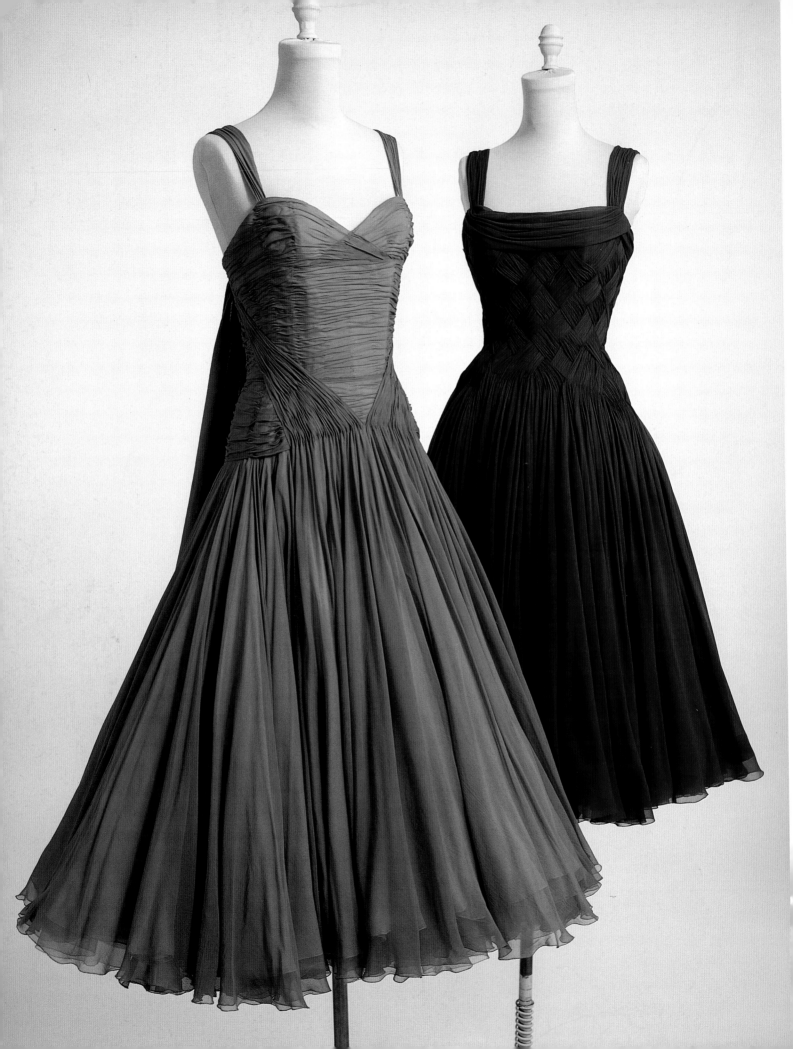

"YOU'RE BEING WATCHED! Dress Right – you can't afford not to!" The
emphasis on conformity (and the subtext of paranoia) in this American adver-
tisement was typical of the 1950s. For almost immediately after the Second
World War ended, the Cold War began. In 1949 Mao Zedong defeated
Chiang Kaishek, the Soviet Union announced that it had an atomic bomb,
and NATO was founded. The Korean War began in 1950 and the United
States developed the hydrogen bomb. Anti-colonialist movements, like the
Mau Mau uprising, swept the Third World. Stalin died in 1953, but Soviet
power continued to hold sway over Eastern Europe. In 1954 the U.S.
Supreme Court ruled that racial segregation was illegal, and the Senate finally
censured Joseph McCarthy. The battle of Dien Bien Phu marked a historic
watershed in the war in Vietnam, signaling the beginning of the end of
French involvement. Krushchev came to power in 1955, and the Hungarian
Revolution was ruthlessly suppressed by the Russians in 1956. In 1957 the
Soviets launched Sputnik, and the Suez Crisis came to a head. The Algerian
war brought bombings in Paris in 1959 and an attempted assassination of
De Gaulle.

These traumatic political events coexisted, however, with an expanding
world economy. The socio-economic structure of the industrialized world
changed dramatically in the postwar period. When the Marshall Plan was
inaugurated in 1947, the European economy was in ruins; a decade later it
was booming and a wide variety of consumer goods was available to the
masses. To a far greater extent than hitherto, this was a mass society when
"fashion for all" became a reality. It is necessary, therefore, to analyze the
wider historical context that formed the environment within which fashion
evolved and acquired meaning.

The structure of the fashion system changed radically. The most important
phenomenon within the world of fashion was the revival and transformation
of the haute couture. Superficially, this development may appear conser-
vative, even retrograde, but, in fact, the couture was in the process of
changing from a system based on the atelier to one dominated by the global
corporate conglomerate. Paris once again ruled the world of fashion, but its
"mode of influence" had changed.

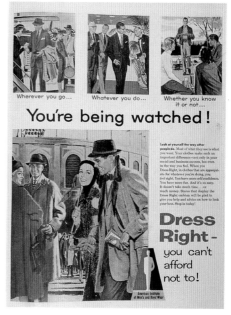

12 "Dress Right." An advertisement
produced by the American Institute of
Men's and Boys' Wear. Photograph
courtesy of The Fashion Association.

11 Jean Dessès lavender and yellow silk
chiffon evening dress with sweetheart
neck and boned bodice, elaborately
tucked and draped, 1956. The Museum at
F.I.T., New York, Gift of Lady Arlene
Kieta, 96.112.1. Jean Dessès brown silk
chiffon evening dress with "basket
weave" of chiffon strips over fitted,
boned bodice, circa 1954. The Museum
at F.I.T., New York, Gift of Francine
Gray, 91.135.6. Photograph by Irving
Solero.

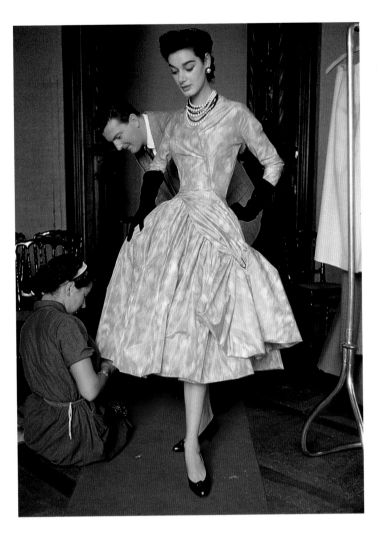

13 An authentic Paris model. Photograph: Photo Researchers Inc. © Mark Shaw.

Couturiers increasingly sold their designs to the mass market, rather than to individual private clients. They also further developed the system of licensing, which had begun in the 1930s as a defense against the illegal copying of designs. Wholesale buyers paid a deposit to view the collections, and this was credited toward any purchase they subsequently made. They could either buy a finished model or a *toile*, along with information about the material and trimmings necessary to make the garment. As fashion historians Elizabeth Wilson and Lou Taylor explain, once in the possession of a *toile*, a New York department store such as Macy's "could reproduce thousands of copies of a $950 design for $80 a time. Alternatively, something much closer to the original could be reproduced, to be sold at a higher price as an 'Original Christian Dior [or whoever] Copy'."

As the French couture regained its power with the triumphant success of the New Look, the American ready-to-wear business provided an industrial model to imitate. European industries were quick to adapt American concepts of rationalized "mass production" (an American term that achieved worldwide currency). The traditional *confection* was increasingly supplanted by the *prêt-à-porter*, and the lines of connection between the couture and less exalted branches of fashion began to proliferate.

"The quality of American ready-to-wear permits one to be well-dressed on an average salary," noted French *Vogue* (December 1948), "[but] young French women no longer have to envy their American sisters the quality of their ready-to-wear dresses. The boutiques of our couturiers present dresses at modest prices." At Fath, for example, one could buy a simple gray flannel skirt and a cashmere pullover sweater. Already by 1948 Dior stockings had appeared, and soon many fashion designers began licensing their names. They also agreed to work directly for manufacturers: in 1948 Jacques Fath signed a contract with the American wholesale manufacturer Joseph Halpert, for whom he designed several collections a year. Not all designers were equally well positioned to benefit from the new situation, however, and the couturiers who came to the forefront after the war were not necessarily those who had been famous before 1940.

From the stunning appearance of the New Look in 1947 until his death a decade later, Christian Dior was the most important designer of the entire postwar period. Reporters covered Dior "as though he were a war," and his name was recognized worldwide. Mass-market periodicals published articles

like Richard Donovan's "That Friend of Your Wife Named Dior," which reported that the House of Dior was grossing an unbelievable $15 million a year, accounting for around 66 percent of the entire French couture's foreign exports. In addition, a multibillion-dollar world fashion industry benefited from Dior's success.

In "How to Buy a Dior Original," Paul Deutschman gave step-by-step instructions about "(1) somehow winning [your] way into, and viewing the 'collection' at one of the top fashion houses; (2) trying on one of the fabulous creations there and (3) being permitted to buy this creation right out from under the feverish hands of the latest visiting movie star." Middle-class women were reassured that "this ambition is quite easy to realize." You might need help from your hotel concierge ("at all the *better* hotels they have arrangements with certain *vendeuses*") and you might wish to rent a Rolls-Royce (although a taxi would do), but ultimately, "a well-padded purse is all you need to come out with an incomparable dress that will be immediately recognizable back home as an authentic Paris model."

First, however, the woman must try on various dresses (assuming that she was more or less the size of the mannequin), pay a deposit of roughly half the price (in 1955 about $400 to $1,000), return to be measured,

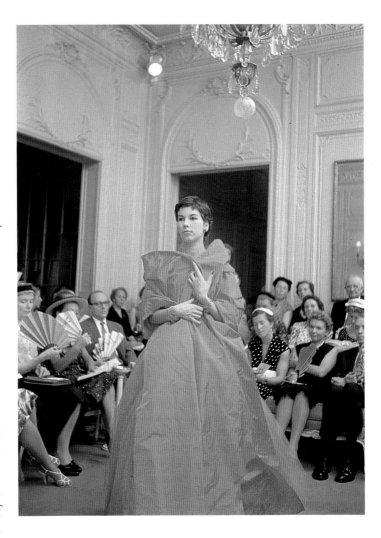

14 At Dior in Paris. Photograph: Photo Researchers Inc. © Mark Shaw.

and then return again for several fittings (first for the linen *toile* and then for the dress itself. "It's a little more complicated and time-consuming and expensive perhaps than buying a dress at the Young Wives Shop at a department store back home . . . But it will definitely be worth it." Even children's books such as *Eloise in Paris* showed the little heroine being fitted for a Dior dress, although she was most unpromising model material.

Journalists joked that "Dior phobia" was rampant among men distressed by style changes and expensive new wardrobes. Obviously, much of this reportage was a deliberate attempt to generate controversy, but it is true that Dior was notorious for repeatedly changing the fashionable silhouette. In 1948 Dior presented his dramatic envol skirt, while asymmetry was the theme of the autumn "Zig Zag" collection. The "Trompe l'Oeil" collection of 1949 included a number of dramatic styles with flying panels to give a sense of movement. In 1950 he presented a vertical line with very narrow skirts and boxy jackets. His oblique line was slanted to one side. In 1951 there was the princess line; in 1952 the sensuous and profile lines. In 1953 Dior presented

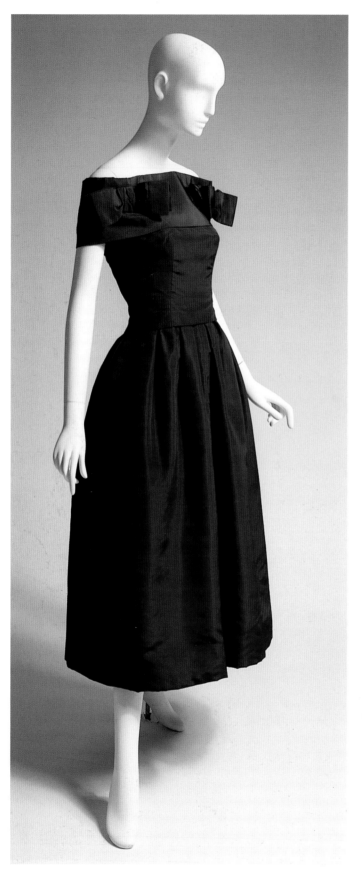
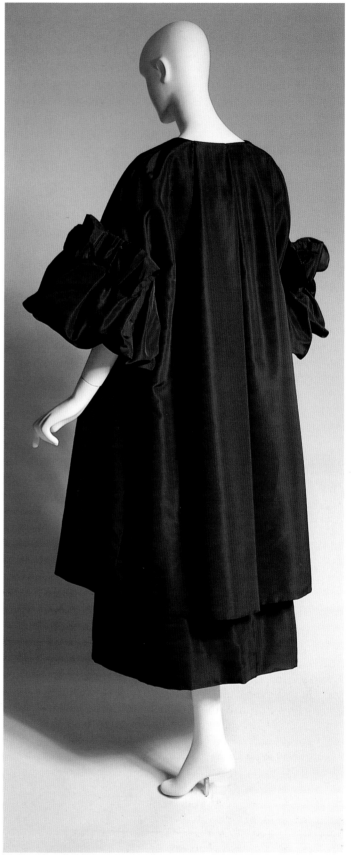

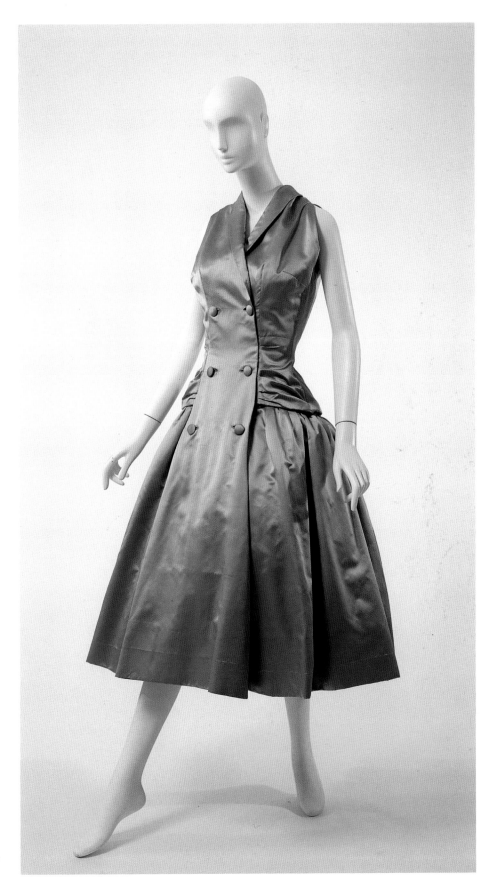

15 and 16 (*facing page*) Christian Dior
New York strapless evening dress with
matching coat and coordinating stole
in aubergine silk faille, 1953–4. The
Museum at F.I.T., New York, Gift of
Mrs. William Randolph Hearst, Jr.,
71.267.3. Photographs by Irving Solero.

17 Christian Dior beige satin evening
dress, 1954. The Museum at F.I.T., New
York, Gift of Sally Cary Iselin, 71.213.20.
Photograph by Irving Solero.

the tulip line, which was padded on top, and the cupola line with wide pleated skirts.

In 1954 Dior created the H-line with the idea of suggesting "the tapering figure of a young girl." The bust was pushed up and the waist dropped down to the hips (this marked the cross-bar of the H). Some of the H-line had a "Tudor bodice" that pushed the breasts up, "like an Anne Boleyn portrait," (as *Vogue* put it). Others emphasized a "Degas bodice" like a ballerina's costume. Some people reacted with hostility to the new high bust, and the style was interpreted as an attempt to flatten the breasts. The collection was mockingly called "the bean line." Dior defended himself: "It has never been my intention to create a flat fashion which would evoke the idea of a runner bean."

"A flattened bust line?" asked *Vogue* rehetorically. "You've read about it, perhaps said no to it as . . . unflattering. But Dior is not defying Nature. Rather reshaping it a little, perhaps beginning a big change." By 1955 the H-line had evolved into the A-line (a term which subsequently entered the fashion vocabulary to describe any dress or coat with narrow shoulders, a high bust and a flared skirt). It is "the prettiest triangle since Pythagoras," said *Vogue*. The A-line, in turn, evolved into the Y-line, which, like the tulip, was a top-heavy look (created with a bolero or a stole collar) balanced on a slender stem.

Dior announced that his aim was "to save women from nature," to make all of them beautiful. This statement, which would not appeal to women today, was greeted then with enthusiasm: "You waved your wand," wrote one woman, "suddenly I was young and hopeful again. I love you."

Dior's greatest competitor for many years was Christobal Balenciaga. A Spaniard by birth, Balenciaga had already established himself in the French couture in the 1930s and continued to design throughout the war. Where Dior was romantic, Balenciaga was austerely classical. If Dior created a fashion in constant metamorphosis, Balenciaga's designs evolved more slowly. Yet, paradoxically, Balenciaga was often extremely advanced — years, and even decades, ahead of his time. As a result his clothing was difficult for many people to understand, and he was most appreciated by a small coterie of fashion connoisseurs, including other designers, such as Hubert de Givenchy, whom he influenced.

Indeed, among the fashion cognoscenti, Balenciaga

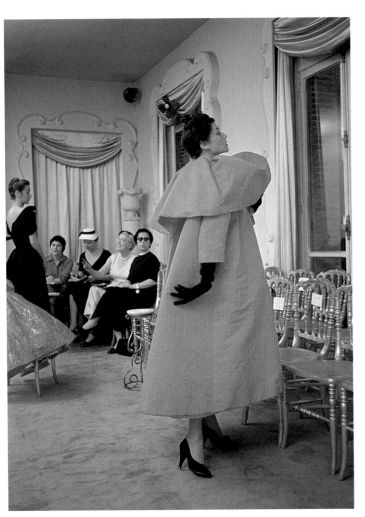

18 At Balenciaga in Paris. Photograph: Photo Researchers Inc. © Mark Shaw.

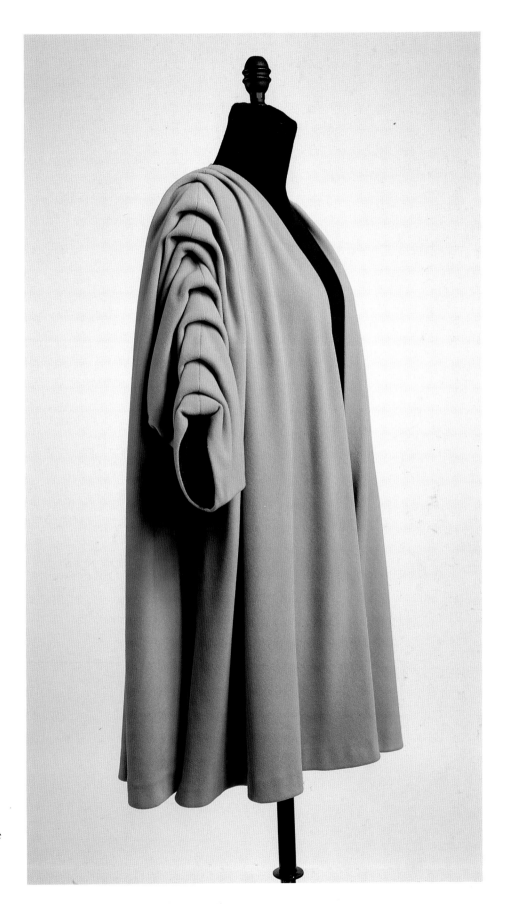

19 Balenciaga coat in beige wool duvetine with deep side pleats along the dolman sleeves, 1950. The Museum at F.I.T., New York, Gift of Doris Duke, 72.81.23. Photograph by Irving Solero.

was and is widely regarded as the greatest fashion designer of the twentieth century. Like Vionnet and Grès, Balenciaga was a true sculptor of fabric. But whereas they liked soft, flowing fabrics, he preferred stiffer materials like silk gazar. It was often said that you had to have the perfect figure to wear a Vionnet, but this was not true of Balenciaga's dresses, which formed an abstract architecture around the woman's body. There is a story about a woman who apologized for her rounded belly, only to have the fitter reply reassuringly, "But Monsieur Balenciaga *likes* a little tummy."

If Dior and, even more, Balenciaga were known for the architectural beauty of their designs, Jacques Fath was praised for the glamour and vivacity of his clothes. He often used diagonal lines, asymmetrical drapery, and floating panels to give a sense of movement. Nor was he afraid of color, frequently using bold combinations, such as bright blue and sea green. Whereas Dior's career was characterized by striking shifts of silhouette (the A-line, the H-line, etc.), Fath maintained an unswerving fidelity to the female form divine, focusing on sexy lines and novel decorative details, such as rows of non-functional buttons. Fath himself was extraordinarily daring in his own wardrobe and was photographed variously in a red tartan jacket, a fringed suede shirt, and a number of fancy-dress costumes.

Fath had a short career, from 1937 until his death in 1954. During the Nazi Occupation "scruples of conscience" did not embarrass Fath, who was closely associated with various Franco-German groups and whose clientele consisted heavily of Germans, wealthy collaborators, and black-marketeers. Unlike Chanel, however, whose reputation as a Nazi sympathizer delayed the resumption of her postwar career, Fath's image emerged intact, and after the war his international career took off.

Fath had "the showy elegance of a character from a Cocteau play" and "the charm of an *enfant terrible*," recalled Celia Bertin, but for some time fashion editors like Bettina Ballard and Carmel Snow tended to dismiss him as "a good-looking child prodigy . . . with slightly theatrical fashion ideas not worthy of the hallowed pages of *Vogue* or *Harper's Bazaar*." Gradually they became increasingly enthusiastic about the way his glove-fitted dresses glorified the female form. (Some have even said that he inspired Dior's New Look.) Certainly, Fath designed some of the sexiest and most glamorous dresses to come out of Paris. The typical Fath dress featured a fitted bodice that molded a slender waistline and emphasized the swelling curves of bosom and hips. Sleeve and collar treatments were important to Fath, and he favored irregular necklines that drew attention to the breasts. Skirts were either very slim or very full, perhaps characterized by a whirlpool of pleats or interesting draped effects. Fath's style of "wearable glamour" had a wide appeal, and, in addition to his own couture collections, he also produced a lower-priced American line.

Fath was increasingly regarded as "the heir apparent to Dior's throne." As

20 Balenciaga evening coat with broken stripes of gray, brown, tan, and black velvet, 1950. The Museum at F.I.T., New York, Gift of Jerome Zipkin, 86.142.3. Photograph by Irving Solero.

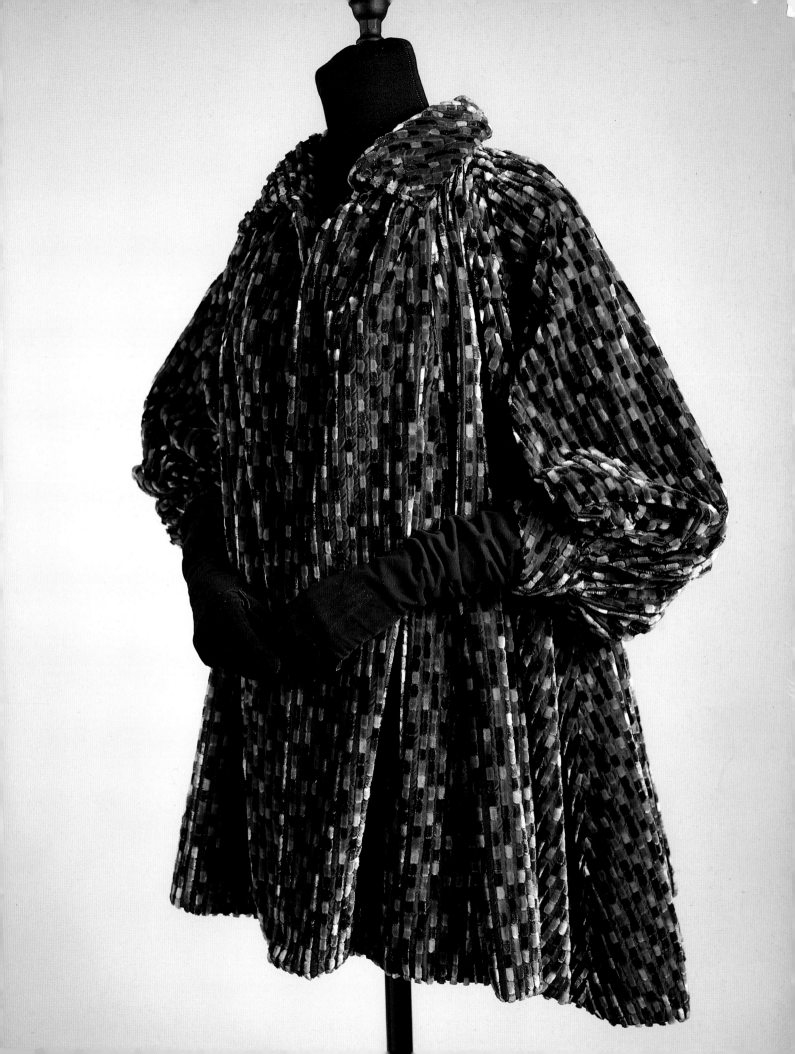

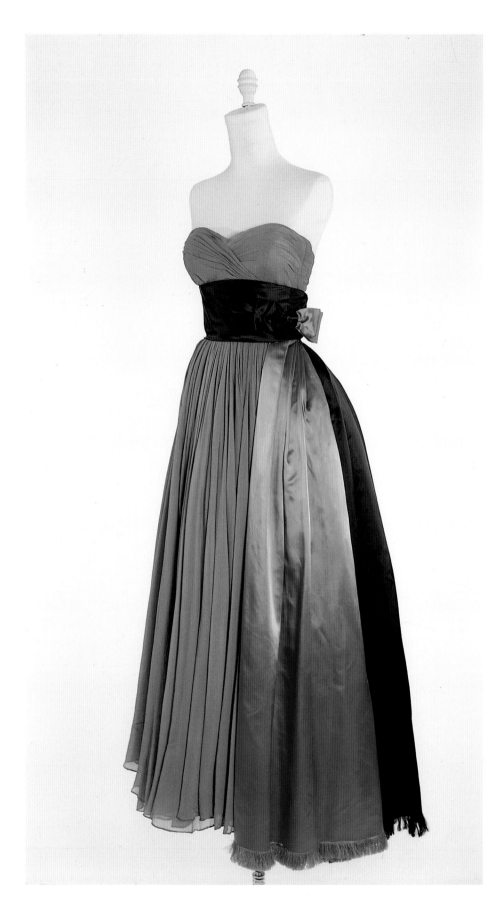

21 Jacques Fath strapless evening
gown in aqua silk georgette with
cummerbund/sash in midnight blue and
mauve satin, c.1952. The Museum at
F.I.T., New York, Gift of Zita Hosmer,
89.111.1. Photograph by Irving Solerno.

Life magazine put it in 1949, "Dior is still generally acknowledged to be the head man, so to speak, of the fashion world, but Fath has recently had a spectacular rise in prestige, and it now seems likely that the next look to confront and impoverish the U.S. male will be the Fath look." Carmel Snow, the famous editor of *Harper's Bazaar*, revised her earlier opinion of Fath, and now declared that, "He makes you look like you have sex appeal – and believe me, that's important."

Fath himself had tremendous personal appeal, with his blond wavy hair and slender physique (a twenty-eight-inch waist claimed one source). He was also very much a social personality; he and his pretty wife loved throwing lavish and imaginative parties, which had the pleasant side-effect of providing excellent publicity; "An atmosphere of glitter, chic and perfumed excitement permeates both his personal and business affairs," observed *Life*. Yet behind the scenes, Fath was struggling with illness. Only a year before his death in 1954, the American press had hailed him as the "fabulous young French designer who . . . is out to make every woman look like a great beauty." In 1954 that promise was cut short.

In 1957 Dior also died suddenly, of a heart attack, plunging the French fashion industry into despair. Fortunately, Dior's assistant, the young Yves Saint Laurent, had an immense success with his first collection for the House of Dior: the trapeze line, an extreme version of the A-line. Here we must pause, however, because it would be a great mistake to interpret the history of fashion as nothing more than a succession of creative geniuses.

In 1954, shortly before his death, Jacques Fath told the United Press, "Women are bad fashion designers. The only role a woman should have in fashion is wearing clothes," and he predicted that "some day all the great designers will be men." His remarks caused considerable controversy, especially among what the press called his "feminine rivals." "Men are the great designers? No! The great designers are women," declared Sophie of Saks Fifth Avenue, citing Chanel and Vionnet as examples of creative genius. Chanel herself laconically replied, "Mr. Fath's statement needs no answer. Facts will answer him." A few months later she reopened her couture house and began lambasting male designers for putting women in uncomfortable, impractical clothes.

But behind Fath's provocative rhetoric lurked an undeniable fact. In the past, women had dominated the French couture; before the war, the most important fashion designers in Paris were the triumverate of Chanel, Schiaparelli, and Vionnet, accompanied by a host of other successful women, such as Jeanne Lanvin, Alix Grès, and Louiseboulanger. After the war, however, the new stars of the couture were men – Christian Dior, Christobal Balenciaga, Jacques Fath, Pierre Balmain, and Hubert de Givenchy.

"Fashion is art. Art is creative and men are the creators," insisted Fath. But the postwar rise of the male designer is a complex phenomenon that cannot

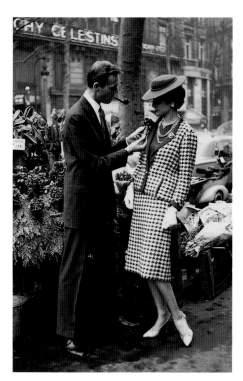

22 Tailored suit by Coco Chanel, 1959.
Photograph by Willy Maywald. © Assoc.
Willy Maywald/ADAGP.

23 (*facing page*) Chanel wool tweed suit
with jacket, skirt, and coordinating,
blouse, Fall 1959. The Museum at F.I.T.,
New York, Gift of Mrs. Walter Eytan,
80.261.2. Photograph by Irving Solero.

be reduced to easy clichés. When the textile millionaire Marcel Boussac backed Christian Dior, fashion photographer Louise Dahl-Wolfe argued, "He picked Dior, I think, because he was a man." But there is no evidence for this. Neither Fath's theory of male superiority nor Dahl-Wolfe's belief in male conspiracy adequately explains the rise of the male designer, which resulted from a complex combination of economic developments and cultural attitudes.

After 1945 fashion was restructured and reconceived as big business and high art. No longer was it a small-scale luxury craft that required a minimal investment. At the turn of the century Jeanne Lanvin had opened her own business with a loan of 300 francs; Marcel Boussac invested $500,000 in establishing the House of Dior. Only a few women were able to marshall this type of financial backing, notably Chanel, whose perfume business was lucrative.

The clientele for the couture had also changed. Before the war a few women of great personal style exerted a tremendous influence on fashion. "Women of fashion were at their most powerful – dictators, in a sense, of a luxurious and capricious way of life," recalled fashion editor Bettina Ballard. A "small egocentric group of women" (like Mrs. Reginald "Daisy" Fellowes and Princess Jean Louis "Baba" de Faucigny-Lucinge) dominated high fashion "by making fashionable what they chose for themselves." After the war there was a less sophisticated mass market. These people were not sure which trend-setters they wanted to follow – society ladies? movie stars? Fashion designers stepped in as the new fashion leaders. The advantage seems to have have shifted to a handful of designers who could be promoted as stars. The genius-dictator was increasingly imagined as a man. Indeed, in a sense there was room only for one "king" of fashion, and much was made of the competition between Dior and Balenciaga. Chanel was again the exception, in part because she positioned herself as women's friend and role model.

"Ah, no, definitely no, men were not meant to design for women," Chanel insisted, "Men make clothes in which one can't move." Thus she conveniently forgot the era between the wars when male designers like Jean Patou made the same kind of loose, comfortable clothes that she revived with such success after 1954. The sight of women in New Look fashions acted on her as "a red flag to a bull," recalled Franco Zeffirelli. In his autobiography he described how Chanel loudly attacked passers-by:

> Look at them. Fools, dressed by queens living out their fantasies. They dream of being women, so they make real women look like transvestites . . . They can barely walk. I made clothes for the new woman. She could move and live naturally in my clothes. Now look what those creatures have done. They don't know women. They've never *had* a woman!

The homophobia that Chanel expressed was all too typical of many

people's attitudes in the 1950s. In the United States, for example, the right-wing witch-hunt against "communists" extended also to the persecution of sexual "deviants." More generally, there was an increasing tendency to interpret reality in black and white with no shades of gray. Gender stereotypes were also primitive; in a reversal of Fath's prediction, Claire McCardell (America's greatest sportswear designer) insisted that "someday all designers will be women. Men, I hope, will be busy with masculine things."

This hardening of the conceptual categories helped position fashion as a pillar of "the feminine mystique." Barbara Schreier, curator of one of the most sophisticated exhibitions devoted to 1950s fashion, *Mystique and Identity*, concludes that women's clothing really was in many ways "a metaphor of the mystique," expressing as it did a veritable cult of femininity. From stiletto heels and waspie girdles to white gloves and aprons, women's fashion promoted restrictive images of femininity: wife-and-mother and/or *femme fatale*. Were male designers responsible for the exaggerated, even caricatured femininity of 1950s fashion? The evidence indicates nothing so simple.

Indeed, the ideology of ultrafeminine fashion was most clearly defined by a woman. In her 1959 book *Wife-Dressing*, the American fashion designer Anne Fogarty argued that "The first principle of wife-dressing is Complete Femininity." Although she herself had a successful career, Fogarty always insisted that she thought of herself "first and foremost as a wife." She advised her readers always to remember that "it's your husband for whom you are dressing." Wife-dressing not only pleased a husband, it also helped his career, since in the new corporate environment a wife's appearance was an issue "especially when promotions to high-echelon jobs are in the offing."

Blue jeans might be popular with "bachelor-girls," but they had no place in a wife's wardrobe. Even when cleaning the house, a woman should look pretty and feminine: "Don't look like a steam-fitter or a garage mechanic when what you are is, purely and simply a wife." Fogarty advocated wearing a girdle "with everything" – a practice that she happily compared with

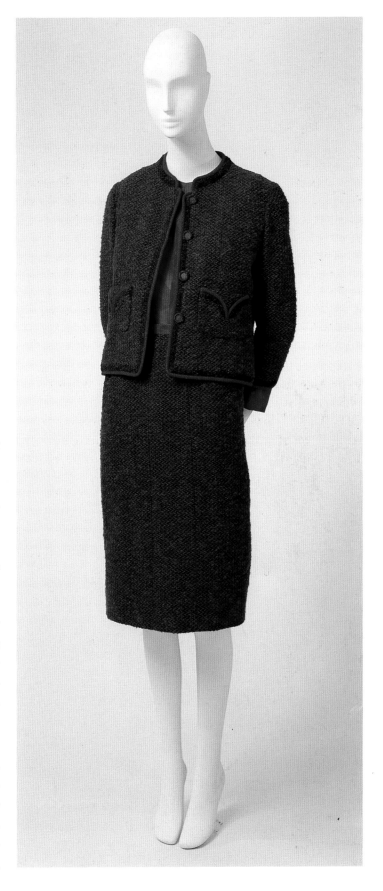

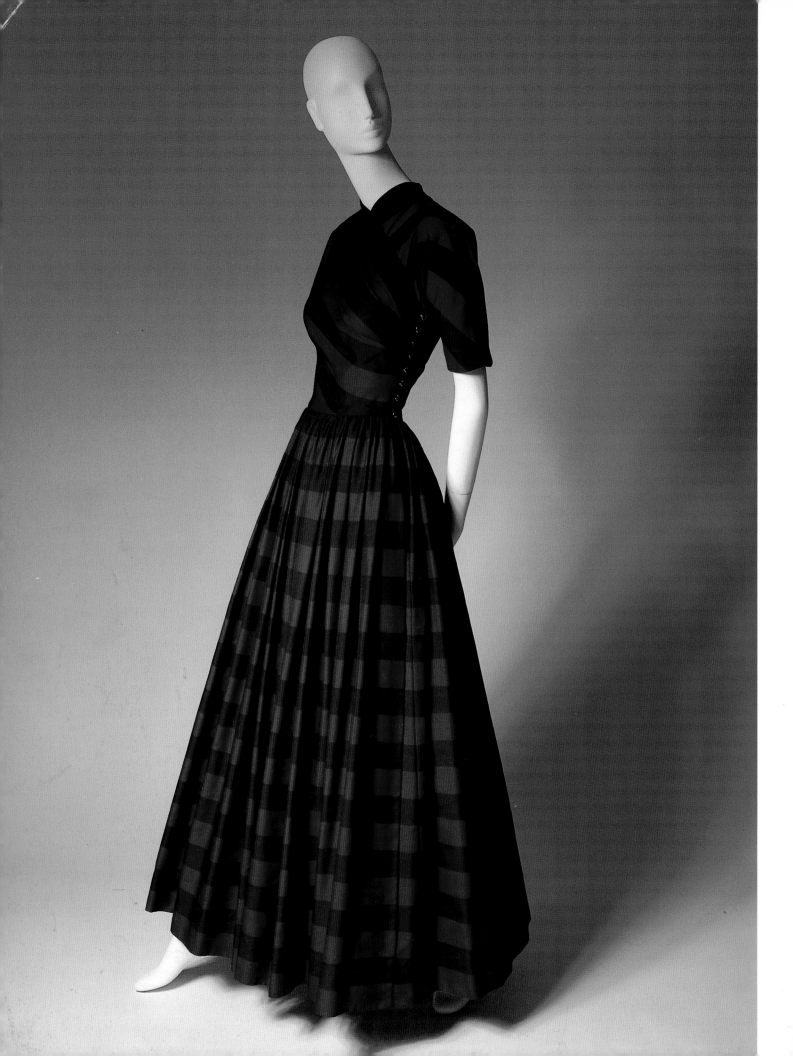

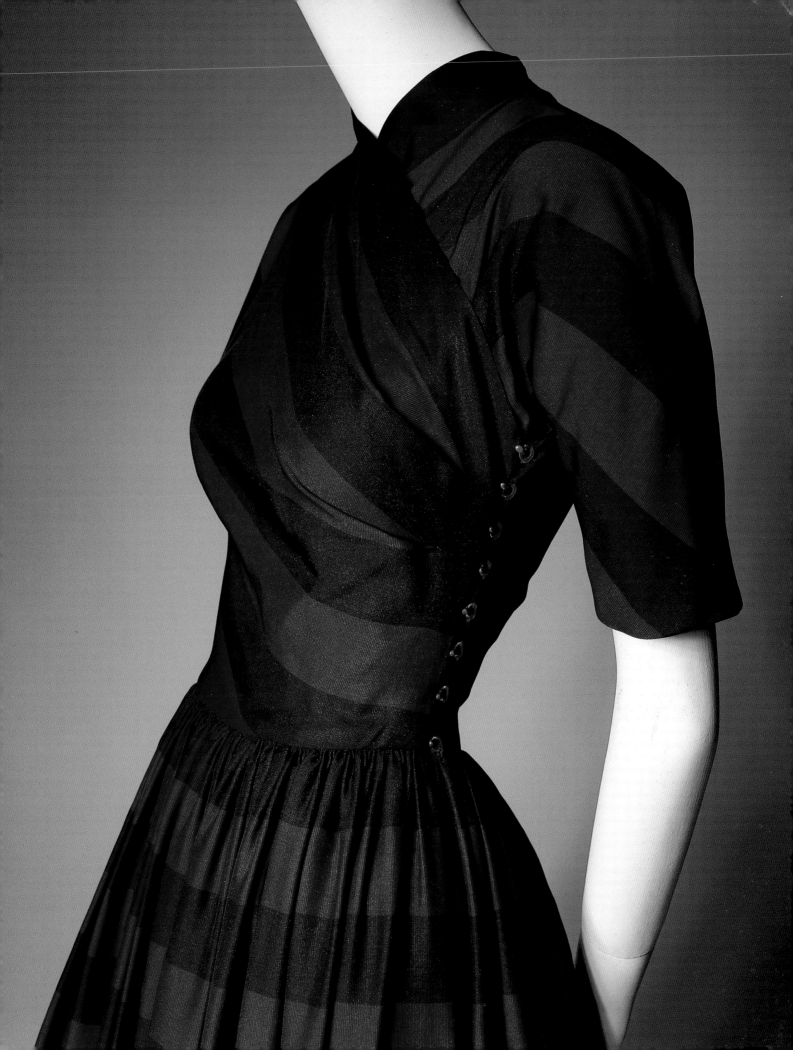

26 Anne Fogarty, fashion designer and author of *Wife-Dressing*. Photograph: Archive Photos.

24 and 25 (*previous pages*) Claire McCardell dress in red and black wide-stripe silk/cotton faille, with brass hooks and eyes, 1955. The Museum at F.I.T., New York, Gift of Mr. and Mrs. Adrian McCardell, 76.173.1. Photographs by Irving Solero.

Chinese foot-binding. She felt "very strongly" that clothes should fit snugly, especially in the evening, when she herself favored cocktail dresses so tight that sitting down was impossible. "You're not meant to suffer," she reassured her readers, but the feeling "should be one of *constraint* rather than comfort."

It may not be accidental that Simone de Beauvoir presented her idea of "elegance as bondage" at a time when fashion was unusually backward-looking and physically restrictive. Indeed, the famous "pornographic" novel *The Story of O*, by the pseudonymous Pauline Reage, drew an overt connection between feminine fashion and sadomasochism. Before her first ordeal, the heroine, O, dresses in "a whalebone bodice which severely constricted the waist." Significantly, O works as a fashion photographer and soon the model Jacqueline catches her fancy:

> Jacqueline . . . was wearing an immense gown of heavy silk and brocade, red, like what brides wore in the Middle Ages, going to within a few inches of the floor, flaring at the hips, tight at the waist, and whose armature sketched her breasts . . . it was what couturiers called a show gown.

This New Look gown was similar to the dress that O herself had worn for her ritual flagellation.

In the 1950s people were constrained by more than their clothes. They also felt suffocated by the conformity that was endemic throughout society, probably more so than at any time since the nineteenth century. An important causal factor was social insecurity; respectability was valued most ardently by those who had only recently risen in the class hierarchy. Just as the middle class had greatly expanded during the nineteenth century, the same thing happened after the Second World War. It was a case of "the fashioning of the bourgeoisie" all over again.

No conspiracy existed to push women back into the home, so that demobilized men could assume their jobs, and housewives could take on their new "job" of buying products. Nevertheless, the fifties saw the rise of a new age of consumerism. Advertisers not only sold consumer items, they also reinforced certain ideologies, such as the doctrine that woman's highest function was to care for her husband and children. "Marriage is . . . best," declared the *Women's Reporter* (June 1948). "A career is nice and will come if she has the time and energy . . . but *first* things first! Take her clothes: she has no desire to be bizarre, conspicuous or extreme . . . The boys don't approve [of conspicuous styles]." A woman's watch-word must be "Good Taste." As Baudrillard and others have demonstrated, the idea of taste is clearly linked to the class hierarchy.

And yet the fifties' conception of "good taste" could be quite extreme! Indeed, a good argument could be made that many of the characteristics of postwar women's fashion (such as its exaggeration of forms and its radical changes in silhouette) were paralleled by developments in, for example, the

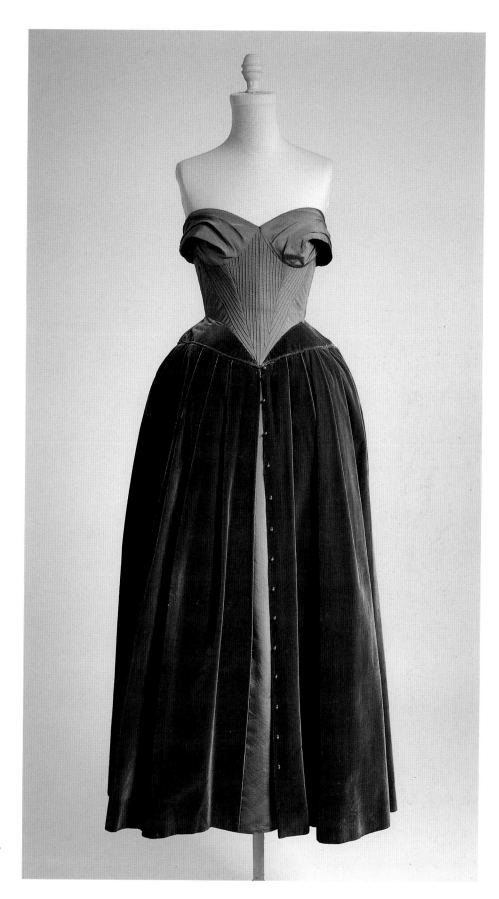

27 Pierre Balmain "Corset" evening
dress in blue taffeta and gray-green
velvet; the boned bodice laces in back,
*c.*1951. The Museum at F.I.T., New York,
Gift of Mrs. F. Leval, 84.125.3.
Photograph by Irving Solero.

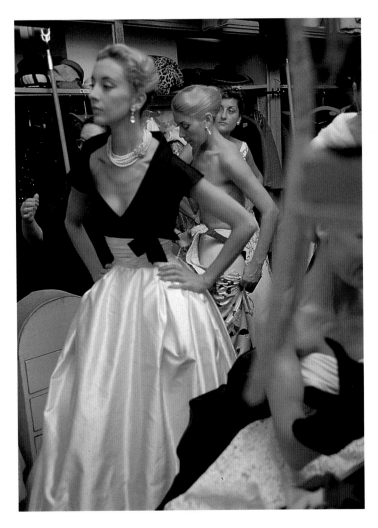

American car industry. Here, too, the most exaggerated car styling was advertised as epitomizing both luxury and good taste.

When Harley Earl [the leading car designer at General Motors] started piling chromium onto Chevy's and Pontiacs, he was triggered by the same impulses that caused Dior to drop the hemline. When he changed the Cadillac from one year to the next, he was just doing what [couturiers] did from season to season.

So argued Christopher Finch in his amusing social history *Highways to Heaven*; and there is much to be said for his argument. Consider, for example, how the 1953 Cadillac featured projectile "bombs" in front that were remarkably similar to the torpedo-shaped brassiere. In the 1950s cars, like women's bodies, were often (unconsciously) fetishized.

It is also significant that, unlike European luxury cars, expensive American cars like the Cadillac were not hand-crafted. Instead, something was *added*, for example tailfins, that served as the visible badge of luxury. The bigger, the newer, the gaudier a car (or dress) was, the more it appealed to what has been called the "populuxe" mentality (a blending of the words "popular" and "luxurious"). Although real couture dresses were handcrafted, by the 1950s there were so many licensed copies that the designer label served as a similar badge of status. For cars and dresses alike, engineering (internal construction) was much less of an issue than styling, and the visual vocabulary was easy to read. Fashionable colors changed yearly – for cars, dresses, radios, even refrigerators.

At the same time, the rules of "appropriate" dress proliferated. Certain styles of dress were strongly associated with particular times and places. Thus, it was said that certain fabrics, such as brocade, "should not go out before 6 p.m." Indeed, the arbiters of fashion distinguished between the type of cocktail dresses appropriate early in the evening, theater dresses suitable for an 8 p.m. show, and full evening dress to be worn after 10 p.m.

Ball gowns were the most opulent type of evening wear. The ball gown had a long skirt and a low decolletage; it was worn with matching high-heeled shoes, long white kid gloves, and a woman's most dazzling jewelry. A ball gown would be too dressy for many evening occasions, however; for theater openings, night clubs and dinner parties, something shorter and less elaborate was preferred. In most such cases, women

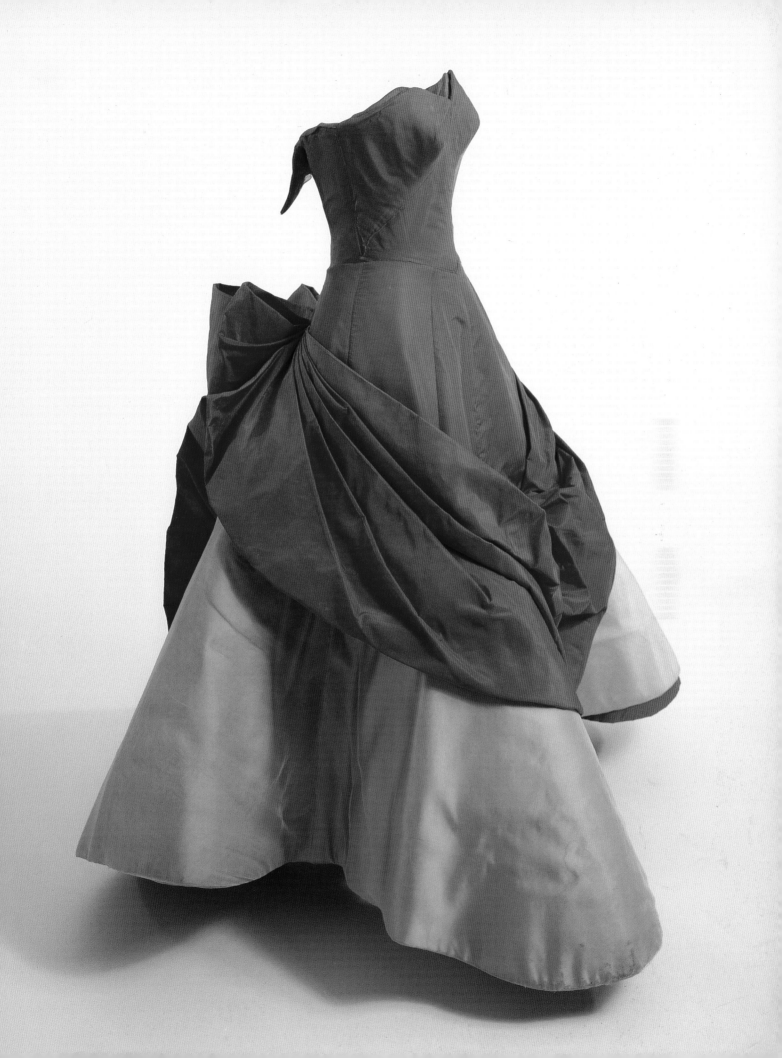

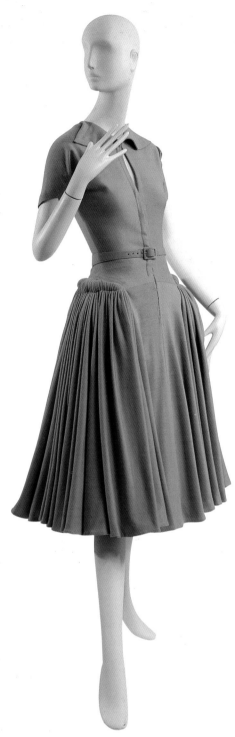

30 and 31 Afternoon dress in wool jersey with side pleats by Madame Grès, c.1950. The Museum at F.I.T., New York, Gift of Mrs. Molly Milbank, 91.253.2. Photographs by Irving Solero.

wore short evening dresses made of rich materials, or else long evening dresses that were simpler than ball gowns.

Cocktail parties first became an important form of entertaining in the 1920s, and the cocktail dress evolved in response to this new occasion. Simpler to organize than a dinner party, the cocktail party was less formal than a sit-down dinner and liquidated social obligations to larger numbers of friends and acquaintances. As a result, the cocktail dress was less formal than the dinner dress. Fashion writers stressed that cocktail dresses should be only slightly décolleté, or not at all. The female guests at a cocktail party wore hats and gloves, although the hostess did not. (By the early 1960s, if the hostess had a garden or terrace, she might choose to wear a "patio dress" or "palazzo pyjamas," styles that recalled the tea-gowns of the belle époque.) It was also perfectly acceptable to wear a dressy suit. For those going directly from cocktails to dinner, a matching jacket might be worn over a dinner dress.

These rules sound oddly dated today – practically Victorian – but they were taken quite seriously until the late 1960s, when society began to be increasingly informal. Until that time there was a continual demand for books such as Geneviève-Antoine Dariaux's *Elegance* (1964), which informed women how to be "well and properly dressed on all occasions." As directrice of Nina Ricci's couture house, Madame Dariaux's words had a ring of authority, as she warned that one should never wear daytime shoes with an evening dress. Although alligator shoes, for example, were expensive, they were to be worn only with a casual ensemble and should be retired at 5 p.m.

Such fashion arbiters as Madame Dariaux devoted a great deal of attention to accessories, because these little extras were regarded as being among the most important elements of an elegant appearance. Thus, it was said that accessories could triple the apparent value of a dress, while carelessly chosen accessories could undermine the effect of even the most expensive clothing. As in the Victorian era, strict rules governed the use and choice of accessories, such as gloves, which were by no means optional. It is little wonder that many women obsessively matched the color of their shoes, gloves, and handbags – although more sophisticated women deplored this tendency.

Throughout the 1950s most middle-class men and women wore a hat almost every day. It was thought that a proper *chapeau* made the difference between being dressed and being well-dressed. In the early 1960s, though, hats began to fall out of fashion. On his Inauguration Day, President John F. Kennedy went bare-headed, violating traditional rules of decorum. By 1964 the author of a book on elegance wrote, "Bravo for the men who still wear a hat!" Women also began to abandon hats, in part because of the fashion for bouffant hairstyles (like the "beehive").

At the U.S. exhibit in Moscow in 1959, an IBM machine ticked off this information:

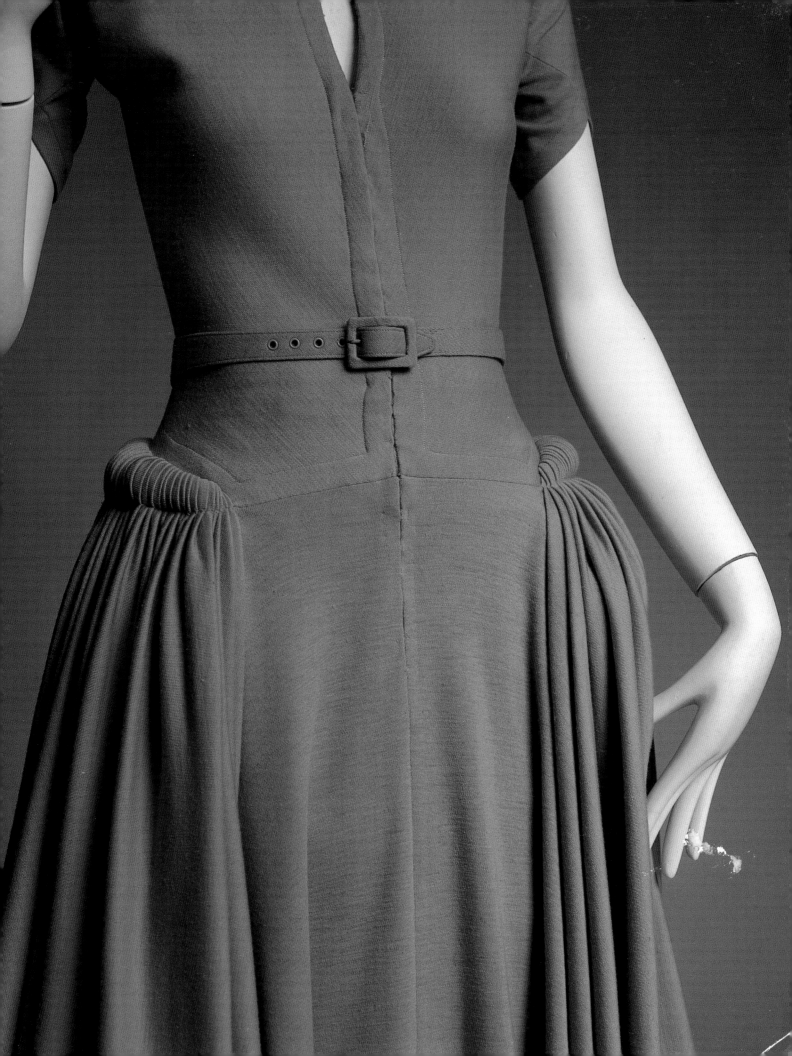

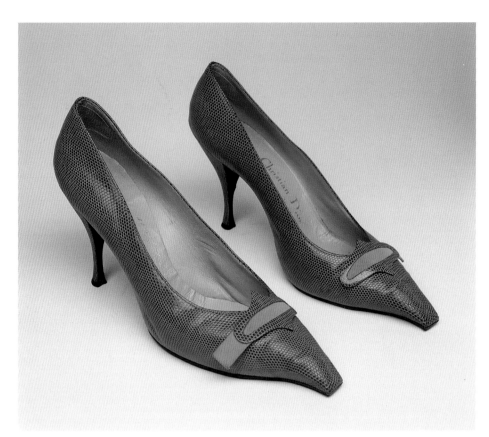

32 Lizard high-heeled pumps by Roger Vivier for Christian Dior. The Museum at F.I.T., New York, Gift of Arthur Schwartz, 79.169.3. Photograph by Irving Solero.

33 Casual daytime wear in the 1950s – with hats and gloves. Photograph: Archive Photos.

The wardrobe of an average American woman in the middle income group includes one winter weight long coat (fur-trimmed or untrimmed), one spring weight coat . . . one raincoat, five house dress type dresses, four afternoon "dressy" type dresses, three suits, three skirts, six blouses, three sweaters, six slips, two petticoats, five nightgowns, eight pairs of panties, five brassieres, two corsets or girdles, two robes, six pairs of nylon stockings, two pairs of sport type socks, three pairs of dress gloves, one bathing suit, three pairs of play shorts, one pair of slacks, and one play suit as well as accessories.

(The accessories were tabulated by another research organization and included "seven pairs of shoes, four handbags, a dozen pieces of costume jewelry, four hats, and assorted scarves, belts, and other addenda.") Eve Merriam, the author of *Figleaf* (1960) thought that this sounded conservative, because it made no mention of "the millions of evening dresses, furs, car coats, jackets, beach coats, and other substantial items of apparel that the industry turns out annually." Still, this gives a fairly coherent picture of the wardrobe of the era.

Although in the 1950s, as we have seen, fashion was strongly associated with a handful of famous couturiers, even a designer of genius is also a

34 A puffy playsuit by the Italian designer Simonetta Visconti was featured in *Life* (1952). Photograph: Photo Researchers Inc. © Mark Shaw Collection.

product of the times. The fashion historian must not forget to look at the reception of fashion, noting, for example, that Givenchy's bubble dress of 1956 was the inspiration for the Barbie doll's 1959 ensemble "Gay Parisienne."

Indeed, the Barbie doll is an exemplary artifact of popular culture, and reveals a great deal about popular attitudes towards fashion. Although fashion dolls have existed since the eighteenth century, they were not primarily intended for children. Most little girls played with baby dolls. The first modern fashion dolls (with breasts and arched feet) appeared in about 1955. The most famous of these was the Barbie doll, which was launched in 1959 by the American toy company Mattel. Once little girls bought Barbie, they were encouraged to buy a large wardrobe for her, including items identified with particular occasions: "Fashion Luncheon," "Movie Date," "Dinner Date," "Theatre Matinee," "Debutante Ball," and so on.

Significantly, the Barbie doll was described as a "teenage fashion model." Just as the concept of childhood only developed in the course of the eighteenth century under the influence of Rousseau and Locke, so also was adolescence a creation of the mid-twentieth century. The "teenager" was born in the 1950s, and with this new being there emerged new fashions; but only slowly. Barbie's first wardrobe of twenty-two outfits contained only a few "teenage" ensembles, such as denim trousers and a checked shirt intended to

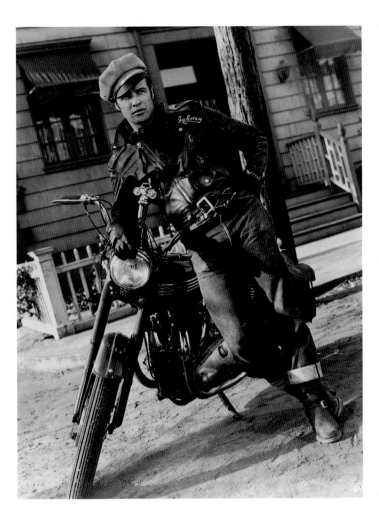

35 Marlon Brando in black leather jacket. Still from the film *The Wild One*, 1954.

be worn to a picnic. Already in the 1940s, blue jeans had begun to be worn by middle-class boys and girls, setting the stage for what would later become a genuine fashion revolution.

For the most part, however, Barbie wore miniature versions of adult fashion. Thus, in addition to "Gay Parisienne" (based on the French couture), she had "Roman Holiday" (inspired by Italian sportswear) and "Easter Parade" (Easter being traditionally a holiday associated with dressing in new clothes and fancy hats). Real teenagers also mostly copied adult dress: their prom dresses, for example, were imitations of women's ball gowns.

But special fashions for teenagers were also emerging, especially in conjunction with the rise of rock and roll. Many white hipsters had already copied the sartorial style of black jazz musicians such as Dizzie Gillespie, for example their berets and shades. Bikers and beats alike were indebted to the hipster look. Significantly, Marlon Brando once described *The Wild One* as a portrayal of "hipster psychology." Certainly, films like *The Wild One* and James Dean's *Rebel Without a Cause* established the black leather jacket as a universally recognized symbol of rebellious youth.

Beats, beatniks, and existentialists formed another style tribe, as Ted Polemus points out in his book *Street Style: From Sidewalk to Catwalk*. Indeed, he argues that "one could hypothesize that the core of what became known as 'Beat Style' was actually Left-Bank style as seen through the dark shades of American jazz musicians." On one trip to Paris, for example, Miles Davis fell in love with Juliette Greco, who introduced him to Sartre and the other existentialists. The beatnik quickly became a media cliché, portrayed in movies like *The Subterraneans* (based on a Jack Kerouac novel) and the television show *The Many Loves of Dobie Gillis*, but the stereotype seems to have taken on a life of its own.

Black became the favored color among artists and intellectuals. Modern dancers wore black tights and leotards, while painters and musicians alike wore black turtlenecks and dark glasses. Bohemian black was very different from Chanel's "little black dress," which had long since become the very uniform of respectability, but other more flamboyant styles also evoked a disdain for conventional, bourgeois society.

In England the teddy-boy look was treated as visible evidence of juvenile delinquency. When worn by working-class youths, items like long jackets with velvet collars subverted the meaning of upper-class Edwardian menswear. The

40

style's irreverence was further heightened by the incorporation of such American elements as string ties. When Bill Haley's *Rock Around the Clock* and the hit songs of Elvis Presley crossed the Atlantic in 1956, the look came together. Indeed, as Polhemus shows, street style was created by many different subcultural groups. Beats like Jack Kerouac wore Levis and "Sloppy Joe" sweaters, and so did those who loved folk music.

A decade before the Beatles, there was Elvis Presley, who married country and western music to rhythm and blues. Presley's sartorial style embraced both the wildly decorative "dressing up" style (showy suits and blue suede shoes) and also the aggressively "dressing down" look of a denim work jacket, jeans

36 Beatniks. Still from the film *The Subterraneans*, 1960.

and boots. Thousands of teenagers also adopted a variety of youth styles. There were "bobby-soxers" in poodle skirts and saddle shoes, and there were "greasers" with ducktail haircuts and sweaty undershirts. There was no single uniform of nonconformity, although a cartoon of the period showed a woman reproaching her artist lover: "Why do you have to be a nonconformist – like everyone else?"

The 1950s was notoriously the era of conformity: the "Organization Man," the "Man in the Gray Flannel Suit," the "silent generation." Increasing numbers of adult women also were working in organizations, "where not only is there pressure to think alike, but also to look alike." Even "youngsters" wanted to "look like everybody else." According to Eve Merriam, a fashion industry professional, the fashion business was partly to blame for stressing the "conformist big fashion sell." "Conformity takes over, for in order to make an appreciable profit, you have to make a lot of one thing and sell it widely." The problem was endemic throughout society; everyone had become "more conformity-oriented."

Merriam gave as an example the triumph of the sack dress, also known as the chemise. In 1957 *Women's Wear Daily* announced that "Givenchy Silhouette Embodies Fashion Trend." This caused dismay among the American public. *Time* magazine captioned photographs of the new Paris fashion: "*Ou est la poitrine, ou sont les hanches, ou est la femme?*" Givenchy replied that the sack was "inspired by modern art, the experimental art that seeks new shapes and

forms transgressing the limitations set by convention. With my new dress form I have discarded, among other things, the limitations set by the female figure itself." To which Merriam impudently asked, "Was he kidding? It didn't matter. The snob appeal caught on." Soon organs of the fashion industry in America echoed the message that "This is fashion's version of the avant-garde . . ."

It is doubtful, however, whether the appearance of the "waistless" dress really proved that in the 1950s people had "become more susceptible to conformism in fashion than at any period of history before." Yet Merriam repeated a number of amusing contemporary quotations that provide evidence of popular attitudes. It is clear, for example, that many Americans did not like the idea of avant-garde art, especially in relation to women's fashion. Many people were particularly indignant about what seemed to them the deliberate obliteration of female sexual attractiveness, which they identified with the tightwaisted dress and the hourglass figure.

Mrs. Lucie Noel, fashion editor of the *Herald Tribune*, berated the Parisian designers who had created the sack: "Can it be possible that this is the war of the sexes and that you are about to exterminate woman, just as the praying mantis devours her lover when he has served his purpose? This could ring the end of Homo sapiens as fast as nuclear weapons might do." Kenneth Collins of *Women's Wear Daily* chided her: "Ah, Lucie, Lucie . . . You still believe that women adorn themselves to entice men . . . Well, it just isn't so. The ungainly chemise is everywhere, yet boys date the girls as eagerly as ever. So clothes, evidently, have nothing to do with these masculine urges." Ultimately, there was a backlash against the sack dress, which had lost its exclusivity through mass copying, but the style set the precedent for the many chemise dresses that followed in the next decade.

Fashion has always involved distinction – drawing a line between the "ins" and the "outs," but the methods used differ in different periods. In the 1960s youth was at a premium; in the 1950s social status was more of an issue. The language of fashion indicated some of the levels of distinction.

As Eve Merriam put it, "A course in semantics will be helpful . . ." In periodicals directed toward the middle class, the prose is fairly straightforward: "Sheath dress by Henry Rosenfeld. Sizes 10–18, $17.95. Contour belt by Corot. Purple gloves from Wear-Right." In more upscale periodicals, declarative prose gives way to more atmospheric discourse. Mundane facts like price and size may be omitted and adjectives are displaced: "The dress, a sheath. The belt, contour. The gloves, purple." At the highest levels of the fashion press, in *Vogue* and *Harper's Bazaar*,

> the language is hortatory, a summons . . . You have been Called. Would you keep the Lord waiting? . . . Therefore accept the dicta from on high and do not question. Today, thick textures, nubby, palpable. Tomorrow, diaphanous draperies, fluid, evanescent. The Lord giveth and the Lord taketh away. Shanti, Scassi, shantung.

37 Gregory Peck in *The Man in the Gray Flannel Suit*, 1956. Photograph: Archive Photos.

38 The "sack-look" in London, 1957.
Photograph: Archive Photos.

Below, in the lesser regions, God is cast into the role of a boss. The magazines catering to this middle trade, such as *Glamour* and *Mademoiselle*, appeal to those who work for a living and to the collegiate young who are accustomed to being bossed either by the office manager or the faculty advisor. The authority above them is not omnipotent [however] . . .

Thus the tone of the middle fashion magazines is authoritative, but tempered with an egalitarian air. They suggest, they cajole, they implore – they make you eager to follow obediently because they are such good sports themselves . . . They suggest that mauve is simply marvelous, but you

needn't go the whole hog – you may want to try only a mauve belt or scarf . . .

In the upper regions, Mauve Is. Don it, or go back to supermarket suburbia where perhaps you really belong. Aristocracy does not perpetuate itself by allowing any old placid cow into the herd.

Merriam's description is amusing, but also right on target: French and Latin words were "reserved for the higher brackets." Where the reader of *Glamour* is coaxed to "splurge on one expensive coat," *Vogue*'s reader sees "the look of *luxe*." Anglicisms are also restricted: *Mademoiselle* calls a dress "wonderful." In *Bazaar*, it's "wizard." The class subtext is fairly obvious. Middle-class readers like clothes to be "pretty" and "darling." But: "Strict, severe, stark, plain, unadorned, rigorous – these are the adjectives most used in the high-fashion vocabulary."

Not surprisingly, "at that high level, sex is similarly in the deep freeeze." Although thinness was desirable throughout the fashion world (long before Twiggy), high-fashion models were (and still are) the thinnest of all. Merriam makes this point quite clear: the Marilyn Monroes and Briget Bardots of the world play no role in high fashion. When a film focused on fashion, as *Funny Face* did, the actress who was chosen to play the top fashion model was the slender gamine Audrey Hepburn. Few real models, however, were quite as young and innocent-looking as Audrey Hepburn. Hers was, in a sense, the face of the future, looking toward sixties' models like Jean Shrimpton.

The top fashion models of the 1950s were glamorous creatures, like Dovima, Dorian Leigh, and Suzy Parker. As Jerry Ford (of the famous model agency) once said of Dovima, "She was the super-sophisticated model in a sophisticated time, definitely not the girl next store." Before achieving success as a model, Dorothy Virginia Margaret Juba was a simple working-class girl who liked reading comic books. Once when she arrived in Egypt for a fashion shoot, she was asked how she liked Africa. "Africa?" she cried. "Who said anything about Africa? This is Egypt." Told that Egypt was in Africa, she said, "I should have charged double rate!" (By 1954 she was charging $50 an hour.)

The leading fashion photographer of the day was Richard Avedon. Avedon told stories with his pictures, posing his models in scenes of glamor and romance – at the opera or a Paris flower market. Although carefully staged, his pictures had a feeling of spontaneity. His greatest competitor, Irving Penn, had a very different style; his fashion photography developed out of his work in still life. Not only were his photographs deceptively simple and elegant, his women also showed impeccable style and elegance.

In 1955 Avedon and Dovima collaborated on one of the most famous fashion photographs of all time, *Dovima and the Elephants*, shot at the Cirque d'Hiver in Paris. Avedon later called the photograph "her peak of elegance

39 Christian Dior ensemble consisting of a two-piece dress and matching jacket in black basket weave wool trimmed in black velvet, Fall 1956. The Museum at F.I.T., New York, Gift of Caroline Hutchins Shapiro, 65.132.1. Photograph by Irving Solero.

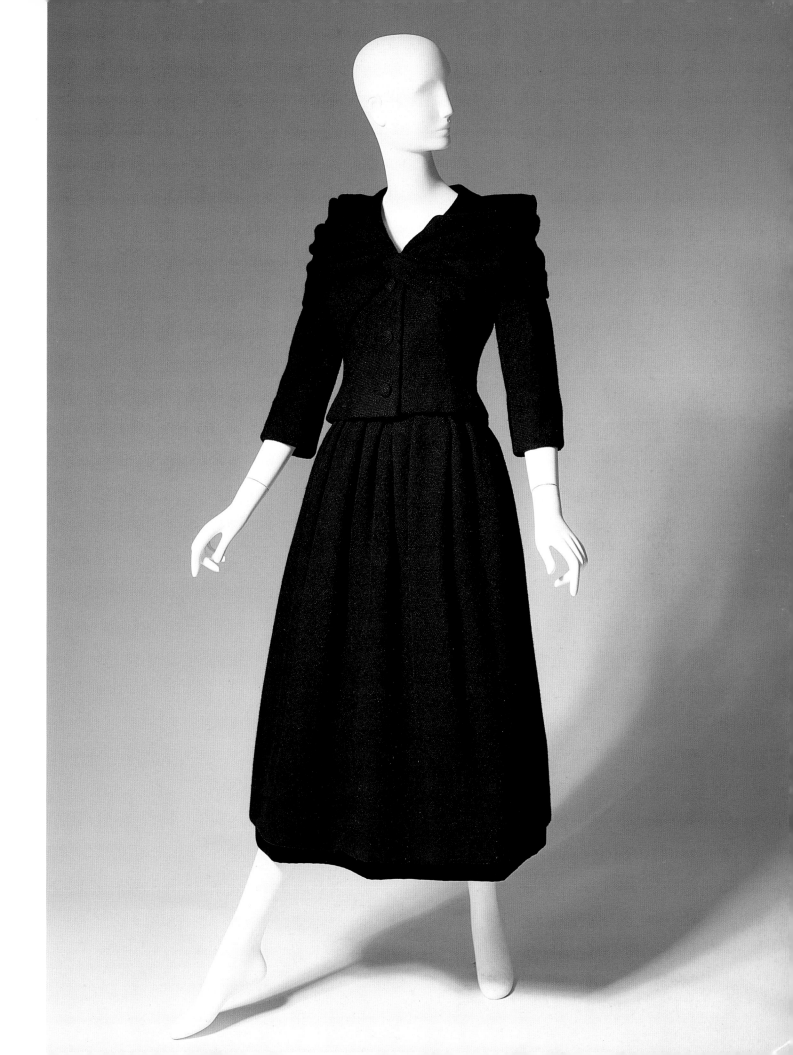

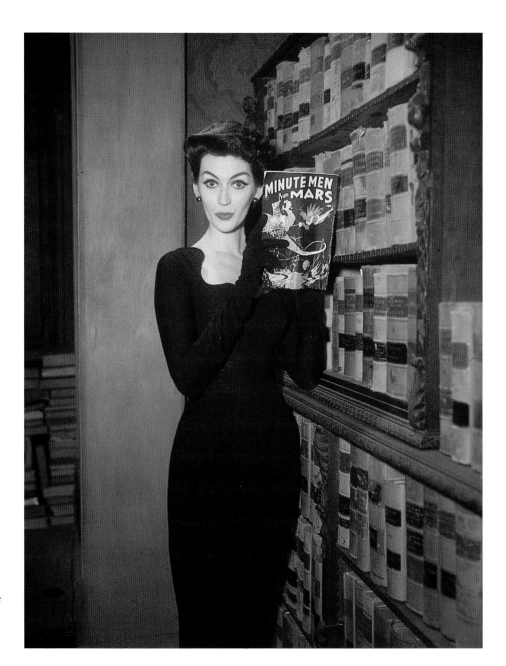

40 Dovima, a top fashion model of the 1950s, in a publicity still for the film *Funny Face*, 1956. Photograph: Archive Photos.

and power." In 1956 Avedon and Dovima collaborated again on the film *Funny Face*. Dovima appeared as a model named Marion, whose exaggeratedly elegant mannerisms (and love of comic books) were gently spoofed. Avedon served a consultant for the film and was himself the original for the fashion photographer played on screen by Fred Astaire. Many of the fashion photographs staged for the film (such as a woman in a Paris flower market) were based on images that Avedon had previously created with another model, Suzy Parker, who also had a cameo in *Funny Face*.

Irving Penn created many beautiful images featuring his wife and muse,

Lisa Fonsagrives. They met in 1947, when American *Vogue* commissioned him to shoot a group portrait of the twelve most photographed models of the day. As the caption in *Vogue* put it, "These twelve share a look of non-adolescence, a look gained not so much from being beautiful as becoming so."

The aristocratic appearance of several top British models served them well not only professionally, but also socially. Fiona Campbell-Warner, for example, married the German industrialist Baron Heinrich von Thyssen-Bornemisza; Anne Gunning became Lady Nutting; Anne Cumming the Duchess of Rutland; and Bronwen Pugh served as Balmain's top model before marrying Lord Astor. Although supreme on the catwalk, however, Pugh's angular proportions were deemed too exaggerated for the readers of *Vogue* and *Harper's Bazaar*.

Indeed, in the 1950s there was a clear distinction between show models and photographic models (unlike the situation today where supermodels appear in both forums). Anne Gunning, for example, only did one fashion show as a favor; terrified at the thought of falling down, she recalled "that sea of facing glaring at me was too daunting. Chanel asked me to model a collection for her, but I knew I couldn't do it . . . I realize now I should have done it. I might have got all my Chanel suits for nothing if I had!" Meanwhile in France famous beauties like Bettina Graziani and Sophie Malga worked primarily as runway models for the couture and only occasionally posed for pictures. Both Bettina and Sophie accompanied Fath on a personal appearance tour to New York, where Sophie shocked an American designer by coming to a fitting without underwear.

Probably the best-known British model in the 1950s was Barbara Goalen, who was often photographed by John French. She moved poorly and clothes needed to be pinned around her very slender hips, but she seemed born to wear the sophisticated creations of designers such as Balenciaga. Like Dovima, Barbara Goalen perfectly exemplified the well-bred, haughty look of the ideal 1950s fashion model.

"PEOPLE ARE TALKING ABOUT . . . Vietnam and the Negro Revolution . . . and Youthquake . . . the eruption of the young in every field." So American *Vogue* put it in 1965 in inimitable fashionspeak, indicating that even fashion journalists, notorious for their tunnel vision, were aware that things were happening in the larger world. The mini-skirt was not the only news of the day.

There is always a larger context for fashion, of course. Yet fashion historians tend to describe the styles of the 1950s solely in terms of developments within the couture, without any reference to the Cold War or the social conformity of the period. This type of narrow, apolitical approach becomes insupportable when dealing with the 1960s. Perhaps sensing this, historians often describe the 1960s as the most "revolutionary" decade in the history of fashion, but what was the nature of this fashion revolution? Images of the sixties remain vivid even today, the more so since the entire era remains profoundly controversial. Fashion photographs provide only a fraction of the historical reality.

The sixties was a period of complete upheaval in political and social, as well as purely sartorial terms. From China to Czechoslovakia, from San Francisco to Soweto, upheaval was not only ideological in character, it was generational. Youth was also the pivotal issue in the fashion capitals of the world.

Vogue's picture is not wrong, only unfocused. The dramatic political events of the decade clearly had an impact on the world of fashion, at least indirectly. But fashion was perhaps more profoundly affected by certain social and cultural phenomena, such as popular music and the sexual revolution, that were often misunderstood at the time and play only a peripheral role in standard histories of the period.

The war in Vietnam, for example, went on for many years before it had any impact whatsoever on fashion, and even then fashion designers were responding primarily to the ironic use of military garb by anti-war protesters. What *Vogue* called "the Negro Revolution," in other words the Civil Rights movement (itself related to the anti-colonialist struggles worldwide) only affected high fashion *after* the "ethnic" look had already become a major theme within the hippy counterculture. Even the appearance of black fashion models like Donyale Luna and Naomi Sims was a long time coming. But *Vogue* was clearly on target about one thing.

41 André Courrèges A-line shift dress in heavy wool, c.1968. The Museum at F.I.T., New York, Gift of Bernie Zamkoff, 78.170.5. Pierre Cardin helmet hat in off-white vinyl, c.1965. The Museum at F.I.T., New York, Gift of The Estate of Janet Sloane, 85.65.10. Courrèges "Space-age" go-go boots in leather with back zipper and velcro closing, 1965. The Museum at F.I.T., New York, Gift of Sally Cary Iselin, 71.213.18DE. Photograph by Irving Solero.

The dominant characteristic of the sixties fashion revolution may be summed up with *Vogue*'s catchword of the day: Youthquake. It was not merely that demographics favored the young. The postwar "baby boom" was a necessary but in itself insufficient stimulus for change. It was because social and economic developments had given young people around the world a self-conscious awareness of themselves as a distinct and unified group that they were able to respond to political events, in the process creating their own culture.

Contrary to popular belief, this was not the first time in history that young people had their own fashions, or that fashion influences trickled upwards from the street, but it was probably the first time that fashions were being set primarily by young people. Hitherto, fashion trendsetters had tended to be, in some sense, the leaders of society. In the 1960s, as *Women's Wear Daily* observed, "The old guard no longer sets fashion . . . The mood is youth-youth-youth."

Looking back on the late 1950s, the English designer Sally Tuffin recalled that "There weren't clothes for young people at all. One just looked like one's mother." This was not entirely accurate, since there were already in the 1950s certain identifiable "teenage" styles. In fact, it was the early appearance and ubiquity of these youth fashions in Britain that set the stage for the emergence of London as a major fashion capital. But Tuffin was correct in contrasting the overall situation in the 1950s, when youth styles were still a minor subtheme in fashion, with the rise and ultimate triumph of youth fashion in the 1960s.

For it was in the sixties that the entire structure of the fashion system was challenged from below. The prestige of the couture came under attack (or, worse, seemed increasingly irrelevant) as upstart designers and boutique owners began to cater to a new youth market, and adult women scrambled to look like their daughters.

Already in the 1950s London was the center of a vibrant youth culture in which fashion played a major role. "For millions of working teenagers now, clothes . . . are the biggest pastime in life: a symbol of independence, and the fraternity mark of an age group," observed British *Vogue* in 1959. Unhampered by an established couture industry, London spawned a host of young designers who catered specifically to "the girls in the street."

One of the first and most successful designers to recognize the widespread desire for distinctively young clothes was Mary Quant, who would later become famous as the "inventor" of the mini-skirt. As early as 1955, Quant had opened her first boutique on King's Road, a shabby thoroughfare in bohemian Chelsea, which was a fashion promenade for London's "mods" and "rockers", youth groups obsessed with music and style.

Without any real training in fashion, but possessed of a clear vision, Quant decided that she wanted to provide "fun" and "exciting" clothes for ordinary

42 Mary Quant mini-dress in rayon crepe with pleated hem ruffle on attached underskirt, *c.*1962. The Museum at F.I.T., New York, Gift of Lillian Rossilli, 77.163.7. Photograph by Irving Solero.

girls like herself. So she opened a boutique, and when she could not find enough clothes to fill it, she began making them herself, "going to a few frantic evening classes in cutting." She worked in her apartment, where her Siamese cats ate the paper patterns. She had no idea that it was possible to buy fabric wholesale, so she bought her material over the counter at Harrods. Despite these difficulties, customers routinely stripped her store, even before she could finish mounting her eye-catching window displays.

"I had always wanted young people to have a fashion of their own," she wrote in her autobiography. "To me adult appearance was very unattractive, alarming and terrifying, stilted, confined, and ugly. It was something I knew I didn't want to grow into." The clothes she made were simple and inexpensive variations on the Chelsea girl or art student look: a box-pleated sleeveless dress with a dropped waistline, a flared black dress with a white collar, a tunic worn with knickerbockers. All were unmistakably young in feeling, and the hemlines on her skirts moved inexorably upward.

"People were very shocked by the clothes, which seem so demure and simple now," Quant's husband and partner, Alexander Plunket Greene, told *Rolling Stone* in 1987. "At the time they seemed outrageous. I think there was a slightly sort of pedophile thing about it, wasn't there?" The fashionable woman of the fifties, "all high heels and rock-hard tits," was replaced in London by a girl with a

"childish . . . shape" and "a great deal of long leg." "Which was all pure erotic fantasy," mused Plunket Greene, "a bit of Nabokov I suppose."

In 1961, the year the Beatles were discovered, Mary Quant went wholesale and started to mass produce mini-skirts and other inexpensive separates. Meanwhile, back in Paris, there were also young designers eager to create innovative styles, but the structure of the couture initially proved less receptive to youth fashion.

In 1960 Yves Saint Laurent designed his controversial "Beat Look" for the House of Dior. Inspired by the beatniks, Saint Laurent also drew on other rebellious youth styles. One of his most famous creations was a black jacket in crocodile skin trimmed with mink and worn with a black mink "crash helmet." It was expensively and exquisitely produced, but it was clearly inspired by Marlon Brando's black leather motorcycle jacket made notorious by the 1954 film *The Wild One*. This look had long been popular among London's working-class male rockers, but nothing like it had ever been seen in the hallowed pages of *Vogue*.

In retrospect, the "Beat" collection was a significant development both in Saint Laurent's career and in the subsequent history of fashion, because it demonstrated that street fashion could be made elegant for an older and more sophisticated clientele. At the time, however, the collection was poorly received by the fashion press both in France and abroad. American *Vogue* complained bitterly that the collection was "designed for very young women . . . who expect to change the line with frequency and rapidity, and who are possessed of superb legs and slim, young, goddess figures."

Very young slim women with long legs were already the goddesses of London. Eroticism in women's dress had traditionally focused on the sexually dimorphic curves of the female bosom and hips. But in the sixties body exposure increasingly focused on the legs. In 1962, and again in 1963, hemlines rose to unprecedented heights and the mini-skirt became the most famous of the youth fashions.

There is some controversy about whether it was Quant or André Courrèges who "invented" the mini-skirt. Courrèges insists, "I was the man who invented the mini. Mary Quant only commercialized the idea." But Quant dismisses his claim: "That's how the French are . . . I don't mind, but it's just not as I remembered it . . . It wasn't me or Courrèges who invented the miniskirt anyway – it was the girls in the street who did it."

Courrèges was steadily raising his hemlines throughout the first half of the sixties, and by 1964 he had evolved a brilliant couture version of youth fashion that was far more sophisticated in conception than anything Quant ever designed. Nevertheless, the historical evidence tends to support Quant's claims. When she made a phenomenally successful tour of the United States in 1962, it only confirmed what everyone in London already knew: she was first – right after the girls in the street.

43 Courrèges "Baby Doll" mini-dress in white crinkle chiffon with appliquéd pink satin flowers with centers of iridescent paillettes. 1967. The Museum at F.I.T., New York, Gift of Sylvia Slifka, 86.49.7. Photograph by Irving Solero.

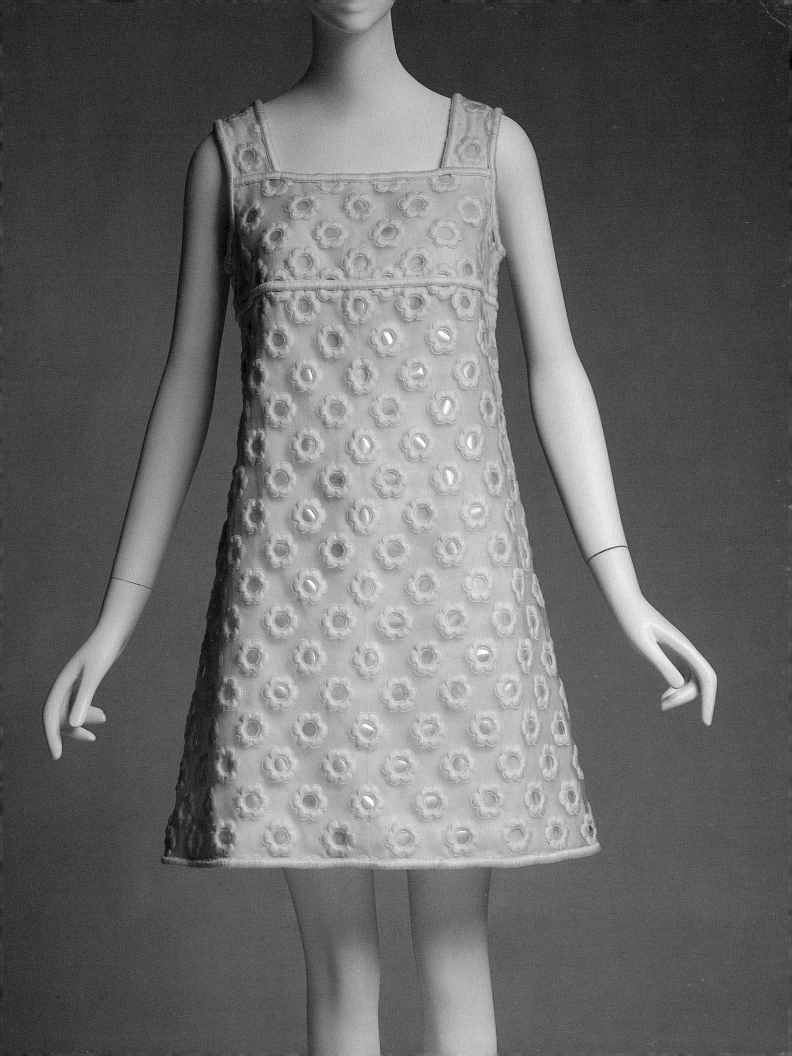

Meanwhile, Chanel, famous in the 1920s for designing the shortest skirts in Paris, denounced the mini-skirt as "disgusting." Indeed, although the new youth fashions swept rapidly through Great Britain, reactions were mixed elsewhere. In 1961 American *Vogue* complacently announced that the "new status symbols" included "Real (not pseudo) Chanel suits, real crocodile shoes . . . and mink – not just any old fur." Yet by 1962 American *Vogue* was extolling "The Quant Revolution," and its "young skinny clothes."

London unquestionably launched the first phase of sixties style. Indeed, one can legitimately describe London as the capital of Youthquake fashions. Before the 1960s new styles had tended to come almost exclusively out of Paris, where the couturiers themselves had exerted a powerful role, epitomized by the international impact of Dior's New Look and the importance of Balenciaga. While the Parisian couture catered to the elite, the international ready-to-wear industry provided similar styles more cheaply produced for the masses of middle-class consumers. New York's fashion industry, for example, was devoted largely to copying Paris.

Then, suddenly, London, which had traditionally been a fashion backwater, known only for its high-quality menswear, emerged in international awareness as a fashion mecca for the young. Although *Vogue*'s editor-in-chief Diana Vreeland continued to admire and to promote the Parisian couture, she was also attuned to the fashion currents emerging from "Young London." One anecdote must suffice to give a sense of the excitement surrounding what came to be known as "Swinging London." On a rainy day in 1965 fashion model Jean Shrimpton and photographer David Bailey were ushered into Vreeland's office in New York. "Stop!" D.V. shrieked to her staff, "Stop! The English have arrived!"

The French tacitly acknowledged (and subtly disparaged) the influence of London, when they spoke of "yé-yé" fashion and "le style anglais." As late as 1965, *Marie-Claire* reported in some astonishment that "England is seventeen years old." London is filled with "les school-girls, les baby-girls, les boy-girls, les girls-girls," all wearing mini-skirts or pants suits, wild colors, and boots. The "eccentric young English" were said to look like "Pop Art in motion." Significantly, however, the same issue of the magazine also carried another article, entitled "30 Years, The Age of Elegance," indicating that there was in France a real ambivalence about "la mode junior."

"Legs never had it so good," boasted the British press, which was understandably jubilant about the international impact of London youth styles. But it was not simply a matter of legs and mini-skirts. The new physical ideal, as a whole, was slender and almost preadolescent. As the *Herald Tribune* pointed out, "The new leg is a little girl leg. To be stuck with [adult] legs and calves is just too crass for words . . . legs and arms seem to match as they do with a child." The Lolita look was everywhere in fashion. And so were countless real-life Lolitas. The invention and mass marketing of the birth control pill

seems to have led almost immediately to more young women having sex at an earlier age. As a result, there developed in fashion a "baby doll" or "little girl" look that was "as sweet as sugar," but "laced with the spice of sex appeal." The new styles, in turn, expressed what British journalist Catherine Storr called "a sexually attractive appeal which . . . heralded women's freedom, albeit sartorially . . . and by extension freed their sexuality."

"Sexual intercourse began in 1963," declared the poet Philip Larkin with pardonable exaggeration. Certainly, the sexual revolution influenced the course of fashion history. As we move into the twenty-first century and fashion becomes ever more erotic and taboo-breaking, we can clearly see how important a role the mini-skirt played in the development of women's fashion. Nor was it only women's fashions, like the mini-skirt, that constituted a genuine pop culture phenomenon. In a profound cultural sense, the feminine versions of Youthquake fashion were actually secondary to masculine modes. And here, too, the accent was on sex.

If Mary Quant was the biggest popularizer of girls' fashion, John Stephen was the leading impresario for English boys. Back in 1957, when Stephen opened the first of his menswear shops on Carnaby Street, menswear was (in his words) "staid, sober, and, above all, correct, advertising your precise rung on the social ladder and even your bank account." But as England's youth culture blossomed, clothing for young men became increasingly colorful, modish, and body conscious, advertising the wearer's sex appeal.

Men's fashion underwent a virtual revolution, the so-called "Peacock Revolution." Adult observers, such as the pioneering fashion historian James Laver, were astonished. Laver had previously developed an elaborate (albeit superficial) theory, according to which men's clothes were governed by the Hierarchical Principle, and women's clothes by the principle of Sex Appeal and the Shifting Erogenous Zone. Were *men* now going to become sex objects? asked Laver in amazement. They already were, young people would have replied, and none were sexier than rock musicians and singers.

Fashion and music together formed the twin pillars on which the first historically significant youth subculture was built. The passion for clothes among British youth developed in conjunction with a new musical idiom, rock and roll, which (as parents unhappily recognized) was all about sex. Born in America in the 1950s, the bastard child of rhythm and blues and country music, rock and roll entered a new phase in England, when groups such as the Beatles and the Rolling Stones became international stars.

There was an symbiotic relationship between male performers and male fans. According to John Stephen (who by the early 1960s was known as the "King of Carnaby Street," because he owned so many shops), when customers like the Beatles and the Rolling Stones adopted a style, "Fans noticed what they wore and wanted to buy the same clothes."

While boys dressed to be like their heroes, girls dressed to attract them.

"It takes a thief to catch a thief," declared the up-to-the-minute British fashion magazine *Queen* in 1964. "So any girl who wants to get herself noticed by boys in the limelight like the Rolling Stones had better get herself the super aid of that phenomenal stealer of limelight, Mary Quant."

Musicians such as Rod "the Mod" Stewart and Pete Townsend of The Who (famous for the line "hope I die before I get old") epitomized the new look and sound. One widely circulated photograph of The Who shows several band members in jackets emblazoned with the colorful pattern of the Union Jack. And in The Who's documentary *The Kids are Alright*, Townsend explicitly linked male fashion with attracting girls: "A lot of girls came to see the group because of various things people in the group wear. John's jacket and medals, my jackets and shirts made out of flags and Keith, who wears sort of pop-art T-shirts made out of targets and hearts . . . We get a lot of audience this way."

But The Kinks may have expressed the ethos best with their gently satiric anthem, "Dedicated Follower of Fashion," which traced the male protagonist as he made the rounds of London's boutiques, shopping for clothes which were "loud but never square." By the mid-1960s half the boutiques in London were devoted to male fashions. Yet rock stars and boutique owners alike drew inspiration from the wider youth culture, and copied "the kids" in the street.

Among London's first trendsetting youth groups back in the 1950s were the teddy boys, who affected Edwardian-style suits and "greaser" hairstyles, and the rockers, who wore black leather bikers' jackets. Both teds and rockers were, or at least looked, defiantly anti-social. Their music of choice was American rock and roll. There were also a few beatniks, who tended to favor jazz and wore proto-hippy "rave gear." Most significant of all were the mods.

The term was an abbreviation of "modern," and unlike the aggressively flamboyant teddy boys and rockers, the mods developed an understated style of streamlined modernity that marked the first really important phase in youth fashion. "It was the mods," said Mary Quant, "who gave the dress trade the impetus to break through the fast moving, breathtaking, uprooting revolution."

The Beatles began their career dressing like rockers and became famous looking like mods. "Are you Mods or Rockers?" asked one journalist. "We're Mockers," replied Ringo Starr.

Mod style was superficially conservative, based on traditional Savile Row tailoring, but sharpened by an Italian edge – sleek Italian mohair jackets and speedy Italian motorbikes. "I liked the Italian stuff," recalled David Bowie years later, "I liked the box jackets and the mohair." Early mods often had to have their clothes custom-made; there was nothing quite like it in the shops. But a mod risked being assaulted by passing rockers or, indeed, anyone else who was offended by the strange attire.

The original mods were a core group of working-class youths, who were

44 Cifonelli man's suit cut from the reverse of a nineteenth-century paisley shawl; single breasted jacket and high waisted pants, 1960. The Museum at F.I.T., New York, Gift of Mr. Jean François Daigre, 90.149.32. Photograph by Irving Solero.

obsessively concerned with issues of personal style. In his famous essay, "The Noonday Underground," the journalist Tom Wolfe described the average mod as an adolescent with an income of about eleven pounds a week: "What the hell is with this kid? Here he is, fifteen years old, and he is dressed better than any man in the office." According to Wolfe, the mods' clothing helped them negotiate between work or school and their "secret life," a world dominated by music and fashion.

The homosexual influence on mod style has not yet been thoroughly researched, but many of the pioneering menswear boutiques had a predominently gay clientele. An advertising brochure for mod fashion in the collection of the Victoria and Albert Museum features a homosexual scenario about a young man named Lance, who is picked up hitch-hiking by a slightly older man. Sexual innuendos give the price of clothing items in terms of the cost of getting into Lance's pants.

Mod style was often bright in color or boldly patterned, both features that were unusual in menswear. Sir Mark Palmer, who was described in a 1967 book as "one of the more extrovert members of the current fashion scene," observed that color was popularly associated with homosexuality: "There was a time when men wouldn't wear coloured clothes for fear of being thought queer." After homosexuality was decriminalized in Britain in 1967, gay men felt less need to disguise their sexual orientation to avoid persecution. Whether or not many mods were actually gay, they obviously felt little need to restrict their sense of style. The new sexual morality for gays and straights, men and women alike, exerted an influence on fashion.

Drug use also, especially widespread amphetamine use, may have had an influence on the development of mod style. The mods' attention to subtle detail (each button just *so*) was probably related to their use of "speed," which tends to promote obsessive behavior. As Pete Townsend of The Who recalled years later, "To be a mod, you had to have short hair, money enough to buy a real smart suit, good shoes, good shirts, plenty of pills all the time and a scooter covered with lamps – and you had to be able to dance like a madman."

Mod style soon spread beyond its initial creators, just as the hippy style was to do a few years later. By 1963 the mod look was everywhere in Young England. By 1966 it was an international phenomenon: "Even the peers are going 'mod'" declared *Life International* in a piece on the "Spread of the Swinging Revolution," published in July 1966.

It all began with the teenage 'mods' who spent most of their pocket money on flamboyant clothes. Now the frills and flowers are being adopted in other strata of Britain's society, and the male-fashions born in London have joined the theatre among the British exports that aren't lagging. The way-out styles already have appeared in such disparate metropolises as Paris and Chicago and may eventually change the whole *raison d'être* of male dress.

They didn't, of course. The Peacock Revolution is over now, and shows no signs of being revived, even as part of the recurrent trend towards sixties retro. Many of the sixties experiments in menswear seem trivial or quaint in retrospect, but at the time the changes in menswear seemed to be the most "revolutionary" feature of the whole Youthquake phenomenon. Nor was this entirely false. Because rock and roll was always primarily a masculine domain, pop fashions occurred first and foremost among young men.

There would never have been the same vital youth culture in London had it been only a question of women's clothes. Furthermore, although styles in popular music would change over time – with punk, disco, and hip-hop ultimately supplanting rock and roll – music has continued to be the single most important influence on youth culture, and thus on youth fashion. Back in the 1960s designers all over London and even in Paris hoped their clothes would be worn by television hostess Cathy McGowan, whose program *Ready Steady Go* was as much a weekly fashion show as a venue for music.

45 Twiggy was the "Face of the Year" in 1966. Her figure measured 32-22-32. Photograph: Topham.

Among those whose clothes were featured on the show were Sally Tuffin and Marion Foale, who were among the first to make trouser suits; Kiki Byrne, a former assistant to Mary Quant; and Barbara Hulanicki, founder of the fashion emporium Biba, where an entire wardrobe cost less than a single garment by Mary Quant. The French ready-to-wear designer Sonia Rykiel also had her clothes on *Ready Steady Go*.

Other important London designers included Jean Muir and Ossie Clark, who designed elegant upscale versions of the new styles, and Zandra Rhodes, who began by designing textiles and moved on to creating dresses modeled on tribal garments.

The clothes themselves were only part of the picture, however. As Quant observed, you also needed to have the right hair style (Vidal Sassoon's geometric bobs epitomized the mod look), the right make-up (pale lips and false eyelashes), the right body (young and thin), and the right attitude.

Among the trendsetters who best captured the look were actress Susannah York, who wore a Tuffin and Foale pantsuit for her role as a boutique owner in the 1966 film *Kaleidoscope*, and the ninety-pound adolescent model Twiggy.

Perhaps most important, though, was model Jean Shrimpton, whose romantic and professional partnership with fashion photographer David Bailey made her

the quintessential "face" of the period. A working-class cockney, Bailey achieved fame as a fashion photographer while largely ignoring the clothes: "A frock is a frock," he said, dismissively. Instead, he chose to focus on the model's sex appeal. Photographing a fashion model was a sexual act, Bailey implied, and the camera was like a phallus.

The image of the fashion photographer as sexual conquistador reached its apogee in Antonioni's 1966 film, *Blow-Up*. With rock music pounding in the background, the actor David Hemmings (playing a character based on Bailey) kneeled over a writhing model (played by real-life model Verushka), his camera clicking away. Automatic camera drives revolutionized the process of photography: the *bzzz bzzz bzzz* was like sex, said Bailey.

Fashion photography definitely entered a new and overtly sexy phase in the 1960s. A comparison of *Blow Up* with the classic 1950s fashion movie *Funny Face* is illustrative of this change. *Funny Face* depicted the world of Paris high fashion, and ended with the photographer proposing marriage to the model, who was conveniently wearing a wedding dress. In place of the romantic or sophisticated scenarios of 1950s fashion photography, featuring elegant models like Dovima or gamines like Audrey Hepburn, the new style of photography was lively to the point of being hyperactive.

46 David Hemmings and Veruschka in a still from *Blow-Up*, 1966. Photograph: Archive Photos.

It featured sexy young "dolly birds" jumping and running, or sprawled seductively on the floor.

Fashion editors had previously functioned as extremely powerful arbiters of style. "Think pink!" commanded the Vreeland-esque editor in *Funny Face*. The real Vreeland was always enthusiastic about whatever was new and exciting ("The English have arrived!") and she has been credited with coining the term "Youthquake," but in the 1960s other members of the fashion press were often confused about the new Youthquake styles.

Describing the trendsetters of 1965, American *Vogue* boasted that "Nobody ever looked like them before. They're the zingos who bolted the pack . . . crashed out of the mold and smashed it to smithereens . . . invented their own look, their own sound, their own age . . . knocked over the establishment and established themselves for today." But the magazine was not really addressing the "zingos" themselves; it was their mothers or provincial cousins who needed to be informed.

This was even more painfully clear when American *Harper's Bazaar* did a

special issue in March 1965 on "the off-beat side of Now," in which readers were solemnly informed that a "bird" was a chick, "bread" was money, and "soul" was a deep authentic sensibility. As music was the life-blood of youth style, it must have amused young people to read that it was possible to "frug that fat away."

Throughout the sixties there was a certain tension between youthful street fashion and the high fashion produced with great artistry for a social elite, but it was a productive tension that resulted in some of the most innovative creations ever to emerge from the couture. Increasingly, new fashions were created from within youth culture; the styles were then adopted and modified by European couturiers, at which point they "trickled down" to mass-market manufacturers around the globe.

Although London inaugurated the first phase of sixties style, Paris soon created its own versions of Youthquake fashion. Three designers, in particular, had a major impact: Yves Saint Laurent, André Courrèges, and Pierre Cardin. At the same time, young stylists like Emmanuelle Khanh, Michèle Rosier, and Sonia Rykiel transformed the *prêt-à-porter*.

In 1962, after his abortive period of military service (during which he had a nervous breakdown), Saint Laurent left Dior and founded his own couture house. Alive to the new fashion currents and a frequent visitor to London, Saint Laurent began showing a number of youthful styles, including elegant versions of leather jackets, trousers, navy pea coats, and safari suits. Trousers for women were an especially important fashion of the sixties, and, as with the mini-skirt, the original impetus came from the street.

"When I 'launched' trousers, I wasn't doing anything original," recalled Yves Saint Laurent in 1969. "Young people didn't wait for me in order to wear trousers. They had worn them for a long time already, while I worked for Dior." And he insisted, "Today fashion is old-fashioned." Yet his own fashions were anything but old-fashioned; indeed, Saint Laurent entered his most creative period in the 1960s.

His Mondrian dresses of 1965, inspired by the paintings of the Dutch abstractionist, caused a happy sensation. American *Harper's Bazaar* described the style as "the dress of tomorrow, the assertive abstraction, a semaphor flag, sharply defined in crisp white jersey, perfectly proportioned to flatten your figure." His pop art dresses of 1966 took as their inspiration the contemporary paintings of American artists such as Andy Warhol and Tom Wesselman. Saint Laurent was also inspired by African art, and his 1967 collection included an evening dress decorated with wood and glass beads, which *Harper's Bazaar* described as "a fantasy of primitive genius."

How revolutionary were couture clients ready to be? In early 1966 Saint Laurent told a reporter, "I am bursting with the desire to go much further and revolutionize everything. Then I think: it would be perfect for the Saint-

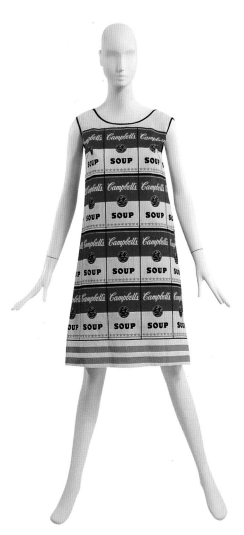

48 (*following page*) Yves Saint Laurent "Mondrian" dress in wool jersey with pieced geometric design, 1965. The Museum at F.I.T., New York, Gift of Igor Kamlukin, 95.180.1. Photograph by Irving Solero.

47 "The Souper Dress" with pattern of Campbell's Soup cans printed on non-woven "paper," 1966–7. The Museum at F.I.T., New York, Museum Purchase, P90.87.1. Photograph by Irving Solero.

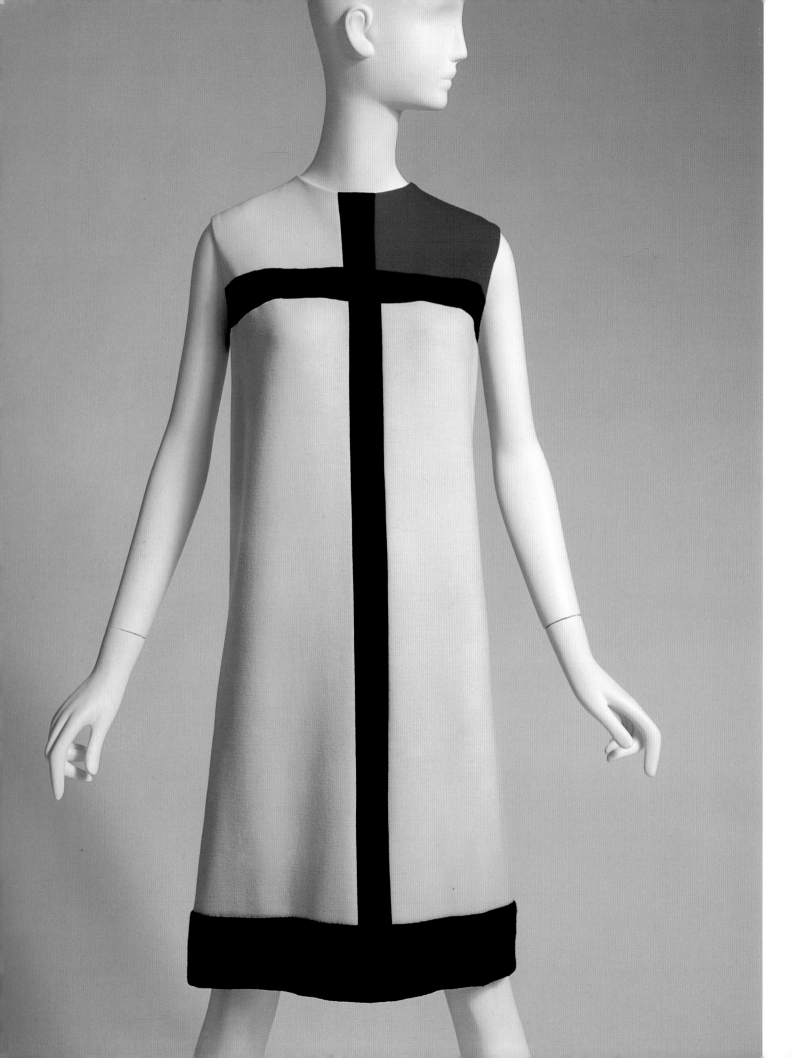

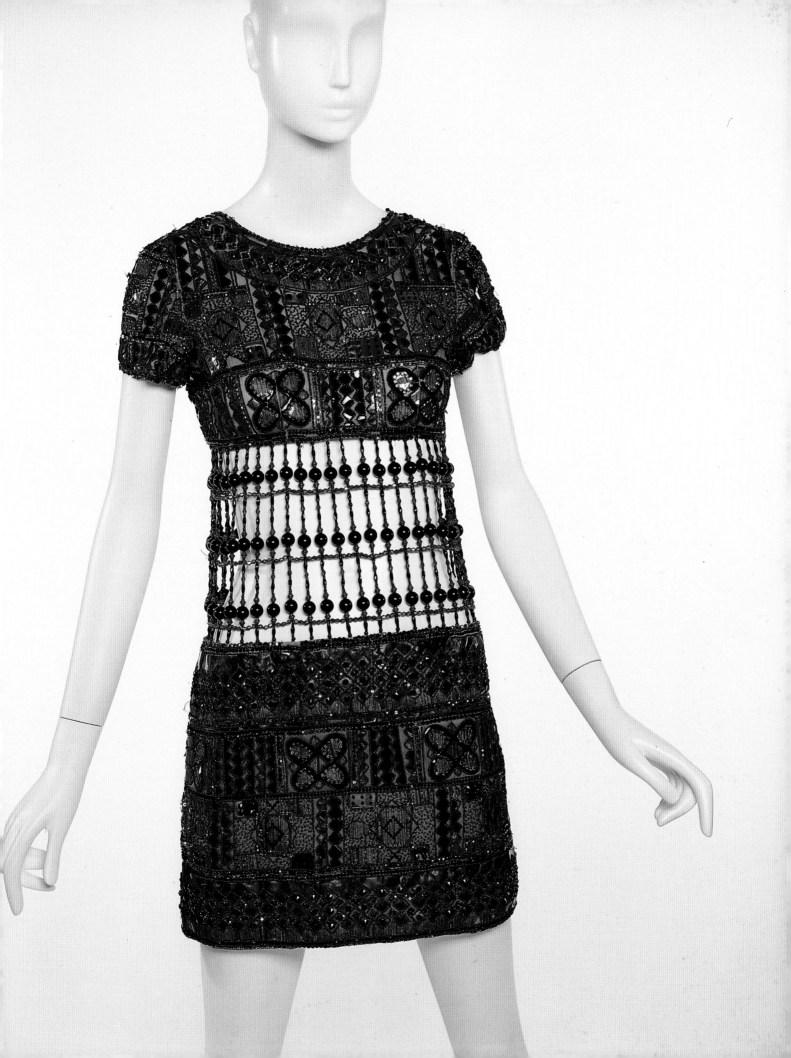

Germain-des-Près boutique at, say, $100 . . . but at couture prices will they accept it?"

One of the pioneers of designer ready-to-wear, Saint Laurent had great success with his Rive Gauche line. "Ready to wear, for me, is not a last resource, a sub-couture; it is the future," said Saint Laurent. "One dresses women who are younger, more receptive. With them, one can finally be more audacious."

Meanwhile, in 1961 André Courrèges showed his first mini-skirts, to be followed by crisp white trousers and white kid ankle-boots. In 1964 British *Vogue* reported that "Courrèges' skirts are the shortest in Paris." More importantly, 1964 was the year his "Space Age" collection made headlines around the world: "He's the most terrific phenomenon to hit fashion for years," exclaimed the British fashion magazine *Queen*:

> The Courrèges message is loud and clear: bold stark simple clothes, exquisitely balanced with scientific precision to achieve a dazzling new mathematical beauty . . . It's a look that couldn't have been dreamed of in pre-Sputnik days. Only a few seasons ago Courrèges looked *years* ahead of his time, outrageously outer-planetary. But this time . . . his collection caused that kind of excitement that only comes once in a blue moon when the times and fashion meet in brilliant collision.

Courrèges invented the "moon girl," but other designers, such as Pierre Cardin, Paco Rabanne, and Michèle Rosier were also inspired by the theme of space-age futurism. Pierre Cardin was one of the first to experiment with new stretch fabrics and plastics. An important figure for both men's and women's fashions, he insisted that "We don't want to keep male dress in the 18th or 19th century." Pierre Cardin was said to have designed an early version of the Beatles' matching suits, but few other men adopted his more adventurous styles, and he had greater success promoting space-age women's fashions.

Paco Rabanne, the son of one of Balenciaga's seamstresses, also incorporated plastic and metal into fashion. Rabanne's 1966 collection featured phosphorescent plastic disks strung on metal wire. A little later he became notorious for designing chain-mail dresses, which were spoofed in the film *Qui êtes-vous, Polly Magoo?*

Even before the first moonshot, Michèle Rosier (nicknamed "the Vinyl Girl") gave a space-age twist to active sportswear. The *International Herald Tribune* argued that Rosier "has done for ready-to-wear what Courrèges has done for the couture" – create "a style without nostalgia."

High tech – from plastic and stretch fabric to industrial zippers – was associated with progress and a happy future. "Zip up, pop on and just go – zing!" advised American *Vogue* (November 19, 1965). "No hooks, no ties . . . everything clings, swings, ready to orbit." The fashion press frequently used terms

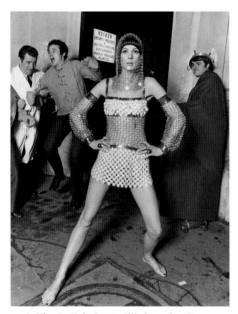

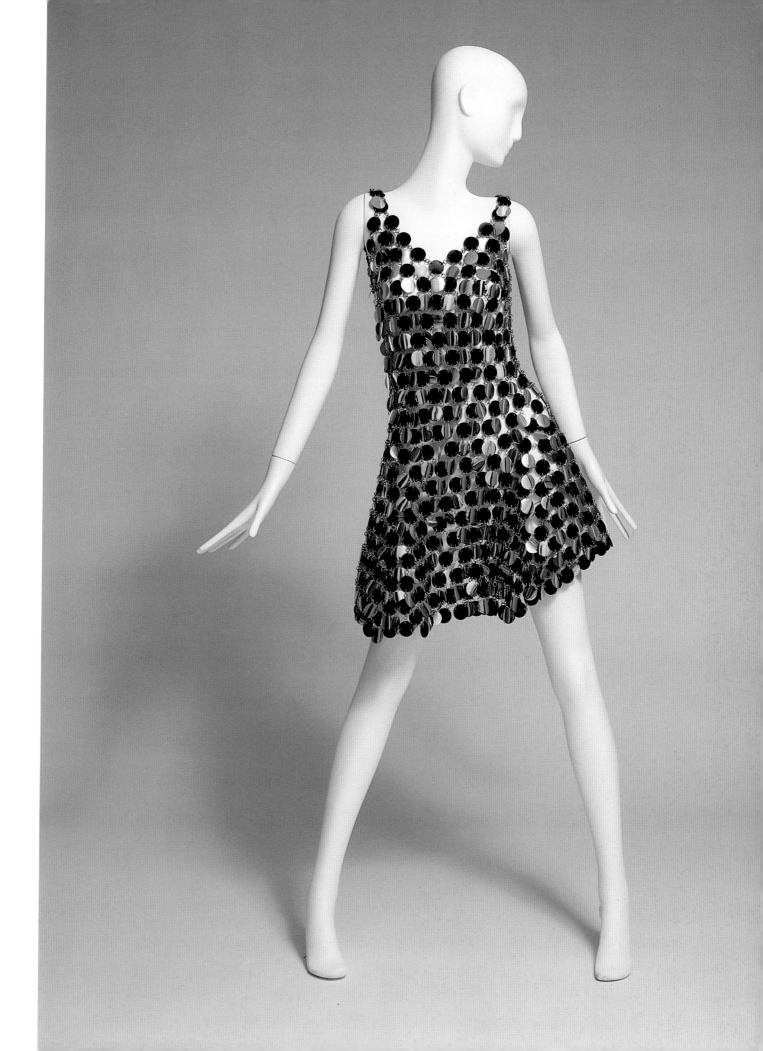

52 Françoise Hardy in a Courrèges pantsuit, 1966. Photograph: Archive Photos/Deutsche Press.

53 Yves Saint Laurent "gangster look" pantsuit in navy wool with white pinstripe, 1967. The Museum at F.I.T., Gift of Ethel Scull, 78.57.6. Yves Saint Laurent Rive Gauche man-tailored shirt in navy and white cotton sateen, c.1970. The Museum at F.I.T., New York, Gift of Ethel Scull, 78.57.8. Photograph by Irving Solero.

such as "intergalactic," "Rocket Age," "orbit," and even "LSD School" to describe new styles.

Beyond technology, the futuristic look functioned primarily as a secondary metaphor for youth. The space age look provided a way to look radically new; as Roland Barthes demonstrated in his book *The Fashion System*, terms like "Spring" and "new" can symbolize "youth." As *Marie-Claire* put it, "Courrèges invents the woman of tomorrow." No one wanted to look like the woman of the past, the older woman. It is possible that fashion designers and editors may have focused on space-age themes, in part, as an alternative to street fashion.

When French pop singer Françoise Hardy wore a Courrèges couture pantsuit in 1966, it symbolized the triumph of French couture in the absence of a genuine French youth culture. Although there were millions of young people in France, they tended at that time to follow cultural trends initiated abroad. In striking contrast to the situation in Britain (where the wealth of youth music provided the basis for London's new fashion power), the relative mediocrity of French popular music contributed to a weak and derivative French youth culture. Saint Laurent was once quoted in the press as saying that he listened to pop music (he mentioned Donovan), but the music connection was not a major part of the new Paris fashions. Couture clients also tended to be much older than Mary Quant's customers (and less likely to listen to the Rolling Stones), but they still wanted to look young.

The new trends in women's dress and appearance had radical implications for the international fashion press and for the fashion industry as a whole, because there was no longer a single, high-fashion look to promote. As *Women's Wear Daily* reported in February 1964, "Conservative buyers are terrified to buy Courrèges before they see what B [Balenciaga] and G [Givenchy] are going to do."

In 1965, soon after acclaiming Courrèges, *Queen* buried his mentor, Balenciaga:

> The End. Balenciaga is fallen, fallen, that great designer. The inspiration of that king of couturiers is dead. How are the mighty fallen . . . ! The great master that used to be three or four years ahead of the others . . . has fallen out of touch with today . . . The mood was 50ish.

Emmanuel Ungaro, who, like Courrèges, had studied with Balenciaga, also advocated a break with the fashions of the past. An proponent of very short mini-skirts, he differed from Courrèges in that he used bright colors, such as pink and orange. When Ungaro opened his house in 1965, he deliberately did not show any evening dresses: "They're not my style." Later he showed an evening dress decorated with ping-pong balls, which was "meant to destroy the idea of evening clothes."

The couture itself was under attack. The development of designer ready-

to-wear was one of the most significant developments of the 1960s: "My number one objective has always been . . . the whole world, and not only fifty women," declared Cardin in 1967. Equally significant was the rise of young stylists like Sonia Rykiel, Emmanuelle Khahn, Jacqueline Jacobson of Dorothée Bis, Michèle Rosier, and Christiane Bailly. In contrast to the situation in the haute couture, where most famous couturiers were men, the majority of successful stylists were women.

"I am a woman," declared Sonia Rykiel. "Consequently, I think as a woman, I design as a woman, I invent as a woman with my woman's passions and desires." Rykiel began the decade as a housewife, without fashion training, and began to design, almost by accident, in 1962, because she was pregnant and wanted to make a beautiful maternity dress. In 1964 she achieved her first breakthrough, when one of her body-hugging "poor boy" sweaters was featured on the cover of French *Elle*. The knitwear that she designed for her husband's boutique, Laura, became popular even in London, where it was featured on the mod television program *Ready Steady Go*. In Paris, as in London, the proliferation of boutiques provided a retail showcase for the new fashions. By 1967 journalist Marylou Luther of the *Los Angeles Times* declared, "Couture is not enough – you need Rykiel."

"Haute couture is dead," Emmanuelle Khanh declared in 1964. "I want to design for the street." Khanh, one of the first generation of young stylists, began her career as a model for Balenciaga, but reacted against his ultra sophistication and described her own style as "anti-Balenciaga."

Balenciaga himself was horrified by the new developments in fashion. *Women's Wear Daily* reported in 1966 that "The Master thinks everyone has gone crazy." In May 1968 the month of the Paris uprising, Balenciaga closed his couture house permanently.

Young people around the world erupted in rebellion in 1968. The effect on fashion was immediate and powerful. Saint Laurent went out to sketch the students and workers on the barricades of Paris. Their clothes inspired that year's collection of proletarian chic. "Recent political events," he declared, "make the Haute Couture a relic of the past."

"Let's kill the couture," agreed Emanuel Ungaro, "kill it in the sense of the way it is now." The couture survived the convulsions of the 1960s, but the structure of the fashion industry underwent profound and permanent alterations. Meanwhile, as the structure of the industry evolved, so also did the content of fashion. Indeed, the next big phase of sixties fashion – the hippy anti-fashion movement – had already begun . . . in America.

In 1967 thousands of young people flocked to San Francisco to celebrate a new culture of love. Flower power replaced space age futurism, and Haight Ashbury became the new Carnaby Street. "The hippie revolution killed the Swinging London image," declared George Melly in his seminal book, *Revolt into Style* (1989), but it would be more accurate to say that since 1965 there

54 Mick Jagger in military-influenced fashion, 1967. Photograph: Topham.

55 (*facing page*) Pierre Cardin "Egg carton" dress in fuchsia "Cardine" Dynel, permanently molded with three-dimensional diamond pattern, 1968. The Museum at F.I.T., New York, Gift of Lauren Bacall, 70.62.1 Photograph by Irving Solero.

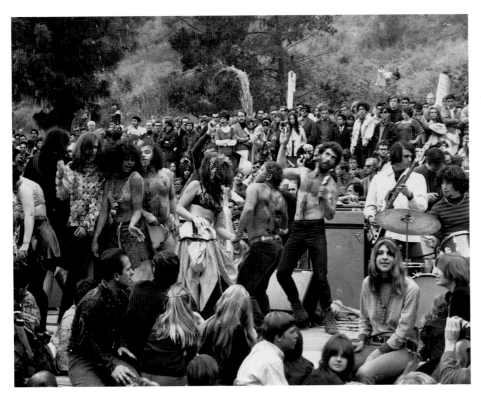

56 Los Angeles love-in, 1967.
Photograph: Corbis-Bettmann/UPI.

had been a close relationship between the two youth capitals of London and San Francisco.

"Mod clothes were the springboard for the hippies' improvisations," writes Joel Lobenthal in *Radical Rags: Fashions of the Sixties*, "while the LSD-influenced iconography of the hippies transformed the landscape of Swinging London." Even before the pivotal year of 1967, Youthquake fashions had been evolving away from the mod or pop look and toward the hippy look.

The continued evolution of youth culture provides the key link. The mods had favored amphetemines, a modern chemical that seemed appropriate within a modern urban landscape. Their clothes were streamlined and their hair artfully trimmed into geometric shapes; they danced the Frug, the Twist, and the Pony – dances that seemed strange to their elders, but which, in fact, had certain prescribed movements.

The hippies, whose drugs of choice were marijuana and LSD, favored exotic, colorful, *psychedelic* styles. Hippy hair was long and wild. Their dances were free-form, and the strains of the sitar floated like incense into their music. Their anarchic patchwork of clothing also boasted of journeys to Xanadu, or at least India and Morocco.

In the 1967 book, *Dress Optional: The Revolution in Menswear*, Mark Palmer was quoted as saying that marijuana and psychedelic drugs "are fantastically important. The part they play in people's dress sense turns them on to color." Typical of the new male style was a predominently orange psychedelic suit from 1968 by the English tailor Mr. Fish.

Many of the same people who had been mods became hippies: Roger Daltry of The Who abandoned the Union Jack for a fringed suede shirt like those worn by the American Indians; and the Beatles shed their look-alike Cardin-style suits for exuberantly exotic clothes, apparently pillaged from upscale thrift shops and Asian bazaars.

"Wow! Explode! The Sixties," recalled fashion designer Betsey Johnson. "It came to life in a pure, exaggerated, crazed out, wham, wham, wow way. The Beatles, Hendrix, Joplin, the Velvet Underground exploding so wonderfully." Johnson's work has always been associated with the music scene, but as her choice of musicians indicates, there was more than one sixties style.

In the mid-1960s Johnson designed pop dresses of clear plastic and colored paper for the legendary boutique Paraphernalia. She made teeny-tiny skirts and skinny T-shirts, on the principle that dressing "should be as uninhibited as possible." As she put it in 1966, "My clothes are for young people who are saying, 'Look at me – I'm alive.'" Johnson's top fitting model was Andy Warhol's "superstar," Edie Sedgewick. Also in Warhol's circle were the members of the Velvet Underground, who favored black leather clothes, in a tough version of New York pop style.

By contrast, rock stars like Janis Joplin and Jimmi Hendrix represented the subsequent hippy look: they wore purple watered velvet, lace in flower patterns, and tie-dyed scarves. It is not accidental that the California-born Hendrix spent nine formative months in 1966 in London, where his sense of style evolved dramatically.

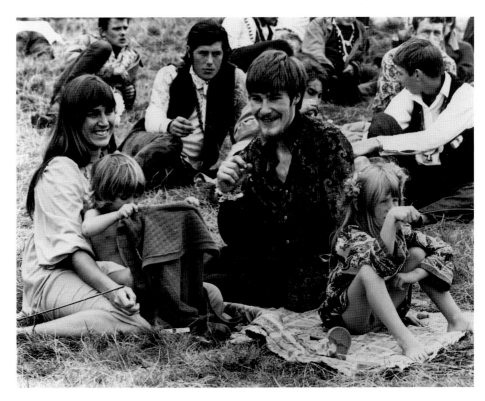

57 British love-in, 1967. Photograph: Corbis-Bettmann/UPI.

Although New York was indisputably the capital of the American fashion industry, the city never had a clear sixties style; trendsetters there had tended to follow first London and then Paris. Although California had no significant fashion industry, it was the center of the film and music industries, so when performers began to adopt hippy styles, there was a temporary efflorescence of California designers. In San Francisco Linda Gravenites designed one-of-a-kind costumes for rock stars like Janis Joplin. In Los Angeles Holly Harp also designed within the counterculture, working in nostalgic crêpe and exotic tie-dye.

But Rudi Gernreich was the most important of America's young "anti-establishment" designers. Based in the Hollywood Hills of greater Los Angeles, Gernreich went to his showroom in New York only twice a year to present his collections. Like Courrèges and Rabanne, whose work he greatly admired, Gernreich repeatedly caused a sensation with his ultra-modern styles. Described by the *Saturday Evening Post* as "the farthest-out of all American dress designers," he was typically Californian in that all of his work showed a basic commitment to physical and psychological freedom. It is significant, therefore, that he was most notorious for his 1964 "topless" bathing suit.

When flower power first became a theme in fashion, the flowers them-

selves initially tended to be pop in style. Flat, bright, geometric daisies, *à la* Mary Quant, were very much in favor. Brightly colored plastic shoes with a daisy on each toe represent a typical example of the transitional look, but soon there was an emphasis on natural fibers; plastic was definitely "out." Indeed, it became a term of abuse to refer to conventional-looking people as "plastic."

By contrast, anything that seemed "natural" and authentic was praised: blue jeans with hand-embroidered floral decoration were a typical hippy style. There was a strong anti-technological sentiment among the hippies that accorded with their Rousseau-ist primitivism. Since nothing seemed more natural than nudity, hippies also favored a state of relative undress. Photographs of the rock festival at Woodstock show bare-breasted young women with flowers painted on their skin.

Flower power was implicitly political: the participants at demonstrations against the Vietnam war often handed flowers to soldiers. Traditional working-class garments, like blue jeans, also became associated with the aptly named "counterculture," yet there was also hostility between the orthodox Left and the hippies, who seemed to leftists to be overly involved with cultural issues and "bourgeois individualism."

Traditional roles were questioned: male, as well as female, hippies wore flowers in their long hair, as a way of redefining "he-man" masculinity in terms of peace and love. Blue jeans and T-shirts were, at least superficially, unisex garments. Yet the hippy movement was hardly feminist, and unisex clothing failed to obscure the sexually dimorphic bodies of men and women. Long hair on men symbolized their rebellion against social conformity and sexual restraint, but only outsiders professed to believe that "You can't tell the men from the women."

Jewelry also was increasingly unisex; both men and women wore love beads and ethnic jewelry, peace symbols and protest buttons. "Men . . . planning a getaway weekend?" asked a New York department store advertisement of 1968. "Pack a turtle, a Nehru and don't get caught without a smart shiny something around your liberated neck. It's what's happening in leisure wear." But jewelry for men was still suspect in other quarters, and the same year the president of Tiffany's told the *New York Times*. "If we know a man is buying a necklace for himself, we will refuse to sell it."

The mainstream press was fascinated, and sometimes horrified, by the hippies. In 1967 French *Elle* reported on "Une Saison chez les Hippies," noting that, "Hippies, in the United States, are a social fact . . . And in France? Nothing." Or at most only apprentice hippies. What would it mean if the hippy ethos spread abroad? The reporter was ambivalent; she found the hippies' "nonviolent vestimentary revolution" to be sympathetic, but was appalled by their drug use.

Looking back on the period, French fashion historian Bruno de Roselle

58 Rudi Gernreich mini-length "kimono" dress in red and violet checked wool knit, 1963. The Museum at F.I.T., New York, Gift of Ruth Deardoff, 77.219.1. Photograph by Richard Haughton.

attempted to interpret the meaning of the hippy revolution in dress. In a brilliant analysis, he described how hippy style began with an "anti-fashion sentiment" among young people, whose criticism of fashion focused on several key points.

Fashion, the hippies believed, was a "system that Society imposes on all of us, restricting our freedom." We may like one kind of clothing, but society imposes another. Not only does fashion "change periodically," thus obliging us to change our appearance, but it also turns us into "consumers," who have to buy new clothes "even if the old ones are not worn out." In part an economic criticism of capitalism, the hippies' argument also implied, philosophically, that "fashion is a perpetual lie." Fashion is damaging, because "this uniformity and this change keep us from being ourselves. Clothing is a means of communication about the self, but we are not allowed to be honest and individual." The solution to this dilemma, according to the hippies, was "to abandon received fashion, in order to invent our own personal fashions."

Theoretically, each individual would create his own unique style. He would "express himself" and "do his own thing" – as the clichés of the time put it. In this way, the individual would defeat "the System," whether this was conceived of as the fashion system, advanced global capitalism, or society in general.

In fact, however, it is not so easy to "invent" clothing. Although many contemporaries perceived the hippy style to be one of "rampant individualism," a "do-it-yourself business, with no dictatorship by fashion tyrants," this was not entirely accurate. The *Tailor and Cutter* complained that, "Currently the world of fashion is one of utter confusion . . . there is every kind of look"; But certain looks prevailed.

When the hippies rejected contemporary fashion, they tended to look for inspiration in the clothing of long ago and far away. The modern industrial world seemed to them corrupt, but surely "authenticity" could be found in the past or in other civilizations. The romanticism of the hippy worldview naturally led them to adopt certain evocative garments, such as the fringed leather shirts and beaded headbands of the American Indians.

Two basic styles were particularly significant: the ethnic look and the romantic-pastoral look. Although hippy women did not abandon the miniskirt, they also adopted long, gracefully flowing skirts, which evoked either traditional ethnic costume or pastoral images of the pre-industrial West. Printed cotton skirts from India and turn-of-the-century white petticoats were two paradigmatic garments.

Although hippy garb was initially handmade or scavanged from thrift shops, it was not long before entrepreneurs began to make and sell individual items, and then to mass-produce them. The Beatles had many of their clothes created by a group of designers (Simon Posthuma, Marijke Koger, Johie Leeger, and Barrie Finch) who called themselves The Fool.

59 Male "hippy" wears Levi Strauss 5-pocket jeans embellished with appliqué, beadwork, and embroidery, c.1969. Gift of Jay Good, 80.176. Man's tan suede vest with fringe, c.1970. Gift of Michael Dykeman, 92.171.1. Man's braided leather belt, with cord and tie ends. Gift of Tony Santore, In Memory of Jack Fenstermacher, 88.134.215. Man's suede belt bag with beaded fringe. Gift of Tony Santore, In Memory of Jack Fenstermacher, 88.134.257. Earth Shoes, c.1972. Gift of Charles Castela & Angelica Lopez, 91.229.1. Female "hippy" wears flared skirt of faded blue cotton denim, made from two pairs of used jeans, c.1972. Gift of Stephen Bruce, 78.100.14. Thermal undershirt, c.1965. Gift of Mrs. Burton Tremaine, 74.44.21A. Red suede bag with beaded tassels, c.1968. Gift of Jane Holzer, 80.181.27. Green suede belt with beads and feathers, c.1968. Gift of Mrs. Michael Kaiser, 88.29.132. Mules with red leather platform and with vamp of woven multicolor, embroidered leather strips, c.1971. Gift of Elaine Cohen, 91.210.41. The Museum at F.I.T., New York, Photograph by Irving Solero.

The Fool's anarchic mixture of brightly colored garments was drawn from traditional cultures around the world. As they put it, "All the people of the earth are forced to come together now and this expresses itself even in fashion. Our ideas come from every country – India, China, Russia, Turkey and from the sixteenth to the twenty-first centuries." The hippy style was nothing if not eclectic, but the look clearly reflected the hippies' worldview.

The Fool claimed that, unlike other designers, who were only in the business to get people's money, "We want to turn them on. Our ideas are based on love." Ideally, people should create their own clothes, the better to externalize their inner consciousness and to communicate with others who shared the same values. Hippy styles rapidly entered the fashion mainstream, but the transmission was not always naturally serendipitous. Although middle-class middle-aged consumers were reluctant to copy the hippies directly, they took their lead from the fashion industry. Once the hippy look had been adopted (and suitably modified) by certain couturiers, it trickled back down to the mass market.

The fashionable hemline began to drop in 1968, although mini-skirts also continued to be popular. Indeed, the micro-mini made its thigh-grazing appearance at this time, bringing hemlines to an all-time high. In 1969, minis, midis, and maxis were all shown in the Paris collections, as were trousers and harem pants. Other forms of sexually revealing clothing, such as sheer "see-through" blouses were also shown.

In relentless pursuit of the new, the fashion press was quick to promote hippy styles, although the strain of explaining radical young looks to an older, broader audience was all too apparent. It had been hard enough explaining the mod or pop look. By 1967 American *Vogue* had to explain LSD, and solemnly announced that "Timothy Leary's paradigm 'Turn on, tune in, drop out,' remains the classic statement of the hippy weltanschauung." In an article on "Love, Mysticism and the hippies," the magazine also quoted the Maharishi Mahesh Yogi ("Enjoy what you are!") and ultimately concluded that there was now a "growth of freedom" and even "cosmic consciousness."

The psychedelia of the hippy period also had its political aspects. In 1968 American *Vogue* published an article by rock critic Richard Goldstein in which he wrote,

> Now beauty is free. Liberated from hang-ups over form and function, unencumbered by tradition or design. A freaky goddess surveying her . . . realm. Kite-high, moon-pure. Groovy, powerful and weird! . . . Exhibitionism is the quiet side of violence: it aims to provoke . . . No wonder it dominates the fashion of the 60s . . . The same turmoil and insurrection that provides the terror of our times also inspires its greatest achievements. The style of the 60s is creative anarchy.

In 1969 *Vogue* announced that "In fashion, the revolution is over."

60 Ossie Clark chiffon dress with "handkerchief" points at cuffs and hem, c.1969. Fabric designed by Cella Birdwell. The Museum at F.I.T., New York, Gift of Barbara Hodes, 87.52.1. Photograph by Irving Solero.

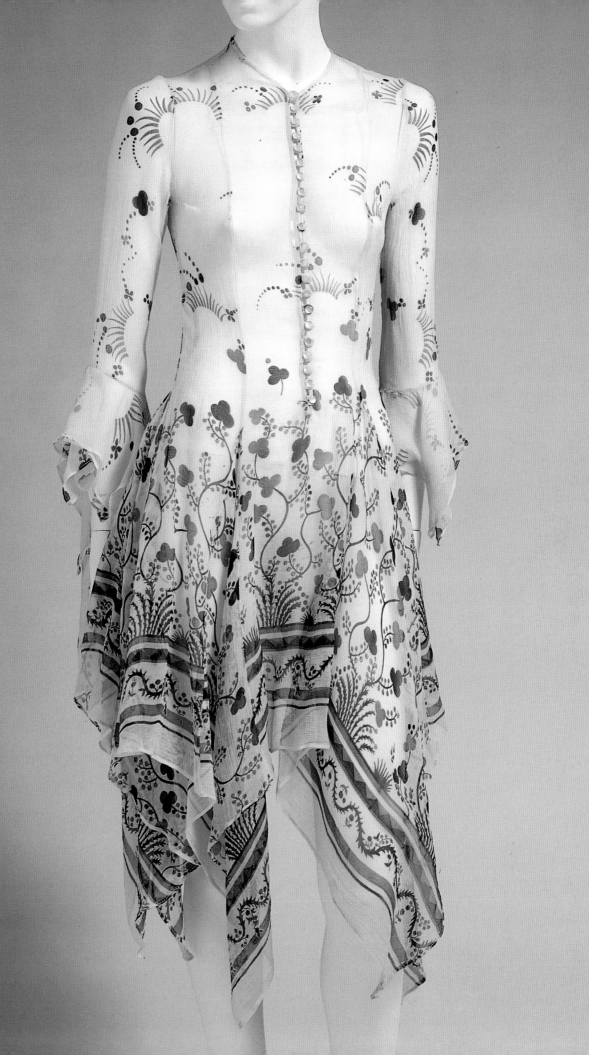

FOR THE LONGEST TIME everyone kept saying the Seventies hadn't started yet. There was no distinctive style for the decade, no flair, no slogans. The mistake we made was that we were all looking for something as startling as the Beatles, acid, Pop Art, hippies and radical politics. What actually set in was a painful and unexpected working-out of the terms the Sixties had so blithely tossed off.

So observed Edmund White in his insightful essay, "Fantasia on the Seventies," which focused on the evolution of gay male sartorial style, away from early-seventies "fantasy clothes" and toward the "new brutalism" of Levis, leather and heavy work boots. But similar changes were occurring throughout fashion.

Like the bastard child of the sixties fashion revolution, seventies style was in confused revolt against its progenitor. "By the seventies everyone wanted to trash the sixties," recalled the American fashion designer Betsey Johnson, but because people disagreed about where fashion should go, it was pulled in radically different directions. People found this confusing, both at the time and in retrospect. In 1975, when Georgina Howell wrote her book, *In Vogue*, the last chapter was called "The Uncertain Seventies." In 1991 when she revised the book, she changed it to "The Schizophrenic Seventies."

Was it really "The Schizophrenic Seventies"? Or was there some deeper cultural unity beneath the chaotic clash of sartorial styles? To understand seventies style, one must recognize that fashion was not in fashion. "Let us grant to the seventies its claim to antifashion, for the freedom to wear what you want, where and when you want, is finally here," declared journalist Clara Pierre in her 1976 book, *Looking Good: The Liberation of Fashion*. Hers was very much the opinion of the day, and the arbiters of fashions risked being dismissed as "fashion fascists" if they dared tell women what was "in" or "out." As a result, fashion journalists quickly adopted a new language of "freedom" and "choice." They constantly reassured readers that "fashion now is the expression of women who are free, happy, and doing what they want to be doing." As British *Vogue* put it: "The real star of the fashion picture is the wearer . . . you."

The American pop journalist Tom Wolfe labeled the seventies "The Me Decade," alluding to the narcissism and self-indulgence that seemed to

61 Halston brown suede coordinates including hot pants, shirt, belt, and fur-trimmed maxi-coat, 1971. The Museum at F.I.T., New York, Gift of Mrs. Michael Kaiser, 88.29.39. Photograph by Irving Solero.

characterize contemporary society. In an article entitled "The Sexed-Up, Doped-Up, Hedonistic Heaven of the Boom Boom '70s," published in *Harpers and Queen* (April 1980), Wolfe argued that people were mistaken in thinking of the 1970s as a period of calm after the "uproar" of the 1960s. Although the political radicalism of the student left had faded away after the end of the Vietnam war, in almost all other respects the cultural radicalism of the 1960s not only did not vanish, it diffused throughout the wider society. Both the drug culture and the sexual revolution, for example, became mass phenomena. If the hippies had one irrevocable effect on culture, including fashion, it was to destroy every rule, except the injunction to please oneself.

Perhaps it is not surprising then that the 1970s have also been called "The Decade that Taste Forgot." Certainly, hot pants and platform shoes provide evidence that fashion's excesses were striking. It was a time of wide bell-bottoms, wide lapels, and wide ties, but the defining characteristics of seventies style were not limited to distortions of size. As the rules of taste and propriety were deliberately violated, the fashion system spawned crushed vinyl burgundy maxi-coats, avocado-green ultrasuede pants-suits, electric blue lycra "second-skin" bodystockings, and silver lurex halter tops. Polyester shirts were open to the waist, and dresses were slit up to the crotch.

"Is bad taste a bad thing?" demanded British *Vogue* in 1971, with the clear implication that the freedom to violate social conventions was liberating. "Everything that we find ugly [and] ridiculous . . . becomes amusing, charming," agreed French *Elle* in 1973. The sophisticated appreciation of bad taste ("kitsch") was only one part of fashion in the 1970s, of course. Later in the

62 Platform shoes by Greca, 1970–72. The Museum at F.I.T., New York, Museum Purchase, P92.11.9. Photograph by Irving Solero.

63 (*facing page*) Yves Saint Laurent man's suit in lime green velveteen; jacket with notch collar and peaked lapel, flared pants, *c.*1972. The Museum at F.I.T., New York, Gift of John Karl, 88.170.1. Photograph by Irving Solero.

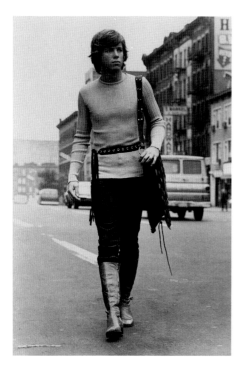

64 Young men's fashion, 1970.
Photograph: Archive Photos.

century, however, when "seventies style" was revived as retro, it was this "trashy" aspect of the decade's fashions that received most attention. In March 1991, for example, American *Elle* began an article on " '70s Sound Style" by observing that "The early seventies have a reputation for being deviant and nasty – which is one reason not to despise its current style revival."

Were the seventies really the "dark . . . hedonistic . . . underside of the sixties dream," as *Elle* put it? What was fashion really like in the seventies? The fashions of the seventies can be divided into two periods. From about 1970 through 1974 fashion was characterized by a continuation of many late-sixties themes, such as conspicuous outrageousness (epitomized by platform shoes and hot pants), retro fantasies (especially Edwardian and 1930s styles), and ethnic influences (notably orientalism but also African-American styles). In its orientation toward youth, freedom, and other counterculture virtues like equality and anti-capitalism, the first phase of seventies style might be described as late hippie diffusion.

From 1975 through 1979, however, fashion became simultaneously harsher and more conservative. On the level of street fashion, the peace and love ethos of the hippies was followed by the sex and violence of the punks. In the world of high fashion, a deliberately decadent style of "terrorist chic" dominated. Yet at the same time, middle-class people increasingly gravitated toward dress-for-success uniformity, which set the stage for the aggressive styles of the 1980s.

When the 1970s began, however, the most striking development was the sound of hemlines falling. In January 1970 the Paris collections emphasized long skirts. Soon afterwards, a cartoon in the *New Yorker* showed two middle-aged businessmen wistfully staring at a couple of young women in the new leg-concealing styles: "It's the end of an era," sighed one of the men. Sixties style did not abruptly end in the first month of 1970, of course. Long dresses had already emerged among the hippies as early as 1967, and the fashion for maxi-coats began in 1968. In 1969, the year of the so-called "micro-mini," Marc Bohan of Dior was quoted as saying that since skirts could hardly get shorter, they would soon get longer. Nevertheless, the Paris collections did mark something of a turning point.

After almost a decade of rapidly rising hemlines, the new, longer length made news around the world. Because the new hemline tended to fall at mid-calf, it was eventually dubbed the "midi," and there was considerable controversy over fashion's move from mini to midi. *Life* published a cover article on "The Great Hemline Hassle," featuring a two-page photo-spread of a woman's legs. "The latest word is long," the magazine dutifully reported, "but . . . many women and all men hate to see the Mini go." Alongside a full-color photograph of a pretty young woman in a mini-skirt was a large caption: "How can we bear to bid goodbye to all this?"

Because the mini had been associated with youth and sexual liberation,

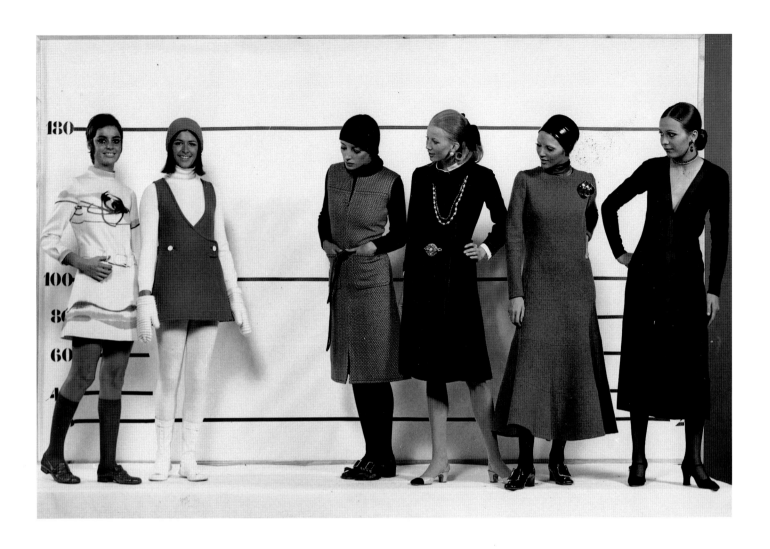

it was said that the midi made women look old and ugly. The American designer Mollie Parnis insisted that "In this age of emphasis on sex and youth, no woman is going to add twenty years to her age by wearing skirts below her knees." The Associated Press reported the existence in the United States of "ban-the-midi" clubs, such as POOFF (Preservation of Our Femininity and Finances), and although we may doubt whether resistence was so organized, it was endemic. Because the midi was officially launched in Paris, the skirt-length debate was also interpreted in the United States in geo-political terms: as French dictatorship versus American freedom.

When Madame Georges Pompidou visited the United States, she naively told the press that Richard Nixon had admired her midi. Political humorist Art Buchwald joked that conservative Republican women had always worn midis. Yet the editor of *Women's Wear Daily*, which had promoted the midi quite aggressively, received an angry letter from a lady in Dallas, who wrote, "We love the mini skirt. And we support Nixon and Agnew too." Hatred of the midi made for strange political bedfellows. Liberals associated the mini

65 Mini, Midi, and Maxi at the Paris Autumn/Winter collections, 1969–70. The "shorts" (Ungaro, Courrèges), the "mediums" (Cardin, Dior), the "longs" (Saint Laurent). Photograph: Archive Photos.

66 and 67 (*following pages*) Giorgio di Sant'Angelo floral print dress with chamois empire bodice, 1973. The Museum at F.I.T., New York, Gift of Ms. Lena Horne, 91.254.25. Photograph by Irving Solero.

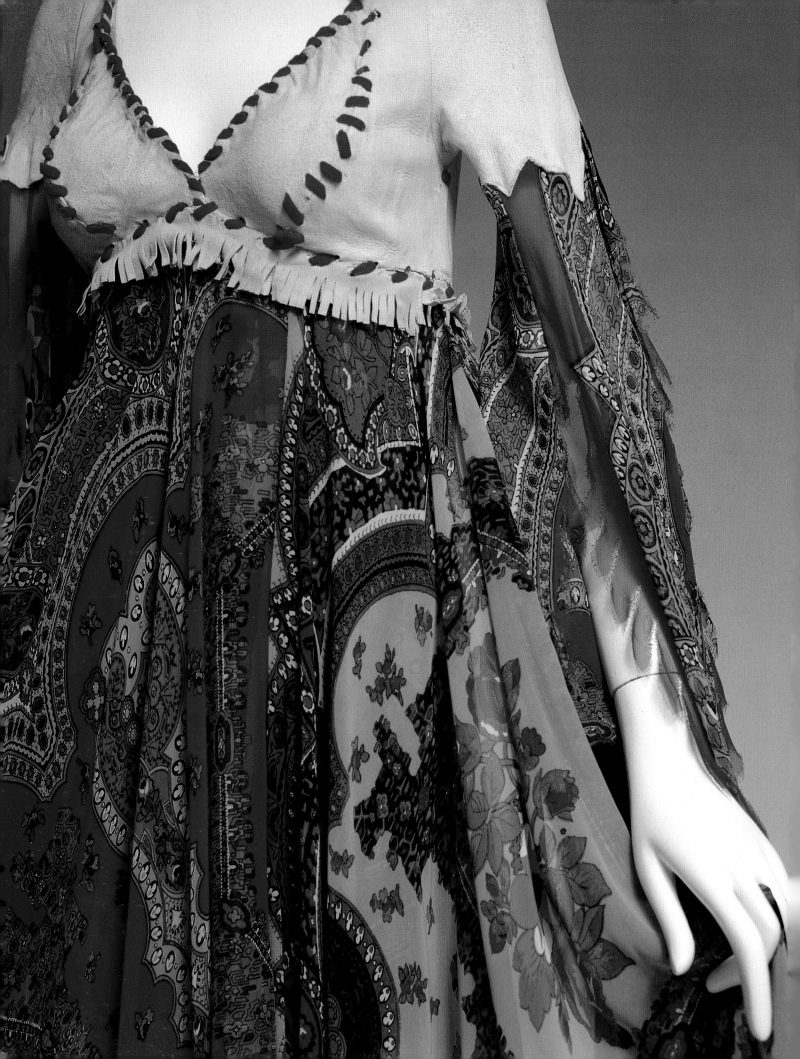

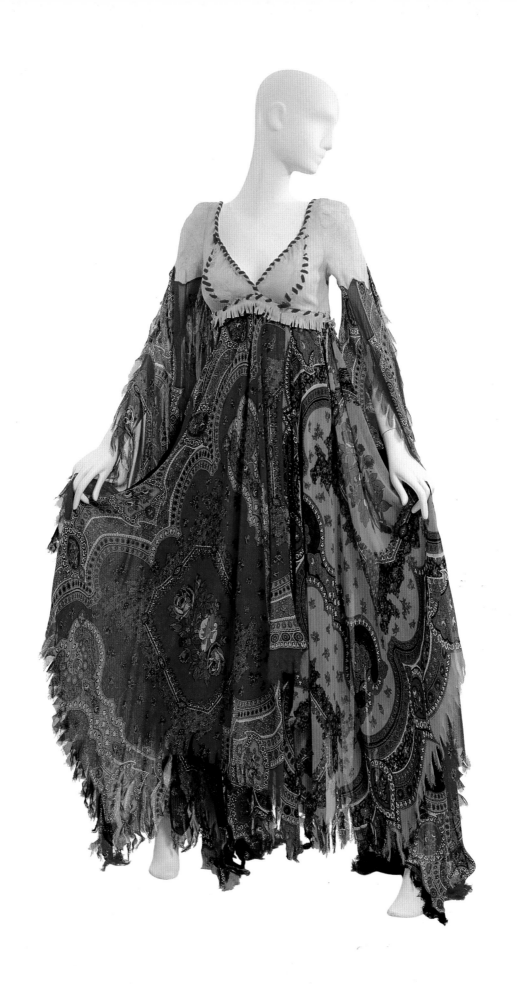

with sexual liberation, but many conservatives were also pro-mini. According to Ellen Melinkoff's amusing social history *What We Wore*, the Lieutenant-Governor of Georgia (a very conservative Southern state) announced, "If any girl ever comes in with one of those midi things on, I'll have her kicked out of the Senate."

Some of the hostility to the midi was economic in origin. The fall of the hemline coincided with the beginning of the deepest economic recession in years. Many consumers were unable to invest in an entirely new wardrobe. Moreover, many manufacturers and retailers still had a considerable stock of mini-skirts in the pipeline or inventory, with the result that they, too, protested against the new style.

It is often said that hemlines reflect the state of the economy. Over the years, a number of journalists have theorized that hemlines go up in times of prosperity (such as the 1920s and 1960s) and go down when there is a recession or depression (as in the 1930s and 1970s). Although superficially plausible, the theory does not work. The stock market did fall in 1970 and again in 1973–4 with the oil crisis, but the market's ups and downs were not mirrored by a corresponding rise and fall of hemlines.

If longer hemlines were not related to a depressed economy, did they, perhaps, reflect women's changing role in society? Many feminists were critical of sexually explicit fashions, such as mini-skirts, but they also rejected the way the fashion industry "manipulated" women's minds by promoting the new long skirts. Feminist hostility to the very concept of changing fashion made them unlikely candidates as fashion trendsetters. Nevertheless, although feminism had little direct impact on the mini–midi controversy, the women's liberation movement was an important phenomenon in the 1970s, and had an indirect influence on fashion.

The result of the great hemline controversy was, perhaps, inevitable. Hemlines fell. "They'll fight like hell, but they'll fall into line," predicted an anonymous expert who was quoted in the March 13, 1970, issue of *Life*; but it took another year or two before most women began to wear longer skirts. This delay has led many observers to conclude that the midi was a "flop," because women no longer "obeyed fashion's dictates." Despite its oversimplification, there is some truth in this argument. In the short run, the midi *was* a failure; the majority of women simply refused to buy it. More importantly, the hemline controversy showed that the fashion mood was anti-fashion and pro-choice. As fashion historian Marylene Delbourg-Delphis has observed, before 1963 women automatically followed fashion; during the sixties, fashion shook people up, forcing them to accept fantastic styles; but in the seventies public opinion rendered fashion "optional."

Public response to the mini–midi controversy was divided. A segment of the population wanted calm and realism; they gravitated toward a kind of uniformity, and ended by emphasizing hemlines that rested a little below the

knee – or else they eschewed skirts entirely, in favor of trousers. For young women fashion had a different trajectory, and the acceptance of longer skirts evolved out of the hippies' love of thrift-store clothes. Long crêpe gowns from the 1930s with tiny fabric-covered buttons were certainly not practical, but they were very romantic. Once these women became used to seeing longer skirts, the look spread rapidly. "For women who couldn't stand the midi one year, we sure bought a lot of granny dresses the next," recalls Melinkoff.

Although hemlines dropped, fashion continued to emphasize legs. Mini-skirts might no longer be the height of fashion, but the new long skirts were often split from ankle to thigh. A 1970 evening dress by Saint Laurent, for example, opened in the front almost to the crotch. The appropriately named "hot pants" also appeared in Europe in 1970, spreading to America by early 1971, when they were featured in many fashion collections. Hot pants were essentially no more than very short shorts made from upscale fabrics such as velvet and silk. Because the style and even the name were popular with men, hot pants quickly became associated with prostitutes. But hot pants were also (briefly) worn even for weddings and in offices. It was a short-lived fad and only adopted by younger women, but while it lasted many hot pants were sold. Melinkoff quotes one woman who recalled that one of her "favorite outfits was a pair of velour hot pants in royal purple with boots . . . to match, in purple suede."

Along with the kitschy pop creations that fashion historian Bruno du Roselle dubbed "savage styles," there was also a growing emphasis on conservative classics, or what the fashion press described as "real clothes for real people." Tired of fashion's excesses, yet sympathetic to the hippies' creed of dressing to suit oneself, many people adopted a modernized version of the classics for work, and sportswear separates (especially jeans) for leisure. The situation was especially critical for working women, who adopted their own kind of anti-fashion. The 1970s was the era of women's liberation, and increasing numbers of women entered the higher echelons of the workforce. Disturbed by the hemline controversy, women increasingly chose to wear trousers, the traditional symbol of masculine power. In 1971, in France alone, the number of trousers for women sold jumped from eleven to fourteen million, while the number of dresses dropped from eighteen to fifteen million.

68 Hot pants by Mary Quant, 1971. Photograph: Archive Photos.

69 Bianca Jagger in a pantsuit.
Photograph: Archive Photos.

71 (*facing page*) Still from the film *The Damned*, 1969. Photograph: Archive Photos.

Bruno du Roselle interpreted this development as part of "the return to calm." He admitted that the idea of trousers for women had traditionally been one of fashion's strongest taboos, but nevertheless argued that incorporating trousers into a bourgeois uniform like the business suit effectively "annihilated" the revolutionary potential of trousers, while simultaneously "rejuvenating" the classic costume. Nevertheless, the trouser suit, or *tailleur-pantalon*, was more radical than he thinks. The seventies marked the first time in history that trousers were really accepted as female apparel, not only for informal occasions but on the street and in the office – a development that really does seem to have reflected women's social and economic liberation. In any case, the very notion of a "return to calm" is problematic, since the mood of the 1970s was poised ambivalently between the revolutionary aspirations of the sixties and the executive "power suits" of the 1980s.

Consider another example of seventies ambivalence: the triumph of blue jeans. Although blue jeans are popularly associated with the 1960s, in fact they became more important in the seventies than ever before. In 1971 Levi Strauss received the Coty Fashion Critics Award, the "Oscar" of the American fashion industry, for its world-famous blue jeans. The same year, the Rolling Stones put out their album *Sticky Fingers* with a cover by pop artist Andy Warhol; it was a close-up crotch-level photograph of a man in tight jeans, complete with a real zipper which could be unzipped.

Why were jeans so popular? In 1973 an advertising trade magazine published an insightful essay by an anonymous "Creative Director," who observed that, "Probably no single garment, outside of a religious order, has been so widely used as . . . a symbol for a change in lifestyle." Around the world, from Haight Ashbury to Tokyo, jeans had been adopted as a symbol of youth and freedom. "What began as the hard-working garment of the hard-working man has been transmuted into the uniform of nonconformity – and a unisex uniform at that."

The uniform of a committed band of rebels and hippies soon spread to a much wider market. By the 1970s blue jeans were no longer really the mark of the worker, the rebel, or the hippy, because everyone wore them. Yet even as jeans became "co-opted" by the fashion system, their signifying value grew more powerful. "What was originally a symbol of rebellion now becomes the symbol of continuity of that movement. As long as Levi's are around, nobody's copped out." Or, as Iain Finlayson wrote in *Denim: An American Legend*, "Clothes could give the illusion that a person had 'dropped-out' a little bit."

As the counterculture was being swallowed up by consumer society, " 'real-life' denim became 'lifestyle' denim." Free to wear anything they wished, people overwhelmingly chose to wear jeans, but popular awareness of different brands and styles subverted the old utopian idea that everyone would be equal in identical jeans. Levi's and Wrangler's had to compete with a host of new "designer" blue jeans, produced by companies like Fiorucci,

Gloria Vanderbilt, Pierre Cardin and Calvin Klein. The sex appeal of jeans was also increasingly emphasized. "Hustler" and "James Dean" became brand-names, to be followed in Italy by "Jesus Jeans." Successive blue jean fashions included bellbottoms, hip-huggers, stovepipes, cuffed jeans, pleated and baggy jeans. Denim was stone-washed, dyed different colors, embroidered, and studded. In 1978, there was even a brief craze for see-through jeans.

Is it valid, though, to imply that jeans had once been anti-fashion before being coopted by the fashion system? Many people have distinguished sharply between anti-fashion (or street style) and fashion. Ted Polhemus, for example, insisted that "The authenticity and sense of subcultural identity which is symbolized in streetstyle is lost when it becomes 'this year's fashion' – something which can be purchased and worn without reference to its original subcultural meaning." He argued that "Even within the fashion industry there is concern at what is seen as 'exploitation' of streetstyle creativity."

This argument is popular because it valorizes subcultural street styles and the people who wear them (marginal groups, workers, young people, minorities), while simultaneously attacking commercial fashion, on the grounds that it has a false and parasitic relationship to "authentic" anti-fashion. Obviously the fashion industry has often copied street style. Fashions no longer "trickle down," they usually "bubble up" from various subcultures, but contrary to what Polhemus believed, the creators of street style do not "naturally" evolve a pure and unchanging style, in contrast to fashion's artificial promotion of new, "trendy" fashions.

There is a complex, dialectical relationship between fashion and anti-fashion. Thus, retro has frequently been criticized on the grounds that it represents either a loss of creativity on the part of fashion designers, or a perverse "nostalgia" for the past. Yves Saint Laurent's 1979–80 collection of 1940s-inspired fashions, for example, was savaged by the press. The clothes were "truly hideous," declared Eugenia Sheppard, who failed to appreciate short skirts, wedge shoes, and a green fox-fur jacket with padded shoulders. It all seemed "vulgar," in "bad taste," "kitsch."

But retro evolved out of the hippies' pillaging of thrift stores. There was some interest among young people in rebellious 1950s youth styles, but probably the most popular period style was that of the 1930s. Visconti's film *The Damned* (which showed Ingrid Thulin vamping around as a fashionable Nazi) became a cult favorite with fashion people. Films such as *Cabaret* (1972) made the look of 1930s-style "decadence" available to a wider audience. In retrospect, it seems clear that retro is one of the most important stylistic features of postmodernism. The elements of pastiche and irony, the mixing together of different and often wildly clashing elements into a form of

70 (*above*) Girl in jeans and platform shoes, 1973. Photograph: Corbis-Bettmann/UPI.

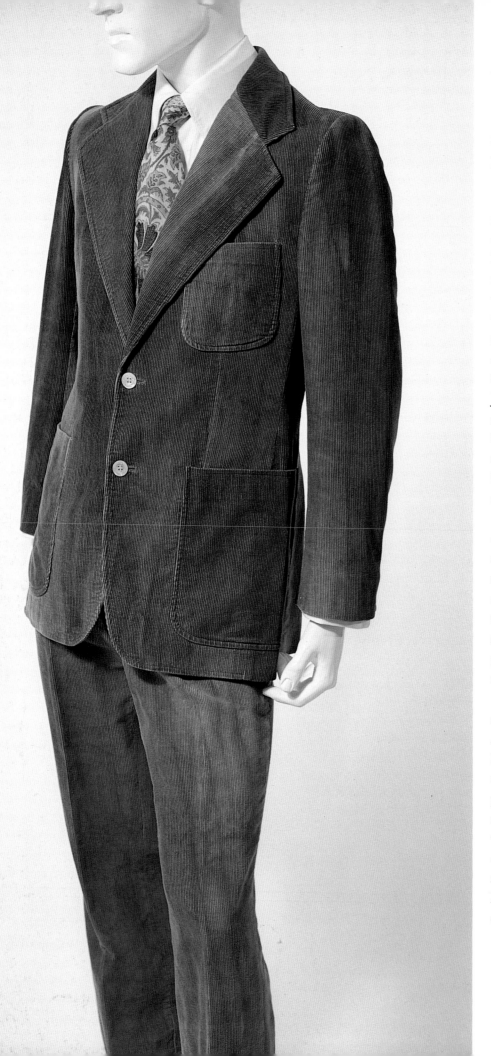

bricolage, is crucial to the late twentieth-century aesthetic sensibility.

In 1970 a group of young people in New York started a new fashion periodical called *Rags*, which featured examples of counterculture style, emphasizing cheap, vernacular garments, like denim jackets (ironically decorated with American flags). In line with the anti-consumerist hippy ideology, there were essays on how to tie-dye your clothes or hand-paint your platform shoes – although the magazine also praised a $50 shirt designed by the young designer Stephen Burrows. Rock star Mick Jagger was cited as a fashion trend-setter, and praised for a stage ensemble that consisted of a dog collar, scoop-necked T-shirt, nail-studded bell-bottoms, and a long tie-dyed silk scarf.

This costume presaged two of the dominant trends of the seventies: androgyny and punk. It also emphasized the continuing importance of music for youth fashion. In addition to rock and roll, the seventies would see new kinds of music, like glam and glitter, heavy metal, funk (black party music), disco, and punk.

Platform shoes and boots were another fad of the early 1970s. The African-American musician Isaac Hayes owned twenty-seven pairs of custom-made, skin-tight, thigh-high platform boots. Glitter and glam rockers like David Bowie not only wore platform shoes and skin-tight clothes, they also violated the taboo against men wearing cosmetics. Although few men imitated their use of eyeshadow, even ordinary mortals

74 Men's ankle boots in multicolor patent leather patchwork by Numero Uno 1969–72. The Museum at F.I.T., New York, Museum Purchase, P92.57.45. Photograph by Irving Solero.

72 (*page 90*) Faded blue cotton corduroy suit made in Austria for Bloomingdale's Mens Store, 1973. The Museum at F.I.T., New York, Gift of Richard Martin, 88.66.5. Photograph by Irving Solero.

73 (*previous page*) Halston tie-dyed silk chiffon evening pyjamas with poncho and matching pant, 1970. The Museum at F.I.T., New York, Gift of Robert Wells in Memory of Lisa Kirk, 91.241.11. Photograph by Irving Solero.

tottered along on platform shoes with two-inch soles and five-inch heels. Indeed, shoes and boots played an extremely important role in seventies fashion, articulating various fashion philosophies. High fashion featured items like purple satin push-down evening boots and jodhpur boots in burgundy suede with reptile straps and heels. Many middle-class white youths favored Frye boots for that old-fashioned workers' look, worn with funky jeans or overalls, lumberjack shirts, and army surplus socks.

Young urban blacks wouldn't have been caught dead in clothes like that, as Tom Wolfe pointed out, "They're into the James Brown look. They're into the ruffled shirts . . . looking sharp. If you tried to put one of those lumpy lumberjack shirts on them, they'd vomit." In his analysis of "radical chic" (published in 1970), Wolfe described various black male fashions: boots with high heels and thick soles, "supercool" Italian silk jerseys, tight pants (*not* jeans), black turtlenecks, leather coats, and all the other accoutrements of the African-American "flash" or "funk" style, which influenced mainstream fashion throughout the first half of the 1970s.

In another essay, "Funky Chic," Tom Wolfe inimitably described this seventies style:

All the young aces and dudes . . . wearing their two-tone patent Pyramids with the five-inch heels that swell out at the bottom to match the . . . plaid bell-bottom baggies they have on with the three-inch-deep elephant cuffs tapering upward to the "spray-can fit" in the seat . . . and the beagle-

collar pattern-on-pattern Walt Frazier shirt, all of it surmounted by the midi-length leather piece with the welted waist seam and the Prince Albert pockets and the black Pimpmobile hat with the four-inch turn-down brim and the six-inch pop-up crown with the golden chain-belt hatband . . . all all of them, every ace, every dude, out there just getting over in the baddest possible way, come to play and dressed to stay.

So-called "blaxploitation" films like *Shaft* (1971) and *Superfly* (1972) further popularized the style. In fact, we cannot underestimate the impact of film and music on the popularization of this style. The film *The Mack* portrayed a veritable fashion show of hustlers in crushed vinyl maxi coats, white fur wraps, and incredibly flared pants. Although older black people often complained about the implications of a look popularly associated with pimps and drug dealers, many young people responded positively to the combination of gangster style and black pride.

Some years later Ted Polhemus would point out that

the Pimp Look fits squarely and logically within that Dressing Up tradition . . . identified with . . . the Zooties . . . and others from socio-economically underprivileged situations. The early 1970s "funkification" of this approach simply accentuated the blatantly erotic, in-your-face sexual possibilities of dress. For example, enormous flares in the trouser legs served to focus the eye on the contrasting ultra-tight fit around the crotch and bottom, while the use of expensive materials like suede and snakeskin underlined the Dressing Up, aspirational . . . message.

75 Poster for the film *Shaft*, 1971. Photograph: Archive Photos.

76 Still from the film *Superfly*, 1972.

Even the staid London *Times* announced that "Afro-American men [were] the best dressed men around." Meanwhile, in Paris a store called Jean Raymond retailed a European version of the look, although, as Fardi Chenoune notes, "The glorious status of wearing Jean Raymond clothes had its negative side – there was always the danger of being forcibly relieved of one's possessions, notably the Weston boots that had become an indispensible accessory."

In Tom Wolfe's sarcastic description of a party held by wealthy white liberals to raise money for the Black Panthers, the socialite Amanda Burden was quoted as saying that she was now antifashion, because "the sophistication of the baby blacks made me rethink my attitudes." Wolfe asked rhetorically, "What does one wear to these parties for the Panthers? Obviously one does not want to wear something frivolously and pompously expensive, such as a Gerard Pipart party dress. On the other hand one does not want to arrive 'poor-mouthing it' in some outrageous turtleneck and West Eighth Street bell-jean combination, as if one is 'funky' and of 'the people.'" The ideal was to look chic, yet raw and vital.

With black fashion in style, young black fashion designers like Stephen Burrows and Scott Barrie also achieved considerable success. Burrows, for example, had hardly graduated from the Fashion Institute of Technology when he acquired his own boutique. Famous for his body-conscious chiffon and jersey dresses, often with "lettuce-leaf" hems and almost always in brilliant colors, Burrows was one of five American designers to show at Versailles in 1973. His main influence came from African-American popular dance. The seventies also saw a continuation of the popularity of African clothes, like dashikis and headcloths, which resembled a more overtly politicized version of the wider interest in "ethnic" style. The Afro hairstyle, for example, became very popular.

Just as the mods and hippies had created their own styles of music and dress, so also did the punks. But instead of "peace and love," the punks created a deliberately aggressive, confrontational style, utilizing the visual accoutrements of sadomasochism. Their slogans were "Anarchy," "No Hope," and "We Are All Prostitutes." Like earlier youth rebels, they were anti-

77 Stephen Burrows calf-length A-line
dress in wool doubleknit, Fall 1970. The
Museum at F.I.T., New York, Gift of
Stephen Burrows, 92.105. Photograph by
Irving Solero.

78 The punks created a deliberately aggressive, confrontational style. Photograph by Ted Polhemus.

establishment and anti-bourgeois, but they were also specifically anti-"left-over hippies." The reason is not hard to find. As sociologist Fred Davis noted, "given the proximity of counterculture youth to mainstream middle-class society, it should not be surprising . . . that certain select hippie parapher-nalia . . . [like jeans] had by the early 1970s come to be worn by adult middle-class men and women as well." The punks hated this, and they reserved their greatest scorn for aging rockers and veterans of 1968.

The punk "style in revolt" was a deliberately "revolting style." Punk clothes were ripped, pierced with safety-pins, and decorated with swastikas, pornographic images, lavatory chains, and tampons. Even the bodies of the punks were pierced and shaved. As Dick Hebdige wrote in *Subculture: The Meaning of Style*,

> Safety pins were . . . worn as gruesome ornaments through the cheek, ear or lip. "Cheap" trashy fabrics (plastic, lurex, etc.) in vulgar designs (e.g. mock leopard skin) and "nasty" colors, long discarded by the quality end of the fashion industry as obsolete kitsch, were salvaged by the punks and turned into garments . . . which offered self-conscious commentaries on the notions of modernity and taste . . . In particular, the illicit iconography of sexual fetishism was . . . exhumed from the boudoir, closet and the pornographic film and placed on the street.

The punks are most notorious for their ripped T-shirts, Doc Marten boots, and "tribal" hairstyles; but more important than safety-pins and mohawks was the way the punks used the visual stategy of bricolage, throwing together wildly unrelated elements, like army surplus and tarty underwear.

The punk style was initially greeted with horror, yet within a very short time, it was a major influence on international fashion. For just as the hippies' affinity with exotic and retro styles had provided a source of inspiration for mainstream fashion designers, so also did the fashion world respond to the punks' obsession with the taboo realm where sex and violence meet. Vivienne Westwood, in particular, enthusiastically embraced punk, and her role underscores the naivité of any rigid separation between anti-fashion and fashion. In 1971, with mainstream fashion divided between mass-market

neo-hippy looks and incipient neo-conservatism, Westwood opened a fifties revival shop in London, evoking the rebels of an earlier era. By the mid-1970s the store had been transformed into a punk/fetish shop called Sex, where Westwood catered to a mixed clientele of about half "genuine" sexual fetishists and half young people who wanted to look "bad." She designed and wore rubber and leather bondage outfits, "cruel" shoes, and other extreme fashions.

Few other fashion designers went as far as Westwood in incorporating the most offensive and threatening elements of punk style. Only Westwood had the nerve to print T-shirts emblazoned with swastikas and

79 Punk style was initially greeted with horror, yet became a major influence on international fashion. Photograph by Ted Polhemus.

pornographic pictures, for example, but "ripped" garments decorated with safety-pins soon appeared in the collections of other fashion designers, like Zandra Rhodes, from where the style filtered down to the mass market. By the end of the decade American *Vogue* felt compelled to criticize "the exaggerated grotesqueries of the international punk style." To wear Nazi-style uniforms, for example, was said to be in "bad taste" – although, as we have seen, this was no longer regarded as a compelling argument.

Punk is a prime example of the new brutalism that characterized the entire fashion system during the later 1970s. It is important to stress, however, that the sinister undercurrent of violence and sexual "perversity" was not limited to subculture styles. Seventies fashion, in general, was heavily influenced by what one American scholar described as "terrorist chic."

Black leather became stylish, precisely because it evoked images of sado-masochistic sex, which was regarded as "the last taboo." Pornographic movies like *Angelique in Black Leather* and the homoerotic *Nights in Black Leather* contributed to the mystique, as did art films like *Maîtresse* which was about a dominatrix, and featured fetish costumes in leather and rubber by Karl Lagerfeld. Even department-store windows featured mannequins that were blindfolded, tied up, and shot. Fashion photography, in particular, was implicated in the new style.

The House of Dior hired Chris von Wangenheim to photograph its costume jewelry, resulting in a famous advertisement that showed a woman, with her wrist in the jaws of a fierce-looking attack dog. Other top fashion photographers, like Guy Bourdin and Helmut Newton, posed models in

scenarios that critics described as violent and "pornographic." Thus, in 1975 the *New York Times* published an article by art critic Hilton Kramer, who argued that in Newton's photographs "the interest in fashion is indistinguishable from an interest in murder, pornography and terror."

Newton often depicted women fighting or in positions of dominance over men or other women. He also enjoyed posing models like streetwalkers, or in settings that emphasized the commercial aspects of sexuality. Because of the puritanism of American society, there was a real scandal when in 1975 *Vogue* published a photo-essay called "The Story of Oh-h-h," which showed a woman hungrily eying a man's half-naked body, and another woman smiling as a man unfastened the top of her bikini. (The title, of course, referred to the famous French erotic novel, in which the masochistic heroine works as a fashion photographer.) French *Vogue* permitted much more overt eroticism, but even in France there were complaints when Newton posed Jenny Capitain as a "cripple" in a picture that strongly resembled fetishistic pornography.

"Cabaret freaks and perverse sex find echoes in today's decadence," wrote art critic Barbara Rose in an essay on "The Beautiful and the Damned," published in American *Vogue* (November 1978). According to Rose, Newton's

> photographs of beautiful women trapped or constricted accentuate the interface between liberation and bondage . . . An anonymous hotel room evokes fantasies of potential erotic adventure. Glittering surfaces catch and reflect light in images that couple elegance with pain, fin-de-siècle opulence with contemporary alienation.

Yet because there were usually "no visible oppressors" in these sado-masochistic "mini-dramas," the photographs implied that the "bondage was of woman's own making."

Newton was hired as a consultant for the horror film *The Eyes of Laura Mars*, which depicted Faye Dunaway as a fashion photographer whose work mixed sex and violence. The film not only publicized some of Newton's most infamous pictures, it also staged typically Newtonesque fashion shoots: in one scene, for example, two models wearing nothing but underwear, high heels and fur coats engage in a violent hair-pulling catfight in front of a burning car. "You don't have to pull so hard," complains one of the women (played by a real model), but the photographer encourages even greater violence. In another scene, while disco music blares, a model pretends to shoot a male model who lies "dead" and bloodied in a pool of water at her feet.

If Newton's pictures frequently focused on sexual aggression, often positioning women as the aggressors, the work of Guy Bourdin focused explicitly on the connections between sex and death. Already in the 1960s Bourdin had posed an elegant fashion model in front of the bloody carcasses hanging in a butcher's shop; in the 1970s he created even more controversial images.

His shoe advertisements for Charles Jourdain were especially notorious: in one advertisement he depicted what appeared to be the aftermath of a fatal car crash; one of the victim's shoes lay at the side of the road.

Bourdin also shot a lingerie catalogue for Bloomingdale's department store. Most lingerie photographs depict a single conventionally attractive female, posed in a romantic private setting, and lit naturalistically. Bourdain posed several "whorish" women together in settings that resembled brothels, and he photographed them using an intrusive hard-flash, which called attention to the presence of the photographer. As a result the pictures looked like hardcore pornography or police photography.

80 Fashion models pretending to fight in a scene from the film *The Eyes of Laura Mars*, 1978. Photograph: Archive Photos.

Although this type of photography has frequently been attacked as misogynistic, some feminists defend it against charges of sexism on the grounds that it is "subversive" and "liberating," because it makes explicit the subtexts that are latent in other fashion images: themes like narcissism, lesbianism, and the male gaze. In this respect the "decadent" style of seventies fashion photography may be compared with punk fashion, for punk also presents images of "bad girls" in stilettos and fishnet stockings, subversively appropriating the symbols of prostitution and sexual perversion, and implicitly refusing to accept the division of women into sexless madonnas and sexual whores.

Despite the punk explosion in London, Paris had regained its position as the capital of fashion. Throughout the 1970s Yves Saint Laurent was widely perceived as "the greatest fashion designer in the world today," and his career throws much light on the evolution of fashion. Aware that his couture prices were "prohibitive" for many women, Saint Laurent told French *Elle* in 1971 that henceforth he was going to focus on ready-to-wear, because his "true public" consisted of "young women . . . who work." A striking picture published in *Elle* showed one of his couture dresses costing 5,500 francs next to a remarkably similar ready-to-wear dress retailing at 650 francs. If he did not close his couture house, he explained, it was "because I cannot morally throw 150 people on the pavement. I guard my private clients for my workers, and not the other way round."

Haute couture, he argued, "perhaps will last another five or ten years. Not more." Later, however, he would reassess the situation, and conclude that the luxury and fantasy of the couture played a vital creative role in society.

Saint Laurent was "today's Chanel," declared *Women's Wear Daily* in 1972. Like Chanel, he pioneered the masculine look in women's fashion, but he did not neglect erotic allure; according to Catherine Deneuve,

> Saint Laurent designs for women with double lives. His day clothes help a woman confront the world of strangers. They permit her to go everywhere without drawing unwelcome attention and, with their somewhat masculine quality, they give her a certain force, prepare her for encounters that may become a conflict of wills. In the evening when a woman chooses to be with those she is fond of, he makes her seductive.

Saint Laurent often exploited the eroticism of sexual ambiguity, most famously in his female version of the tuxedo suit, *le smoking*, which Helmut Newton photographed for French *Vogue* in his signature style. His evening clothes also revelled in the retro and ethnic influences so beloved of the hippies. "Evening, for me, is the hour of folklore," he told *Le Figaro* in 1972.

81 Yves Saint Laurent Russian collection, 29 July 1976. Photograph: Fairchild Publications/*Women's Wear Daily*.

With his Russian – or Ballets Russes – collection of 1976–7 Saint Laurent launched a "fantasmagoria" of oriental influences. Building on the big look of the mid-1970s, he created spectacularly luxurious costumes, such as sable-trimmed gold brocade Cossack coats and long gypsy skirts in iridescent silks. "A revolution . . . that will change the course of fashion around the world," proclaimed the *New York Times* in a front-page article. "The most dramatic and expensive show ever seen in Paris," declared the *International Herald Tribune*. Some observers did complain that the collection was "nostalgic" and too close to "costume" to be really wearable, but American *Vogue* defiantly insisted that, "What Yves Saint Laurent has done . . . is to remind us that fashion, in its radical form of haute couture, *is* costume . . . It strikingly illustrates the degree of sophistication attained by fashion's analysis of history."

"I don't know if it is my best collection, but it is my most beautiful collection," said Saint Laurent, adding, "It was my answer to the press which had disqualified the haute couture as old-fashioned and antiquated." Characterized by Marxists as Saint-Laurent's "rich peasant" collection, it triggered a new wave of ethnic fashions, which were produced at all price points.

Then, in the winter of 1977–8, Saint Laurent produced his Chinese collection, featuring yet more theatrical luxury. The romanticization of the Orient has a long history in the West. But the popularity of the "Chinese look" in the 1970s was also partly the result of the growing normalization of relations between the People's Republic of China and the western democracies.

Look called it "Mao à la mode" and *Newsweek* prattled about "how to look like a cool coolie." In the world of western fashion, however, there were two distinct Chinese-inspired looks, which Marc Bohan called "poor Chinese and rich Chinese" styles. As *Women's Wear Daily* noted in 1975, the rich look was "in direct contradiction to the anti-fashion Chinese work clothes French fashion editors are wearing and touting." These work clothes had as one subtext an enthusiasm for leftist, anti-colonial politics and a new western fantasy about the workers' paradise.

By contrast, the "rich Chinese" or "Mandarin look" reflected "the luxurious side of old China," or rather, not China but what one Italian fashion magazine called "ancient, faraway *Cathay*, the promised land of Marco Polo." This would reach its apotheosis in Saint Laurent's "Chinese" collection of 1977–8. Saint Laurent also wrote a manuscript that reveals his lyrical perspective on Asia:

> Fabulous boyards, grandiose samurais, wild Mongols, a whole epic poem of golden brocades [and] choking barbarian furs . . . The shadow of the

82 Yves Saint Laurent Chinese collection, 27 July 1977. Photograph: Fairchild Publications/*Women's Wear Daily*.

Great Wall against which I shatter myself is more terrible than Genghis Khan's bronze shield. The vapors from my slashed mind make all the dynasties come alive with their furor, their arrogance, their nobility, their grandeur . . . From the Gates of Heavenly Peace flow wild silks which irrigate the temples and tea-houses with their voluptuous fluidity. From the terraces and from the pagodas of the Red Pavilion I can see my dreams dance on the silvery waters of the River of Love.

"Let's face it. Russia is out, and China is in," declared Eugenia Sheppard of the *International Herald Tribune*. "Yves Saint Laurent switches to mad Mongolians, ferocious female samurais and Chinese empresses for his new fall collection." In 1980 Saint Laurent launched his new perfume, Opium.

But beyond costume, a new modernism was coming into style. For just as pop art had been replaced by minimalism in the world of fine arts, so also did fashion minimalism flourish. The American designer Halston was especially influential. Like Chanel, Halston began his career as a milliner and achieved considerable success, but by the late 1960s millinery was in irreversible decline, and Halston moved into womenswear.

83 Halston halter-neck dress.
Photograph © Times Newspapers Ltd.

He created soft, relatively unconstructed, interrelated separates. He focused, in particular, on trousers and tunics for both day and evening. He loved using the new and expensive artificial fiber Ultrasuede, and was also known for his liquid jersey (so appropriate for the "soft seventies") and for his sequinned versions of sportsclothes.

"You're only as good as the people you dress," Halston claimed. By 1972 he had his own boutique, which *Women's Wear Daily* dubbed the "latest gathering ground for the Cat Pack." He designed silk caftans for clients like Babe Paley and Marie-Hélène de Rothschild; jersey halter-jumpers for Liza Minnelli and Lauren Bacall; suede coats for Jackie Onassis and Pamela Harriman; and simple little shirtwaist dresses for everyone. "The herd instinct is the new chic," reported Eugenia Sheppard, "It's like belonging to a club."

For all the elegant minimalism of Halston's style, the new brutalism was also apparent in the window displays created for him by Victor Hugo, such as the one showing a roll of silk charmeuse – with a black leather whip tossed onto it. Even more notorious was Hugo's window filled with mannequins dressed in black lingerie – posed as if attacking each other with guns, knives, and whips.

Halston himself became heavily involved in the notorious disco scene at

84 Halston sweater coat and dress in lavender cashmere, with matching gloves, 1972–3. The Museum at F.I.T., New York, Gift of Mrs. Michael Kaiser, 88.29.2. Photograph by Irving Solero.

Studio 54, which reminds us that disco was an important aspect of seventies popular culture that profoundly influenced fashion. Disco was originally a gay phenomenon, but by the end of the decade even the Barbie doll wore disco dresses. In the early 1970s Barbie wore hot pants and granny dresses, while Ken wore bellbottoms and denim. After an initial flurry of youth styles, however, Barbie and her friends subsided into wearing boring separates. Then at the end of the 1970s "Superstar Ken" donned sunglasses (just as Halston did), while "Superstar Barbie" began wearing glittering, luminescent gowns (like Liza Minelli).

Disco dressing emphasized materials that picked up the light, like lurex. Soon *Vogue* also emphasized "shine," "gleam," and "evening shimmer," promoting items like flesh-colored satin tube tops. Although mainstream fashion featured relatively long skirts, women at discos favored micro-minis. As one observer noted, "The constantly resurrected 60s miniskirt has truly found a second home [at the discotheque]." Preferred footwear included "the highest-heeled, the raciest, nighttime sandals" or "disco glitter" track shoes.

Even underwear got shiny, as Gossard/Lily of France released a collection of brassieres called "The Glossies." Indeed, disco also helped introduce underwear as outerwear. Especially popular were silken slip dresses with spaghetti straps. By 1978 the Paris couture included "a prodigious variety of see-through confections . . . revealing every part of the female anatomy." In Milan also that year, "Most collections looked like underwear shows."

In the late 1970s "the Italian uprising" began to threaten French fashion hegemony. Milan offered a genuine alternative to Paris. "Weary of French fantasy clothes and rude treatment on Parisian showroom floors, buyers were happy to take their order books next store," announced *Newsweek* in 1978. The clothes coming out of Milan were, admittedly, not couture, but they were extremely stylish. "They were classically cut but not stodgy, innovative but never theatrical. They were for real people – albeit rich people – to wear to real places."

Already by the mid-1970s, the attention of the international fashion press had begun to move inexorably away from the Roman couture (which was essentially an imitation of Paris) and toward Milan, which was emerging as one of Europe's fastest-growing fashion capitals. Crucial to the rise of Italian ready to wear was the revival of the Italian textile industry. "The best textiles in the world are Italian," argued John Fairchild, the publisher of *Women's Wear Daily*. Moreover, Italian textile companies began to give significant financial backing to Italian clothing manufacturers, especially those producing high-quality ready to wear – clothes that combined the casual qualities of American sportswear with European luxury and status.

"The Italians were the first to make refined sportswear," recalled Fairchild. "Americans don't mind spending if the sweater is by Krizia or Missoni." Krizia was a design firm founded by Mariuccia Mandelli, Italy's top female

85 Detail of Missoni three-piece sweater set, 1973 (plate 87). Photograph by Irving Solero.

86 "Leopard" style evening dress by Jean-Louis Scherrer, 1977. Photograph: Archive Photos.

87 Missoni three-piece sweater set with shirt-style jacket, sleeveless top and long pleated skirt in flame pattern knit, 1973. The Museum at F.I.T., New York, Gift of Helen Rolo, 84.122.4. Photograph by Irving Solero.

88 Halston tailored shirt dress in beige ultrasuede, 1972. The Museum at F.I.T., New York, Gift of Mrs. Sidney Merians, 82.193.4. Photograph by Irving Solero.

designer. Missoni was a family-owned company specializing in knitwear; its designers helped pioneer new mixtures of materials and colors. Menswear also played an important role in the emergence of the modern Italian fashion industry; Italy had long been known for its fine tailoring and handsome accessories, but the situation that developed in the 1970s was significantly new.

In her essay, "Stylism in Men's Fashion," Chiara Giannelli Buss argued that "The concept of 'made in Italy,' hitherto the guarantee of fine materials, excellent workmanship and *good taste* [was replaced] with that of the 'Italian look,' the status symbol of a new economic power, conscious of the social implications of fashion and with a decidedly international character." Particularly influential was Giorgio Armani, who began designing under his own name in 1974. Significantly, he designed menswear first, and only after he had revolutionized this stodgy field did he turn around and do the same thing for women's wear.

Thus, along with terrorist chic, the second half of the seventies saw a growing emphasis on what might be called "conservatism with a choice." As we have seen, the fashion press described the phenomenon as "real clothes for real people," especially "what you need most – clothes for day." In practice, this meant slightly-below-the-knee skirts, trousers, and "dress-for-success" suits. These clothes were often shown on healthy-looking fashion models, like Lauren Hutton, who were made-up to look "natural" in sheer lip gloss and other minimalist cosmetics.

It was also possible to style and photograph conservative-looking clothes with a decadent edge, through the use of glamorous make-up, fetishist accessories, and hard-flash photography. The "no make-up" look of the early to mid-1970s was increasingly replaced by a look of deliberately heightened artificiality. Like vampires, fashion models had pale pale skin and deep red lips. Indeed, lips were the most important facial feature, in contrast to the previous period when the eyes were emphasized. Now that doe-eyed look was dead, replaced by a shiny, wet, blood-red mouth.

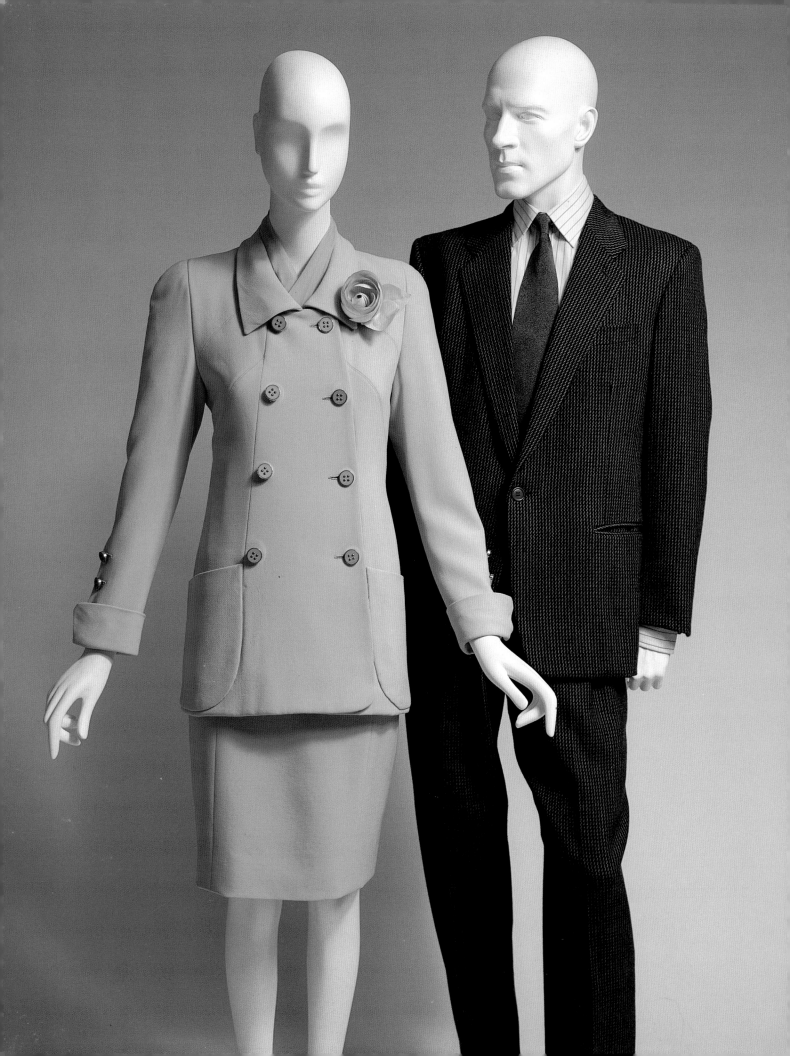

FIVE EXCESS: THE 1980S

This is the Eighties,
Decade of money,
Ten years of fun.
More and more party,
More and more "stuff."
Bigger is better,
Too much is not enough.

THESE ARE THE LYRICS to a song performed by an all-designer band at the 1990 Council of Fashion Designers of America Annual Awards Show. In her work on fashions of the 1980s, Jacqueline Nims quoted the song as evidence of the *Zeitgeist*. Pouf skirts and power suits were not the only fashions of the eighties, of course, but in a sense they do seem to epitomize the decade. The eighties have been stereotyped as a "decade of greed" and "excess." Within journalistic discourse, this interpretation of the eighties has focused on themes such as the money culture, the glamor of investment banking, the booming art market, the status rituals of the nouveaux riches – and the stock market crash of 1987.

"Crime? Greed? Big Ideas? What Were the '80s All About?" asked the *Harvard Business Review* in 1992. Other journalists asked variants of the same question and came up with a number of theories. Was it "A frivolous decade?" "Disaster or triumph?" Certainly it was "A decade marked by sharp contrasts." But the experts argued about the ultimate effects of "trickle-down" economics. Cornel West and James Baker characterized the 1980s in *Newsweek* (1994) as "Market culture run amok," and *Business Week* (1992) titled one article, "A Long Morning After (The 1990's Economic Decline Due to Excesses of the 1980's)."

As it happened, the stock market crash of 1987 coincided with Christian Lacroix's New York opening, and there were those who drew a connection between the two events. In her essay, "Dancing on the Lip of the Volcano: Christian Lacroix's Crash Chic," society journalist Julie Baumgold argued that "Lacroix makes clothes of such extravagant, gorgeous excess as to divide the classes once and for all." And she adds, "Clothes of such brilliant luxury and defiance probably haven't been seen since eighteenth-century French aristo-

89 Tailored suit in pale rose wool by Karl Lagerfeld for Chanel, 1986. The Museum at F.I.T., New York, Gift of Mrs. William McCormick Blair, 94.115.1. Man's tweed suit by Giorgio Armani,. 1982. The Museum at F.I.T., New York, Gift of Mr. Jay Cocks, 85.58.7. Photograph by Irving Solero.

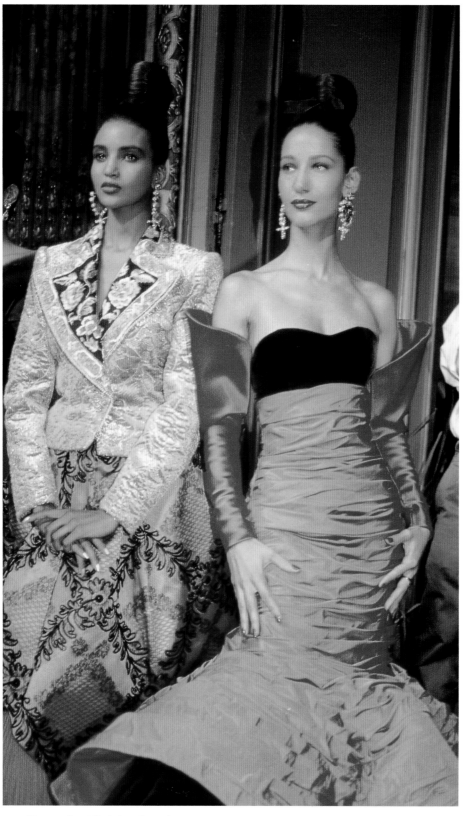

90 Dresses by Christian Lacroix, 1987.
Photograph © Roxanne Lowit.

crats rattled in carts over the cobble-stones on their way to the guillo-tine." It was not that the free-spending members of the New Society were in immanent danger of a new Reign of Terror, but the friv-olous and theatrical look of their Lacroix dresses — extended over hoops or bustles, and adorned with garlands, fringe and ribbons, in a riot of red, pink and gold, stripes, polka dots and roses, and costing some $15,000 to $30,000 per dress — seemed to signify a decadent society wholly abandoned to the cult of conspicuous consumption.

And yet this kind of *Schadenfreude* is too glib. Rich ladies have always worn expensive dresses, and fashion's extravagances are easy to mock. As Gilles Lipovetsky observes, "fashion can not be separated from conspicu-ous consumption . . . In eras of in-equality, conspicuous consumption has to be understood as a social norm . . . [and] as a necessary imperative for the insistent representation of social distance and social hierarchy."

During the 1980s throughout the industrialized world, people in the top economic strata enjoyed signifi-cant increases in disposible income, and responded by flaunting their wealth in the purchase of expensive consumer goods, including clothing. Policies introduced at the beginning of the 1980s by President Ronald Reagan in the United States and Prime Minister Margaret Thatcher in the United Kingdom set the eco-nomic trends of the 1980s in motion. These policies included tax reform, deregulation, and heavy deficit

spending (in America) and tax reform and privatization (in the U.K.); centrist or center-right governments in many of the countries of western Europe followed analogous policies designed to produce economic growth and an expansion of private wealth.

These policies were designed explicitly to enrich the upper-income members of society; as an American phrase of the time put it, "a rising tide lifts all boats." In other words, the increasing wealth of society's richest people would "trickle down" to help others as well. Or as the film character Gordon Gekko put it in *Wall Street* (1987), "Greed is good." The idea was controversial even at the time, and by the 1990s journalists used Gekko to characterize "materialism and selfishness in the 1980s." A writer for *Rolling Stone* described the eighties bluntly as "the gimme decade."

In practice the trickle-down effect was more theoretical than real, but in terms of consumer spending on luxury goods that made little difference. Most members of the middle class were unlikely in any case to spend much money on Armani suits, Gucci loafers, and Rolex watches. But "yuppies" (young urban professionals) throughout Europe, America, and Asia, enjoying a sustained and substantial increase in disposable income, were very much inclined to buy all of those things, and to compete with one another in displaying their purchases. Like participants in previous economic booms, the yuppies assumed that the good times would never end. As yet another slogan of the time put it, "Whoever dies with the most toys wins!"

The yuppies had plenty of money to spend, and saw no reason why they should save it rather than spending it. Not surprisingly, this aroused hostility among many of those who were not enjoying the pecuniary benefits of hostile takeovers and corporate mergers. By the end of the decade T-shirts and graffiti offered a new slogan: "Die Yuppie Scum!"

In the meantime, the designers and manufacturers of fashionable clothing and accessories grew rich on the yuppies' purchases. As Holly Brubach wrote in the *New Yorker* (1992), "Conspicuous consumption . . . during the Reagan years was regarded as a badge of personal achievement . . . The heroes of the eighties, who built junk-bond empires and casinos and shopping malls as monuments to themselves, outfitted their wives in dresses by Christian Lacroix."

Christian Lacroix was, of course, an extremely important figure in the fashion world of the 1980s. In 1985, while at the House of Patou, Lacroix seemed to come out of nowhere to become one of the most talked-about couturiers in Paris. His use of startling colors and extraordinary accessories attracted enthusiastic attention. In 1986 he introduced his famous bouffant (or "pouf" or "bubble") cocktail dresses, and was awarded the Dé d'Or (the Golden Thimble), a prize given by the international fashion press to the best couture collection of the year.

Lacroix was frequently compared to Karl Lagerfeld of Chanel: "They vie

for the spotlight with their fresh infusions of design genius into the . . . couture tradition." Or, as Charoline Olofgörs put it for *Details*, "Christian Lacroix and Karl Lagerfeld are making the haute couture à la mode again. What Jean-Paul Gaultier did for ready-to-wear, Christian Lacroix is doing for haute couture, though their styles are completely different. They both offer us a happy laughter."

"I'm dressing a new generation of young beautiful women who want luxurious but witty clothes," said Lacroix. "The trick is to add precisely the right dose of fantasy without falling into *le gag*." It is crucially important to understand the role of fantasy in Lacroix's work. His clothes were not simply opulent and luxurious; richness, per se, was typical of the older generation of couturiers, and especially those who catered to a Middle Eastern clientele. Like Lagerfeld and Gaultier, Lacroix was a witty iconoclast, who was not afraid to go over the top.

In January 1987 Lacroix left Patou and opened his own couture house. On July 26 he showed a collection of sixty extravagant outfits, mostly dresses for the fanciest social occasions, inspired by the traditional flouncy costumes of southwestern France. His debut collection was a carnival of wild colors and extravant historical silhouettes: a yellow satin balloon skirt with black pom-poms; flamenco influence in a snugly draped evening dress that flared at the hem; a satin fichu wrapped around the bodice of a short, flaring dress worn over multiple petticoats. Elsewhere – tangerine fringe, ice-pink mohair, a printed ponyskin coat, "very strong, crazy things," he said, "because it is the only way of keeping haute couture alive."

Lacroix was immediately heralded in the fashion press as "the latest fashion genius." "A new star – no question," declared *Women's Wear Daily*. "For Lacroix, a Triumph; For Couture, a Future," wrote Bernadine Morris in the *New York Times*. "With his first collection under his own name, Christian Lacroix has been catapulted into fashion's hall of fame. Like Christian Dior exactly 40 years ago, he has revived a failing institution, the haute couture . . . He has done it with verve, whimsy and a youthful air." Many other journalists agreed that it was "the most innovative fashion statement since Dior's New Look" – or at least since the apotheosis of Yves Saint Laurent.

Amidst a chorus of praise, some feminists saw Lacroix's "spectacular rise to the top of the fashion world" as part of a "backlash" against liberated modern women. Other critics found his opulence unseemly at a time when the homeless were sleeping in the streets. By 1988 the near-deification of Lacroix had triggered a backlash of its own.

"No frills, no ruffles, no kidding," announced American *Vogue*; "Let's not have any *fun* around here," added Diane Rafferty, sarcastically. In her article, "In Defense of Christian Lacroix," Rafferty criticized "the fashion police . . . kill-joys dressed in mannish, purposeful uniforms of tasteful beige and black," who wanted to eliminate frivolous items like fuchsia pouf skirts. She

91 (*facing page*) Pouf dress by Christian Lacroix, 1987. Photograph © Roxanne Lowit.

92 (*following page*) Bill Blass evening ensemble with red cotton cashmere knit V-back sweater, long red silk stain skirt, matching satin high heel pumps and leather gloves, 1984. The Museum at F.I.T., New York, Gift of Bill Blass, Ltd., 85.91.1. Photograph by Irving Solero.

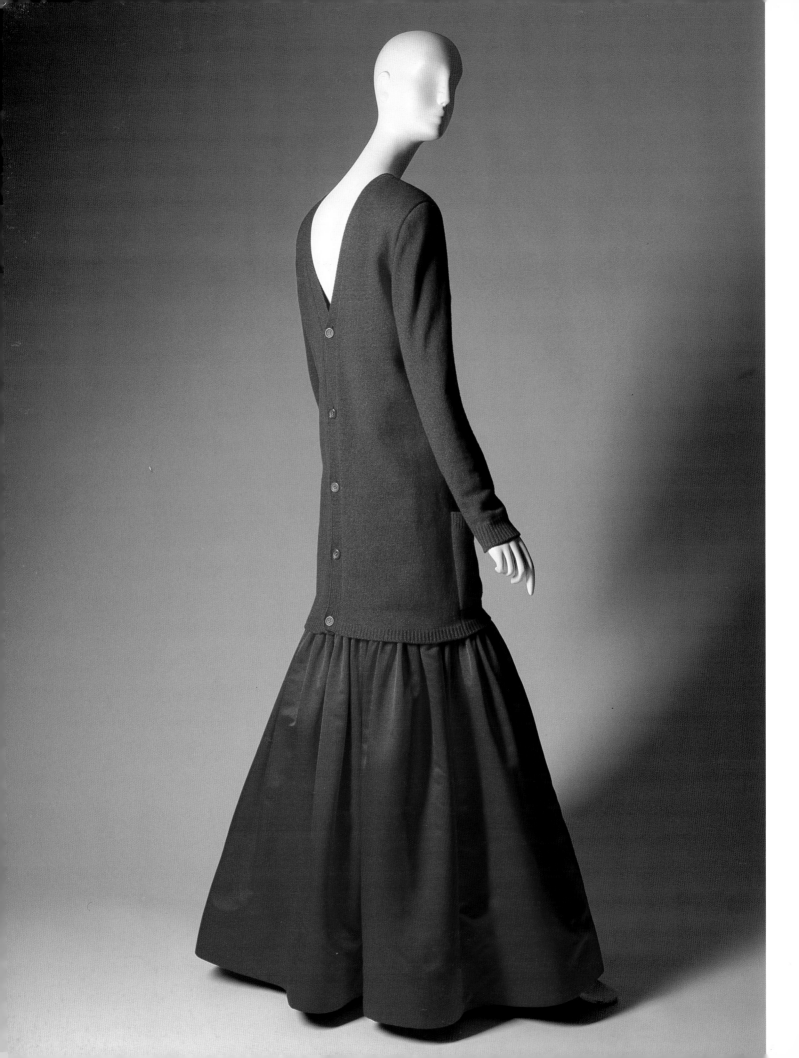

quoted the American fashion designer Calvin Klein, who had self-righteously announced, "I couldn't design a pouf if you put a gun to my head." No, he couldn't, she agreed, but were the homeless any happier at the sight of women in very expensive gray business suits? Do women *have* to wear sensible, androgenous, understated clothes? Is there no place in fashion for originality, humor, romance, sex appeal, panache? Couldn't fashion be enjoyed? Weren't there some people who liked to play with fashion? Nailing her thesis to the wall, Rafferty insisted that "In some strange way, French couture seems to share the spirit and courage [of street style]." In particular, she compared the spirit of the couture to "the iconoclasm of the punks, the nostalgia of the . . . New Romantics, [and] the . . . elan of . . . Congolese *sapeurs*."

In Congolese slang, to be a *sapeur* was to belong to La Société des Ambianceurs et Personnes Elégantes. These young dandies (also known as "les Parisiens") were criticized by people of an older generation, who spoke in the language of anti-colonialism, "authenticity," and Marxism. "This youth fringe has been identified as a hotbed of delinquency," wrote one psychology professor, who urged the African press to emphasize what he called "the misery and lamentable condition of life in France." Just as western critics deplored the expense and retrograde fantasy of Lacroix's clothes, so also did West African politicians criticize the "bourgeois" extravagances of local dandies. To pay $200 for a pair of shoes in Africa certainly qualified as conspicuous consumption.

The *sapeurs* were also attacked for their attitude, for allegedly imitating their former colonial overlords. More than a decade earlier, across the Congo River in Zaire, President Mobutu Sese Soko had actually forbidden his countrymen to wear western suits. In the name of African authenticity, he promoted, not African clothing (which presumably seemed insufficiently modern), but a kind of Nehru or Mao jacket – worn with a silk foulard. This was known as the "abacost," an abbreviation of "à bas le costume" (or "down with the suit"). Papa Wemba, one of Zaire's most popular performers and himself a *sapeur*, responded by singing, "Don't give up the clothes. It's our religion."

The religion of fashion had devotees around the world, but their cult aroused opposition from moralists, and by the 1990s the anti-fashion mood called for "sackcloth and ashes." Tom Wolfe's novel *The Bonfire of the Vanities*, a satire of eighties' money culture, borrowed its title from events in fifteenth-century Florence when the reformer (and martyr) Savonarola preached against art and luxury. With the naturalistic zeal of a modern Zola, Wolfe used clothing descriptions to devastating effect. His protagonist, Sherman McCoy, is a Wall Street bonds salesman, whose vast wealth allows him to think of himself as a "Master of the Universe."

Women were expensive trophies to be flaunted. In one scene McCoy's mistress wears a bright blue couture jacket with "shoulder pads . . . out to

93 (*previous page*) Zandra Rhodes "Elizabethan" evening dress in gold lamé and matching jacket with ornament of ruffles, spirals, and "sunburst" knife pleats, 1981. The Museum at F.I.T., New York, Gift of Mr. Bouke De Vries, 91.158.1. Photograph by Irving Solero.

94 (*facing page*) Carolina Herrera silk gazar evening dress with voluminous puffed sleeves, Fall 1981. The Museum at F.I.T., New York, Gift of Carolina Herrera, Ltd. Photograph by Irving Solero.

here." In another scene his wife wears a bare-shouldered dinner dress with "short puffed sleeves the size of Chinese lampshades" and a puffed skirt "that reminded Sherman of an aerial balloon." When they get to the party, the hostess, too, wears a "ferociously puffed" dress. One of the other guests ("a tasty morsel!") is wearing a "black sheath that ended several inches above her knees and hugged her luscious thighs and the lubricious declivity of her lower abdomen and rose up to a ruff at the top that resembled flower petals." As Wolfe noted, "This season no puffs, flounces, pleats, ruffles, bibs, bows, battings, scallops, laces, darts, or shirrs on the bias were too extreme."

None of this was entirely new, of course. The 1960s had also enjoyed a powerful bull market (known as the "topless market") and socialites had worn wildly extravagant clothes. In the 1980s *Women's Wear Daily* chronicled the parties and party dresses of "Nouvelle Society" as much as trends within the fashion business itself, but in the 1960s, too, the contours of "fashionable society" had rapidly expanded to include a number of improbable interlopers. (Indeed, Wolfe himself had written some amusing pages on that phenomenon.) But the 1960s were also characterized by an emphasis on youth, "idealism," and "liberation" – whereas the tone of the 1980s seemed crassly focused on money and power.

The worldwide popularity of television programs like *Dallas* (which was first shown in 1980 and soon attracted millions of viewers) lends support to this interpretation. Moreover, *Dallas* was not an anomaly, but rather spearheaded the introduction of similar programs, such as *Dynasty* and *Lifestyles of the Rich and Famous*. (One must stress, however, that the kind of extravagant clothes that were featured on *Dallas* and *Dynasty* were not really typical of high fashion; rather, they were what the masses imagined rich people to wear.) Nor did cocktail dresses à la Lacroix form more than a minor part of the rich ladies' style, and one restricted primarily to a brief moment from about 1985 to 1988.

Nevertheless, the rich look was significant. Even in the world of toys, there was a distinct trend towards conspicuous consumption. The Barbie doll, for example, acquired "designer" jeans in 1982 and in 1985 designer evening gowns, allegedly created by Oscar de la Renta. She already had a fur and jewelry safe. During the eighties popular interest in fashion designers reached a new high; there was a true fascination on the part of the public with "genius" creators, especially those like Lacroix and Lagerfeld who played the part so well.

Writing in the *New Yorker* in 1988, Holly Brubach noted that the days were past when fashion began with the kids on the street and designers rushed to copy it. "Now we are in the throes of what *Le Nouvel Obs[ervateur]* calls 'la vogue aristo,' and the couture, having regained its stature, is once again in full swing." A Chanel suit made to order cost eleven to sixteen thousand dollars, reported Brubach, and it cost "up to three thousand dollars for

95 The stars of *Dynasty*, ABC Television Network's popular 1980s nighttime serial. Photograph: Archive Photos.

a Chanel suit off the rack." While remaining loyal to Chanel's style, Brubach was ambivalent about Karl Lagerfeld's version of it. And, indeed, at the heart of the Chanel/Lagerfeld phenomenon, there was a certain tension.

The House of Chanel had been in the doldrums since the death of Mademoiselle Chanel in 1971. Then, in 1982, Karl Lagerfeld was invited to design for Chanel. He had already become internationally respected in the 1970s for his work for Chloé and Fendi; now he became, perhaps, the world's most famous designer. Lagerfeld's mission at Chanel was to transmute the basic elements of the Chanel style and make them contemporary. At first he was in charge only of Chanel couture (with his protégé Hervé Leger in charge of ready to wear), but soon Lagerfeld assumed total control. Journalist Javier Arroyello credited Lagerfeld with being

the man who broke the spell of the Chanel mummy. He likes to picture himself as an emergency doctor who . . . rejuvenated the famous Chanel suit, the exhausted uniform of the *grandes bourgeoises*, through repeated shock treatments (he brought leather and even denim to the kingdom of gold-trimmed tweed) and intensive corrective surgery (wider shoulders, roomier jackets, a sharper silhouette that included even pants).

At the beginning, no one could have guessed how violently he would "deconstruct" Chanel. In place of the classic boxy tweed jacket, he introduced jackets made of terrycloth, denim and stretch fabric. In place of sensible knee-length skirts, he offered hemlines that either grazed the ankles or exposed most of the thighs. "When luxury goods become an institution, then they are boring," said Lagerfeld. So he enlarged and exaggerated the classic Chanel accessories, making pearls the size of golf balls and gold chains as heavy as those worn by rap stars.

There were occasional complaints that Lagerfeld had "vulgarized" the Chanel look, but sales increased dramatically, and Chanel boutiques sprang up like mushrooms after the rain everywhere from Oklahoma to Tokyo. The average age of the Chanel customer dropped from the mid-fifties to the late thirties. "All the stuff pre-Karl was so-o-o square," said Caroline Kellett, a young English fashion editor. "Putting it on, I just felt a frump." There was no danger of that wearing Lagerfeld's version of Chanel.

Innovative and iconoclastic, Lagerfeld wore the Chanel mantle lightly. Not French himself, he never had a feeling of reverence for the legendary Chanel. "Coco became too refined, too distinguished at the end of her time," said Lagerfeld. "When she lectured on elegance, she was *so* boring. It was more fun when she was young and cruised around being a kept woman." Lagerfeld's mandate, of course, was to renew the Chanel look, but while he admitted that "Chanel has to stay Chanel in a way," he also stressed that there was room to expand beyond "those knit suits."

For Lagerfeld, fashion was about change, whereas Chanel explicitly rejected

96 (*following page*) Karl Lagerfeld for Chanel "Homage to Coco Chanel" evening dress in black silk crepe with trompe-l'oeil "jewelry" beadwork by Lesage, 1983. The Museum at F.I.T., New York, Gift from The Estate of Tina Chow, 91.255.9. Photograph by Irving Solero.

fashion in favor of style, and the term most often used to describe the Chanel style is "classic." Chanel took herself very seriously, and she would not have been amused to see Lagerfeld accessorize "her" clothes with hats shaped like armchairs or strawberry tarts. This whimsical approach is really much more akin to the spirit of Chanel's great rival Elsa Schiaparelli, who designed hats shaped like shoes and buttons like asprin. As a quintessentially modern, even, one might say, a postmodern designer, Lagerfeld insisted that "Nothing should look serious . . . everything should have a light touch."

Lagerfeld always used the Chanel signature – so cleverly that the result was neither a copy nor a parody, but a witty tribute to Chanel. Thus, his version of Chanel's "little black dress" had a wealth of *trompe l'oeil* jewelry embroidered on it. He sometimes threw caution to the winds: "Atys," a red satin evening dress heavily embroidered with gold was the most extravagantly beautiful dress of 1987, and seemed to tease the ghost of Chanel, who once said, "Scheherazade is easy, a little black dress is difficult."

"Karl Lagerfeld is the designer today with the most influence, the only designer who could bring Chanel to such a peak," said *Women's Wear Daily* publisher John Fairchild. Certainly, Chanel was the jewel in the crown of Lagerfeld's fashion empire, but the self-proclaimed "fashion nymphomaniac" always had a multiplicity of other interests. Asked once by André-Leon Talley if he saw himself as the new Mademoiselle Coco Chanel, Lagerfeld protested, "No, no, no. I am Miss Chloé, Miss Fendi, Miss Etcetera, etcetera."

Throughout the 1970s Lagerfeld had been a powerful influence on fashion. Fashion editor Marylou Luther hailed Lagerfeld in the *Los Angeles Times* (November 3, 1974) as "the new idea man of the seventies," who "walked right by" the better known Yves Saint Laurent to become "the king of design leadership." Lagerfeld's soft, diaphanous "shepherdess dresses" of spring 1975, his fall 1977 collection (described as a "swashbuckling salute to prerevolutionary France"), and his poetic 1978 collection were especially admired. In 1984 he also opened his own fashion business. Throughout it all, the fashion press slavishly followed the man known as "Kaiser Karl," who was feared for his razor-sharp wit (often at the expense of other designers) and admired for his ability to stay at the cutting edge of fashion year after year.

The rich look formed only one part of eighties fashion, albeit an important one. Equally significant was the issue of humor,

which was a factor in the success of designers as different as Lagerfeld, Lacroix, and Jean-Paul Gaultier. (Lagerfeld once told *Vogue*, "If you don't have humor, you don't have much.") Another key element was fashion's emphasis on the body. Indeed, from the beginning of the 1980s body-consciousness was at the heart of contemporary fashion.

The 1980s were characterized by a pronounced emphasis on physical fitness, which had a significant impact on the culture of fashion. When Florence Müller and her colleagues at the Musée des Arts de la Mode created the catalogue and exhibition *Nos Années 80*, they focused first on "the body," showing fashions by designers like Jean-Paul Gaultier, Thierry Mugler, Issey Miyake, and Azzedine Alaia. In terms of high fashion, Alaia was, indeed, the most important designer of the early 1980s. As the catalogue puts it,

> For the first time in the history of western fashion (with the exception of the epoch of the Directory), woman's body, which fashion had always sought to modify by dissimulating or deforming it, played an interactive role in the form of clothing. This fashion which shocked at the beginning of the eighties is now completely accepted.

As Müller points out, this development was, in its way, as radical as the rise of the mini-skirt. In the 1980s it ceased to be necessary for women to wear a skirt or trousers at all; they could simply pull on leggings and a leotard, or lycra bicycle shorts and a sort of brassiere. It was, however, incumbent upon them to *internalize* the corrective aspects of fashion, and to mold their bodies into a fashionably muscular shape. The 1980s saw a craze for athletics (especially aerobics, jogging, and body-building), which was contemporaneous with the trend towards more body-conscious clothing.

By 1984 even the Barbie doll was dressed for aerobics in spandex leotards: "Hot new trend in fashion – aerobics," noted the Mattel toy catalogue in 1984, the year when "Great Shape Barbie" was launched. As the advertising copy put it, Barbie looked "trim 'n terrific" in her "trendy looking" athletic clothes. "Working out is the sensation of the 80's," reported the 1985 catalogue, "and guess who's working out in her very own Workout Center?"

Many designers, both in Europe and America, catered to the aerobics-sculpted bodies of fashion trendsetters, but the most important "cult" designer in this respect was Azzedine Alaia. "Probably the most copied and influential designer of the early eighties, Alaia defined an era of sensational, skin-tight shape with a genius for cut and seamed-in sex appeal," declared *Women's Wear Daily* in a notorious article of 1986 that announced his rise "and fall."

Azzedine Alaia's body-worshipping designs used spiral seams, curves, and darts to create an ultrafeminine silhouette. Stretch fabrics and accessories like belts and corsets also served to emphasize womanly curves. Named best designer of the year in 1985 by the French Ministry of Culture, the Tunisian-born designer had already been dressing private clients in Paris for two

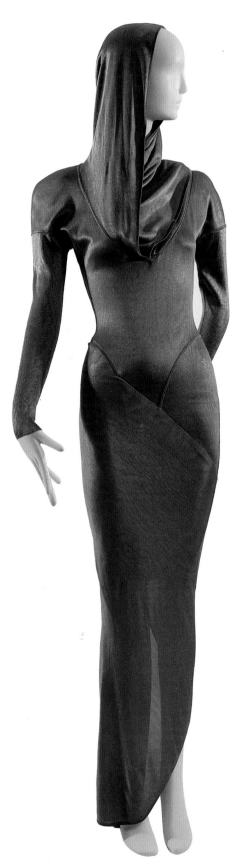

decades. Before that he had dressed "the smart set of Tunis, new money." As Alaia told Talley, "The women were slaves to Paris fashion."

Alaia himself became a cult hero by redefining body-dressing. He started his ready-to-wear business in 1981. (A previous attempt to design leather clothes for Charles Jourdain had been unsuccessful: "When they saw the collection, they screamed," Alaia told the painter Julien Schnabel, "They told me it was S&M.") But Alaia was already a favorite with the French press, especially at *Elle*, where many editors had long been wearing his custom-made clothes. In 1982 he was picked up and proclaimed an overnight success by international fashion journalists.

In a 1985 interview with Joan Juliet Buck, Alaia explained his philosophy:

> A woman is like an actress, she's always on stage. She has to look great to feel good. If she's going to wear clothes by a designer instead of just wearing her man's sweater and a pair of trousers – that's all anyone needs – then the clothes should make something happen . . . The dress has to be part of her, she has to feel it on her body.

Buck then commented that "His clothes have in common with the corset and tight jeans the fact that they provide as much pleasure for the wearer as for the onlooker." They "hold you tight and show you off." According to Alaia, "The moment when a woman can show her body is so short; they have to make the most of it. A young woman with bare shoulders, a low-cut top, that's a gift of nature."

Alaia-clad women resembled "highly sexualized versions of Darth Vader," wrote Buck – like dominatrixes from outer space. His tight skirts "cupped the buttocks in no uncertain manner." Indeed, for many people his derrière-enhancing tight cut was almost too provocative. According to journalist G. Y. Dryansky, "To criticize or praise Azzedine Alaia for the tightness of his skirts is to miss his real importance. Alaia is today's fascinating update on snobbery." In other words, to remove "the stigma of bourgeois dress," one need only squeeze into a little something by Alaia. She quoted Alaia saying, "A definition of taste escapes me. Today, everything can be bizarre and everything can be beautiful . . . For me there is no vulgarity, and the street is never in bad taste."

"I don't know what sexy is," continued Alaia, "but I'm interested in femininity." He said that he loved women's bodies, also that he liked "dressed-up women at all times." At the museum at the Fashion Institute of Technology, there is a dress with a circular seam running from the collar to below the waist. In soft sea-green, it resembles the skin of a mermaid, from the hood that covers the woman's head to the train that trails after her. There is also a suit that Alaia designed; it consists of a short skirt with a zipper in the back – going from the hem up – and a jacket that swells and curves; even without a body inside it radiates femininity.

97 (*previous page*) and 98 (*facing page*) Azzedine Alaia "Mermaid" evening dress in green acetate knit with hood, spiral zipper set in curved seam and fishtail hem, Winter 1986. The Museum at F.I.T., New York, Gift of Azzedine Alaia, 87.3.2A. Photograph by Irving Solero.

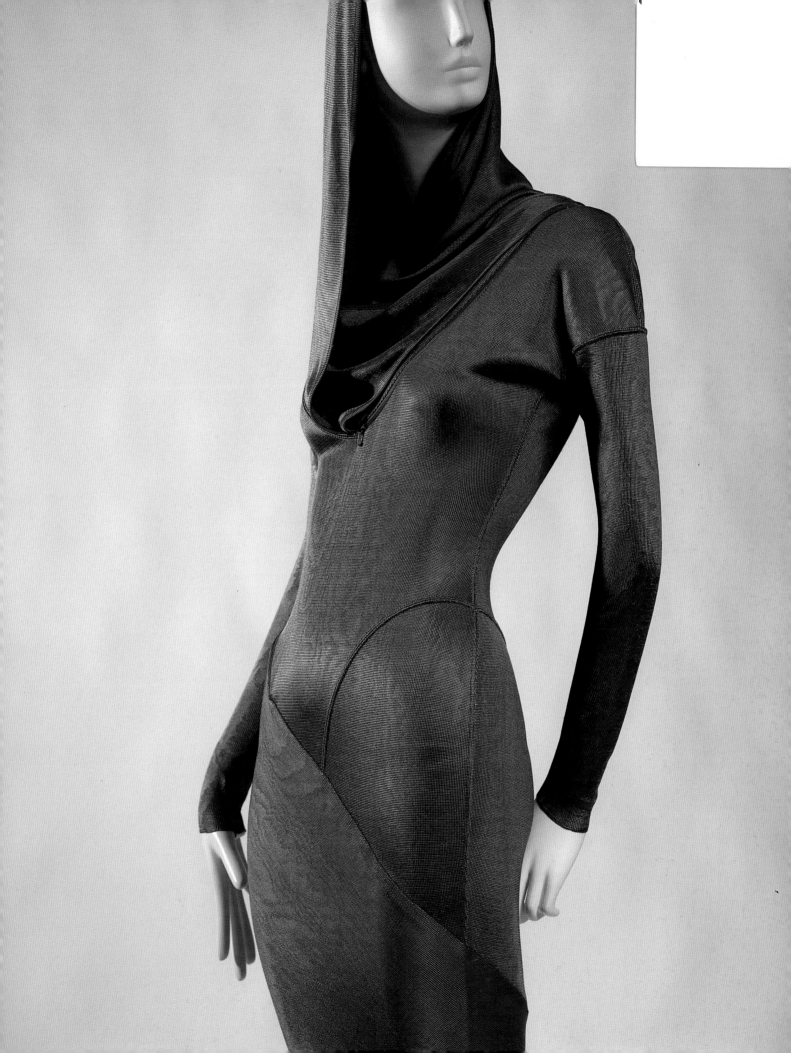

We know even before he said it, that the creators he most admired were Madeleine Vionnet and Charles James, yet Alaia's women were much more aggressively female. He was slow to design trousers, for example, and when he did he made intricately seamed ski trousers. As Edmund White put it in 1988,

> The strong, abstract seams were the secret of the perfect Alaia fit, those pathways laid down on the bias across the body, lines as magical as the tailor's dummy stitching in the metaphysical paintings of de Chirico or the mysterious flowcharts of the acupuncturist – lines that lovingly cup breasts, whittle the waist, lift legs, mold legs.

Looking back at the eighties, Alaia seems even more important than he did at the time. As veteran fashion journalist Georgina Howell put it in January 1990 in an article assessing what eighties style meant for women, "The past decade saw fashion expand by clinging tightly to well-toned bodies." In more recent collections, Alaia achieved the same clinging, flattering effects with synthetic fabrics that stretch.

Research into materials and techniques was a key feature of eighties' style. Lycra and other stretch fabrics revolutionized fashion. Utilized first in clothing for active sports, these materials were rapidly incorporated into high fashion. Natural and "noble" materials (like silk, linen, and wool) were also fashionable, and so were new hybrids such as stretch velvet. The imperative to work out applied to men as well as women, although men tended to prefer jogging to aerobics, and it took longer for them to accept stretch fabrics.

Müller has argued that whereas in the seventies the androgynous image of woman was at its apogee, the eighties witnessed the triumphant return of femininity; but this is too simple. Azzedine Alaia and Barbie to the contrary, the female form divine was not the only body in fashion.

"The 'androgynous' look is everywhere," reported American *Vogue* (August 1984). In fact, the look was not so much androgynous as it was masculine. This was not immediately apparent, however, since many people interpreted the new ideal body as "natural." "Broad shoulders and a lean body reflect an attitude of today," argued dress designer Norma Kamali (who commissioned a song called "Shoulder Pads" to play on her fashion video).

In a brilliant essay on "The New Androgeny," the art historian Anne Hollander pointed out that the new ideal (for men and women alike) was characterized by broad shoulders, muscular arms, narrow hips, hard buttocks, and a flat stomach. Curvacious hips and full thighs were not fashionable for either sex. The ideal body (for both sexes) was not only thin and young, but also increasingly muscular. As one American advertisement for exercise equipment put it, "A hard man is good to find." Furthermore, both men and women overwhelmingly preferred to wear essentially masculine clothes.

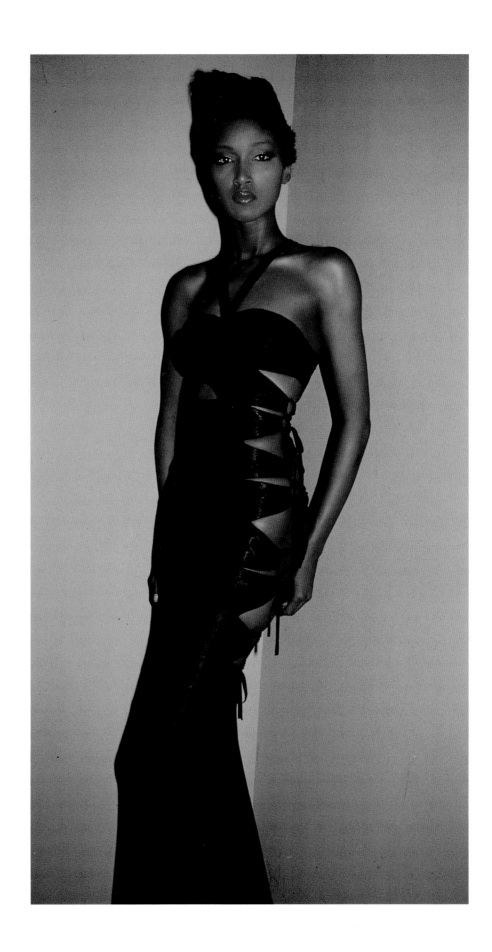

99 Dress by Azzedine Alaia, 1985.
Photograph © Roxanne Lowit.

When contemporaries spoke of "the energetic eighties," they focused on body consciousness, as exemplified by second-skin fashions, like jeans. In 1980 Calvin Klein launched his line of blue jeans with six television commercials directed by Richard Avedon and featuring Brooke Shields, a fifteen-year-old model and actress, who had played a child prostitute in the 1978 Louis Malle film *Pretty Baby*. The most notorious of these commercials had Shields asking, "Want to know what comes between me and my Calvins? Nothing." After television censors objected to the nymphet's suggestive poses and risqué lines, several stations cancelled the commercials. Klein himself appeared on a television talk show and boasted about how sexy his jeans were: "The tighter they are, the better they sell."

Fashion jeans had, of course, already appeared in the late 1970s, and consumers had indicated a willingness to pay double or triple the price of ordinary jeans for more highly stylized designer versions. Calvin Klein made such an impact on this market that in 1990 *Women's Wear Daily* described him as "the man who virtually invented designer jeans." Within a few years the very word "Calvins" was used in his commercials as a synonym for sex organs: "All she has to do is wiggle her Calvins to make my Calvins crazy."

More profoundly revolutionary than the Brooke Shields commercials, however, were Bruce Weber's advertising photographs of sexy men clad only in Calvin Klein underwear. Erotic images of women in lingerie were nothing new, but a lingering puritanism and homophobia had militated against the portrayal of men as sex objects. In 1982 Weber created the most famous erotic photographs of men ever used in mainstream advertising. Weber treated his models like magnificent physical specimens. Illuminated by a clear bright light, the models were often shot from below, enhancing their god-like aura. Soon gigantic billboards towered over the modern cityscape, showing naked muscular male torsos above pure white underpants that bulged provocatively.

In 1983 Klein launched man-style cotton underwear for women. *Time* magazine reported nervously on "Calvin's New Gender Benders," but *Women's Wear Daily* called it "the hottest look in women's lingerie since the bikini brief." The boxer shorts had a "controversial" fly opening. "It's sexier with the fly," Klein said. "These things are carefully thought out." Group sex was an implied theme in some of Klein's underwear advertisements, which showed two men and a woman lounging together, clad only in their genital-hugging underwear. When Klein launched his perfume Obsession in 1985 the body beautiful was stripped of clothes altogether and bathed in a blue-movie ambiance. "In Calvin's world, polymorphic perversity is par for the course," noted fashion journalist Michael Gross. "Quaint morality is banished." Or, perhaps, sex had simply been recast as a contact sport. Sports had certainly been redefined as sexy.

One of the most perfect expression of high-tech body dressing was Issey Miyake's molded red plastic bustier, shaped like a real female torso, complete

100 Issey Miyake molded plastic bustier, 1983. The Museum at F.I.T., New York, Gift of Krizia Co., 87.12.1. Photograph by Irving Solero.

with bellybutton and nipples. Miyake was the first of the new wave of Japanese designers that swept Paris (along with Kenzo and Kansai). One of fashion's greatest artists, Miyake designed his own textiles and let fabric determine form. He pioneered novel treatments of both natural and artificial fibers and dyes, creating amazing pleats and abstract shapes.

"Miyake is a genius," said Giorgio Armani, and Parisian curator Yvonne Deslandes called Miyake "the greatest creator of clothing of our time." The designer himself has said that "Without the wearer's ingenuity, my clothing isn't clothing. These are clothes where room is left for wearers to make things their own." Rather than working within the western tradition of tailored clothes, Miyake began with the abstract shape of the kimono, which leaves a space between body and cloth. Although the kimono developed centuries ago, there is nothing retro or "costume-y" about Miyake's designs.

The next wave of avant-garde Japanese designers appeared in Paris in the early 1980s. The most important were Rei Kawakubo of Comme des Garçons

and Yohji Yamamoto. Suzy Menkes, fashion reporter for the London *Times*, described the sensational effect of Kawakubo's spring/summer 1983 collection for Commes des Garçons: "Down the catwalk, marching to a rhythmic beat like a race of warrior women, came models wearing ink-black coat dresses, cut big, square, away from the body with no line, form, or recognizable silhouette." While admitting that she was "intellectually with the Japanese in their search for clothing that owes nothing to outworn concepts of femininity," Menkes nevertheless felt that the French "can have my body to dress."

Other fashion journalists were shocked and appalled at the loose, black, irregular garments presented by the Japanese. In their articles they used the language of mourning, poverty, and atomic warfare, arguing that the clothes made women look like "nuclear bag-ladies." As one writer put it, "The dread and hopelessness that pervade so many of the recent clothes by Japanese designers, notably Rei Kawakubo, are nowhere to be found in Saint Laurent's collections . . . The woman who wears Comme des Garçons is . . . unwilling to dress herself up so that other people have something pleasing to look at."

When American *Vogue* featured Kawakubo's clothes in 1983, an outraged reader demanded to know why anyone would want to pay $230 for "a torn . . . shroud." Joan Kaner, then vice-president and fashion director at Bergdorf Goodman said that "Rei's clothes are interesting to look at, difficult to wear. How much do people want to look tattered?" Yet Kawakubo's infamous "ripped" sweater, which she called a "lace sweater," was not ripped at all. The seemingly random pattern of holes was the result of careful thought and technology. According to Kawakubo, "The machines that make fabric are more and more making uniform, flawless textures. I like it when something is *off*, not perfect. Handweaving is the best way to achieve this. Since this isn't always possible, we loosen a screw of the machines here and there so they can't do exactly what they're supposed to do." Her sweater is today in the fashion collection of the Victoria and Albert Museum, where it is recognized as an important development in late twentieth-century design.

Irregularity, asymmetry and imperfection were important elements in traditional Japanese aesthetic philosophy. As Harold Koda has observed, the aesthetic and conceptual meaning of the "rips" in Kawakubo's sweater differs significantly from the political and satiric meaning of the ripped and oversized "poor look" that simultaneously emerged as an element of London street style, which Vivienne Westwood made famous. Japanese designers like Kawakubo and Yohji Yamamoto were drawing on an entirely different tradition when they experimented with cutting asymmetrically so that, say, one side of a jacket would be longer or wider than the other.

The new Japanese clothes also tended to be oversized and loose; to a hostile viewer, big and bulky. "They do nothing for the figure," complained Kaner, "and for all the money going into health and fitness, why look like

101 Rei Kawakubo for Comme des Garçons "slashed" robe in black sweatshirt knit, 1983–4. The Museum at F.I.T., New York, Gift of Charles Rosenberg, 92.13.3. Rei Kawakubo for Comme des Garçons "Slash and tie" oversize top and calf-length, asymmetrical skirt, Fall 1983. The Museum at F.I.T., New York, Gift of Jean Rosenberg, 88.157.3. Photograph by Irving Solero.

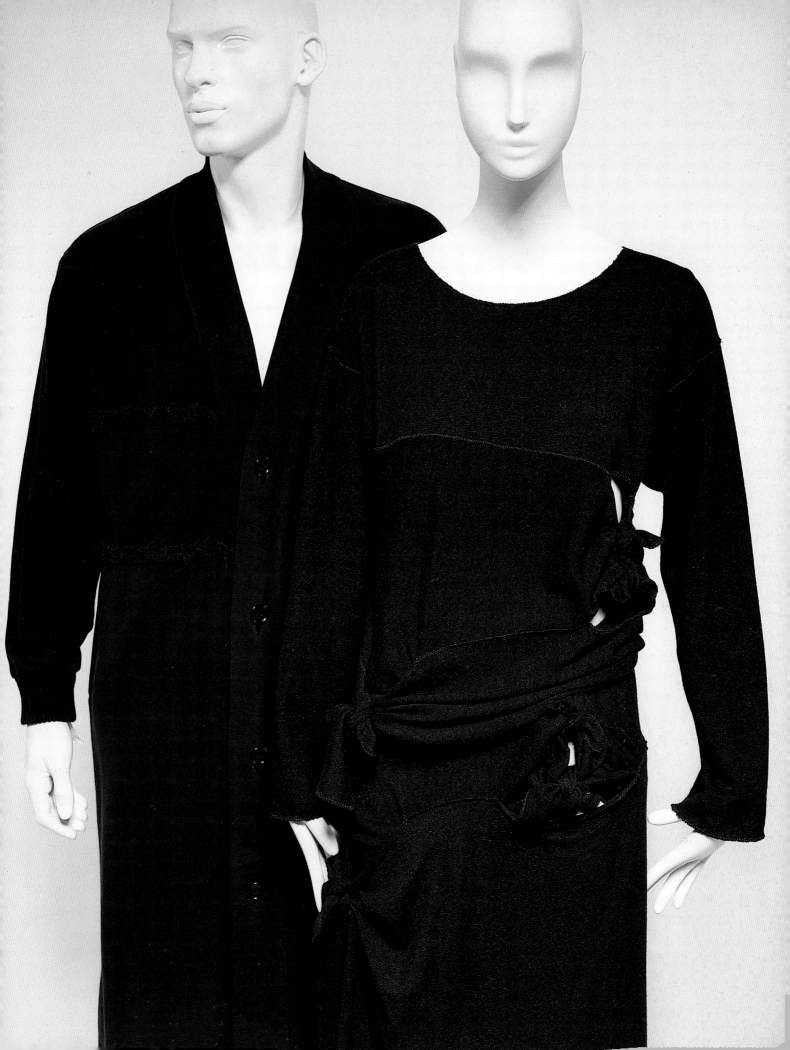

a shopping bag lady?" For several years the Japanese conception of the relationship between body and clothes puzzled and annoyed many westerners; French designer Sonia Rykiel speculated that the Japanese must be "afraid of the body." In fact, they had a very different conception of sexiness. As Kawakubo told *Vogue*, "I do not find clothes that reveal the body attractive."

Kawakubo's clothes are "probably somewhat difficult to relate to immediately" (one of her press releases admitted), but by the end of the decade many people would have agreed with *Vogue's* Charlotte DuCann, that avant-garde Japanese fashion was "the supreme modern style, the style that yanked fashion from its seventies nostalgia right into the monochrome eighties . . . No other country has singlehandedly caused quite so much outrage and adulation in such a short time as Japan." Within half a decade the Japanese had succeeded in radically revising contemporary perceptions of fit and proportion, and in inaugurating the reign of black.

Black became the quintessential "anti-fashion" color in the 1980s; Kawakubo, especially, was said to work in a dozen shades of black, but black was soon adopted by other designers around the world for a variety of reasons. Crucially important was the association of black clothing with an artistic and intellectual persona. Earlier ideas about bohemian black and rebellious black were particularly influential, and looked back to 1950s beatniks and bikers. Black was once again "hip" and "cool."

"It's a very peculiar sensitivity that artists seem to have about black," declared *Rags* as early as 1970. "Black just doesn't pick up vibes and doesn't send out any; it's very protective." Within a few years, purple tie-dyed velvets would be traded in for studded black leather. The popularity of black in the 1980s was overdetermined. The Japanese made the color avant garde again. They, in turn, were followed by young European designers like the Belgian Anne Demeulemeister, whose use of black evoked the "decadent" poets of the nineteenth century. (In 1990 she was quoted as saying that she could not imagine a poet in any color other than black.)

New "style tribes" like the "goths" and the "pervs" also favored black, because it evoked night, danger, death, sin, and sexual perversity. More mainstream designers updated Chanel's concept of the chic "little black dress." Nor should we ignore more banal concerns, such as the idea that black was "practical" and "slimming." Black was not, of course, the only fashion color in the 1980s. In a decade so openly devoted to financial success, many people chose to wear business attire in neutral colors, such as beige and taupe. The use of subtle and sophisticated "androgenous" neutrals was pioneered by Giorgio Armani.

When Armani was featured on the cover of *Time* magazine (April 1982), the article began with a quote from Pierre Bergé, the business partner of Yves Saint Laurent. Asked about Italian fashion, Bergé insisted that except

102 Menswear-influenced styles by Giorgio Armani, 1984. Photograph © Roxanne Lowit.

for "pasta and opera, the Italians can't be credited with anything!" Bergé demanded, "Give me one piece of clothing, one fashion statement that Armani has made that truly influenced the world." It was a rash challenge to make to an American journalist, and Jay Cocks impudently replied, "Alors, Pierre. The unstructured jacket. An easeful elegance . . . Tailoring of a kind thought possible only when done by hand . . . A new sort of freedom in clothes."

Already by the mid-1970s Armani had begun to soften men's clothes. Armani said that he wanted his clothes "to draw more attention to the body," yet he rejected the stiffly tailored business suits that traditionally symbolized masculine rectitude, introducing instead "deconstructed" jackets, without padding and stiff interlinings. The shoulders dropped and broadened, the lapels and buttons crept downward. Armani used softer, more easily draped "luxury" fabrics (such as cashmere and silk-and-wool blends), which have a greater tactile appeal than the tightly woven wools more typical of men's suits.

Thus, one might argue that Armani eschewed "phallic" hardness in favor of satisfying what Freud called "the libido for touching." In the same way he expanded the repertoire of colors available to men; in addition to traditionally masculine colors like navy blue and steel gray, he added softer warmer shades.

No sooner had Armani "feminized" (or eroticized) menswear than he turned around and interpreted his menswear look for the female consumer. Beginning with his first womenswear show in 1975, and really getting under way in 1979, when he showed his draped tailored jackets, Armani dressed women in fashions directly inspired by menswear classics – *his* menswear classics. In the 1980s his fame spread even further. Armani was the "man of the moment," declared *Vogue*.

Much of Armani's popularity (and the appeal of the Italian look in general) derived from the way it "came to bridge the gap between the anti-Establishment 60's and the money-gathering 80's" (as Woody Hochswender put it). If the tailored suit had long signified business-like respectability, now it also projected an image combining sensuality and physical power – for men and women alike. An Armani suit symbolized easy self-assurance and understated elegance.

The Italian look also represented sex, and not only because Italians themselves have the reputation of being sexy. The new Italian fashions of the late 1970s and 1980s were sensual in a very particular way. "Armani disarmed men and their clothes erotically without unmanning them," wrote journalist Judith Thurman. "He freed them to be looked at and desired by women (and other men)." Not long before this would have been widely regarded as a hostile remark, but as gender stereotypes became less rigid men were increasingly willing to present themselves as sex objects. No doubt tailoring his

remarks to what he thought people wanted to hear, Armani told a reporter for *Gentlemen's Quarterly* that his style was "a study in making men look sexier."

The film *American Gigolo* certainly emphasized the erotic appeal of Armani's clothes. In one scene, the gigolo's lady client buys him Armani (less vulgar than paying cash?), and according to Thurman, "His shopping trips provided the film's true sexual excitement." According to the publicity releases for *American Gigolo*, no fewer than thirty Armani suits were featured in the film. In another scene, we see the gigolo going through his closet, which is apparently entirely Armani, and then lovingly laying a selection of clothes on the bed.

According to Giovanna Grignaffina's essay "A Question of Performance," people already had an image of Armani, so within the context of the movie the clothes functioned as a sign "of versimilitude." Not only were Armani's clothes immediately recognizable to the movie audience, but they were "also perceived as being in the realm of values." That is, people knew what Armani clothes signified: casual, expensive, sexy elegance. No wonder Jack Nicolson, Dustin Hoffman, John Travolta, and Richard Gere were all so eager to tell journalists about their own Armani clothes.

When Calvin Klein graduated from the Fashion Institute of Technology in 1962, American designers were mostly producing knock-offs of European fashions. This began to change in the 1970s, as women increasingly entered the workforce and began demanding clothes comparable to menswear classics. Klein exploited the potential of both the women's liberation movement and the sexual revolution to become one of the leading exponents of the new American look.

Denouncing "gimmicky, overdesigned clothes," and extolling "simple clothes" that looked and felt "easy" and "free," Klein combined basic shapes like the tank top and the sports jacket with what his company called "couture fabrics." He favored fine wools like cashmere, cavalry twill, camel hair, and crepe gabardine, as well as leather, suede, cotton, linen, and silk. Preferred hues were pale neutrals, such as alabaster, bone, parchment, ivory, cream, blond, bisque, buff, stone, pale taupe, dove gray, platinum, pewter, wheat, khaki, and caramel, along with a few darker neutrals like olive, navy, and black.

It was a monochromatic and minimal look, but it also had a discreet erotic edge. "I like clothes that slide when the body moves," Klein said. The effect was "sexy in a refined way, not trashy" and with the "quiet look of luxury." Although he is often accused of copying Armani, Klein had developed his own style by 1973 (before Armani began designing for women). Like Halston, who was a friend and inspiration, Klein created an interchangeable wardrobe of trousers, skirts, and jackets, which were intended to form a modern capsule wardrobe.

Although the pantsuit of the 1970s tended to disappear in the 1980s, the injunction to "dress for success" had not been forgotten. Many working women adopted a uniform that combined a broad-shouldered jacket and a very short skirt. What was signified by this style? In his book, *Fashion, Culture, and Identity*, the sociologist Fred Davis described "the rather masculine, almost military styles that were fashionable among some women in the mid-1980s: exaggerated shoulder widths tapering conelike to hems slightly above the knee." He admitted that it is "difficult even now to infer quite what this look meant to the broad mass of fashion consumers."

The dominant interpretation has associated padded shoulders with "masculine authority," but people perceived the look in various ways. When the style first appeared (for example in the designs of Thierry Mugler), the fashion cognoscenti saw it as "a kind of gender-inverted parody of military bearing." This was hard for most women to understand or appreciate. Socialites fretted that it was too severe and unfeminine, and housewives saw it as ugly and irrelevant. If factory workers were even aware of the style, "it may have been devoid of meaning for them altogether, although nonmeaning in something that for others is pregnant with meaning is itself a kind of meaning in absentia."

Many career women liked the style, however, "because it seemed to distance them from unwelcome stereotypical inferences of feminine powerlessness and subservience." Consider the terms used to describe fashion's new line: "Man-style tailoring for women," "the menswear look," "great jackets" with "stronger," "bigger," "square", "strongly defined" shoulders. The jacket reigned as "the ubiquitous fashion piece." Many designers featured shoulder pads of gargantuan proportions, and in 1990 (shortly after the style had become demodé) a cartoon in the *New Yorker* depicted a middle-class husband saying to his wife, "You're home now, Adele. Why don't you take off your shoulders?"

"Power" was one of the key words of the decade, epitomized in expressions like "power dressing." In the 1980s executives of both sexes wore "power suits" with broad shoulders, while men also wore "power ties" of expensive silk in "power colors," such as red and yellow. So ubiquitous was the theme that in 1986 American *Vogue* even reported a new fashion phenomenon, "fear of power dressing." For although women had supposedly been "liberated" from the "deliberately de-sexing pinstriped" dress-for-success uniform, they still worried about undermining their "credibility" if they wore the wrong clothes.

Even children's toys were redesigned to accommodate contemporary ideas about women's role. In 1985, the Barbie doll (who had once inhabited a suburban "dream house") acquired a new home. As the Mattel catalogue put it, "Beautiful office on one side. Glamorous bedroom on the other." The new "Day-to-Night Barbie" dressed for success in a double-breasted hot pink

business suit with a matching pink briefcase containing a toy credit card; "Girls can pretend she's a lawyer, fashion editor or head of a modeling agency." "After five, girls can remove her jacket, reverse her skirt, change her shoes, and she's ready for a night on the town." Many real women did essentially the same thing, dressing for power during the day and glamour at night.

The English fashion journalist Georgina Howell has described the decade as "the aggressive eighties." Certainly in the world of avant-garde fashion, designers like Thierry Mugler showed hard, constructed silhouettes with padded shoulders, cinched waists and high heels – a kind of "butch glamour." An analysis of fashion photography also reveals that there was a proliferation of images depicting muscular "supermodels" using dominant or aggressive body language (especially towards male models). Later on, these models would be referred to as the "Glamazons." These pictures were presumably intended to be "read" as indicative of the modern woman's will to power, but they often came close to pornographic fantasies of woman as dominatrix.

"Sex sells music and it sells clothes," observed the American designer Marc Jacobs. People like to "dress up and look . . . like a star." In 1985 the Council of Fashion Designers of America gave a special award to MTV (music television) for its influence on fashion. "Every era has had its stars whose dress or look has been copied by fans," said Jean-Paul Gaultier. "Now the pop stars have an enormous influence." Gaultier, of course, famously collaborated with the pop star Madonna in breaking fashion taboos.

Inspired by rock and royalty, pirates, witches, and "savages," Vivienne Westwood also constantly pushed back the boundaries of acceptable dress. After the heyday of punk, Westwood changed direction and launched what became known as the "New Romanticism" (1978–82). Historical revivalism was a major street style in London, and Adam Ant's music video *Stand and Deliver* made a hero of the eighteenth-century highwayman, leading Westwood to create her famous "Pirate" collection of 1981. Pillaging world history for cults and images that she felt had "power," Westwood next created "Savages", a collection of oversized garments and exposed seams, to be followed a few years later by "Witches". The "Buffalo" collection (1983) showed urban cowgirls wearing satin brassieres over their rough dresses, helping to launch the trend for underwear as outerwear.

In 1985 she launched the "mini-crini," a short bell-shaped skirt supported by collapsable hoops. It was attacked as unwearable and absurd, but within two years it had spawned legions of puffball and bubble skirts, of which the most famous was Lacroix's pouf skirt. Perhaps the most important of Westwood's innovations, however, was her revival of the corset. Yet for all Westwood's influence on fashion's avant-garde, her own business remained small.

Jean-Paul Gaultier was the dominant force in advanced fashion circles during the eighties. His clothes consistently made headlines, although skep-

103 Fashion from the Pirates collection by Vivienne Westwood.

104 Corset by Vivienne Westwood from the Harris Tweed collection, 1987. Photograph courtesy of Vivienne Westwood.

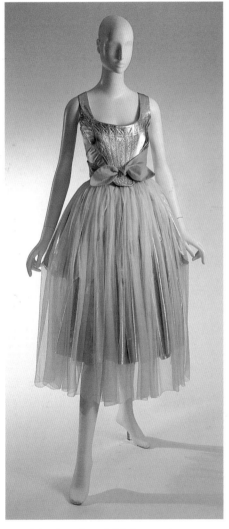

105 (*above*) and 106 (*facing page*) Vivienne Westwood dress with silver leather bustier and long full skirt in sheer white over silver metallic, 1988. The Museum at F.I.T., New York, Museum Purchase, P89.60.1. Photograph by Irving Solero.

tics questioned the validity of his most notorious designs, like skirts for men and conical bras for women. *L'Enfant terrible de la mode française* was born in 1952; after working for Cardin and Patou, he launched his first collection in 1976; he really began to take off, though, in 1979/80 with his "James Bond" collection, a wild mixture of retro and ethnic influences. "Paris Gaultier", his existentialist collection of 1982/3, drew on images of Juliette Greco and the zazous. This was followed by the "Dadaism" collection, which included his first corset-dresses.

For Gaultier, seduction and subversion went hand-in-hand. "A woman, like a man, can be feminine," he said. In 1985 his collection "And God Created Man" featured the skirt for men, while "Wardrobe for Two" (androgyny) also focused on issues of sex and gender. Masculinity and femininity continued to be explored in collections like "Joli Monsieur" (the dress for men) and "The Dolls" (petticoats for all occasions). As Gaultier said in 1984, "Gender-bending, huh! It's a game. Young people understand that to dress like a tart doesn't reflect one's moral stance – perhaps those *jolies madames* in their little Chanel suits are the real tarts? I'm offering equality of sex appeal."

Were issues of taste (and social class) more unspeakable even than sex? Collections like "Le Charme Coincé de la Bourgeoisie", "French Gigolo", and "The Concièrge is in the Staircase" – triggered charges that Gaultier was the apostle of bad taste. "Me, I like everything," he said. "Everything can be beautiful or ugly . . . I like different kinds of beauty." He showed his strange clothes on unconventional models (fat women, old people, heavily tattooed and pierced people).

107 (*above left*) "Corset" dress in orange rayon velvet by Jean-Paul Gaultier, 1984. Photograph © Roxanne Lowit.

108 (*above right*) Yellow "girdle" dress by Jean-Paul Gaultier, 1984. Photograph © Roxanne Lowit.

109 (*facing page*) Jean-Paul Gaultier "corset" dress in orange rayon velvet with cone bust and back lacing, Fall 1984. The Museum at F.I.T., New York, Museum Purchase, P92.8.1. Photograph by Irving Solero.

"The first fetish I did was a corset," recalled Gaultier. "That was because of my grandmother." As a child, he found a salmon-colored, lace-up corset in her closet. "I thought, 'My God, what is that?' . . . Later I saw her wearing it and she asked me to tighten it." He was "fascinated" by what he regarded as "one of the secrets." He has created many corset-inspired clothes for both men and women, although he is most famous for the corsets and cone bras that he made for Madonna. "It was like a fantasy exaggerated," he explained. Questioned by a journalist, he admitted that the torpedo-shaped breasts were, perhaps, "a little aggressive." Putting the cone bras on her male dancers was Madonna's idea, he said. "I don't put bras on guys." He did put men in high heels and fishnet stockings and corsets, "but they were corsets for men."

Many fashion journalists have complained that Gaultier dressed women

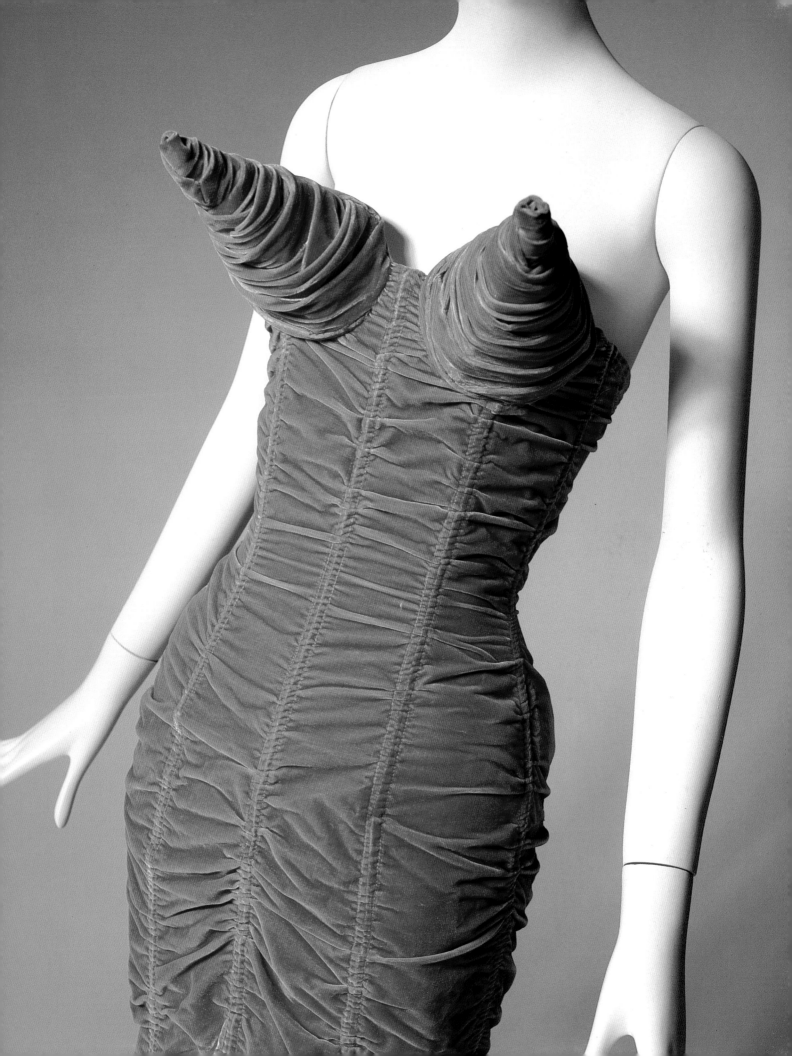

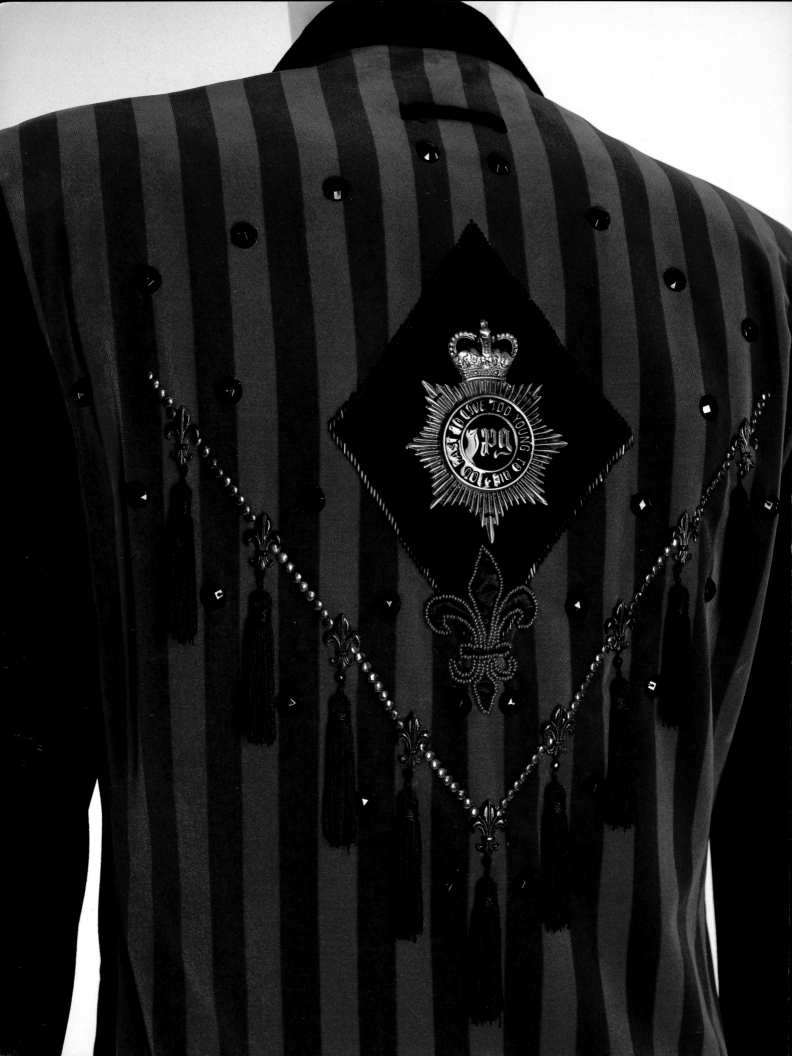

like "fetishistic whores," but as Diane Rafferty noted in the *Village Voice*, "Weirdly, by playing so wildly with fetishism, Gaultier sort of frees you of it . . . his clothes don't dominate you." His shoes alone brilliantly exploit all the kinks – from rubber boots and high-heeled sneakers to weird shoes with multiple heels. The novelist Tama Janowitz wrote an essay for *Vogue* that helps explain why Gaultier's outrageous clothes have had such success: "Now we feel there is nothing wrong with dressing ourselves as a prostitute, provided that this costume is chosen with deliberate humor and irony. Humor and irony: That is what clothing is all about." At the same time, she argues, there is a reevaluation of the past; both the "real past" and a "movie past." With postmodern fashion, everyone wears a costume, and "each of us becomes the star of our own lives." In surveying the styles of the eighties, we must stress that Jean Paul Gaultier, at least, was certainly not dressing the wives of junk-bond millionaires, and yet he was unquestionably one of the most important and influencial designers of the decade.

110 Gaultier Homme "heraldic" jacket in black wool gabardine decorated on striped velveteen back with Renaissance-style tassels and emblem inscribed "Too fast to live, too young to die," 1988. The Museum at F.I.T., New York, Museum Purchase, P88.76.4. Jean-Paul Gaultier pants in olive rayon stretch fabric embroidered with brown fleurs-de-lys, 1988. The Museum at F.I.T., New York, Museum Purchase, P88.76.5. Photograph by Irving Solero.

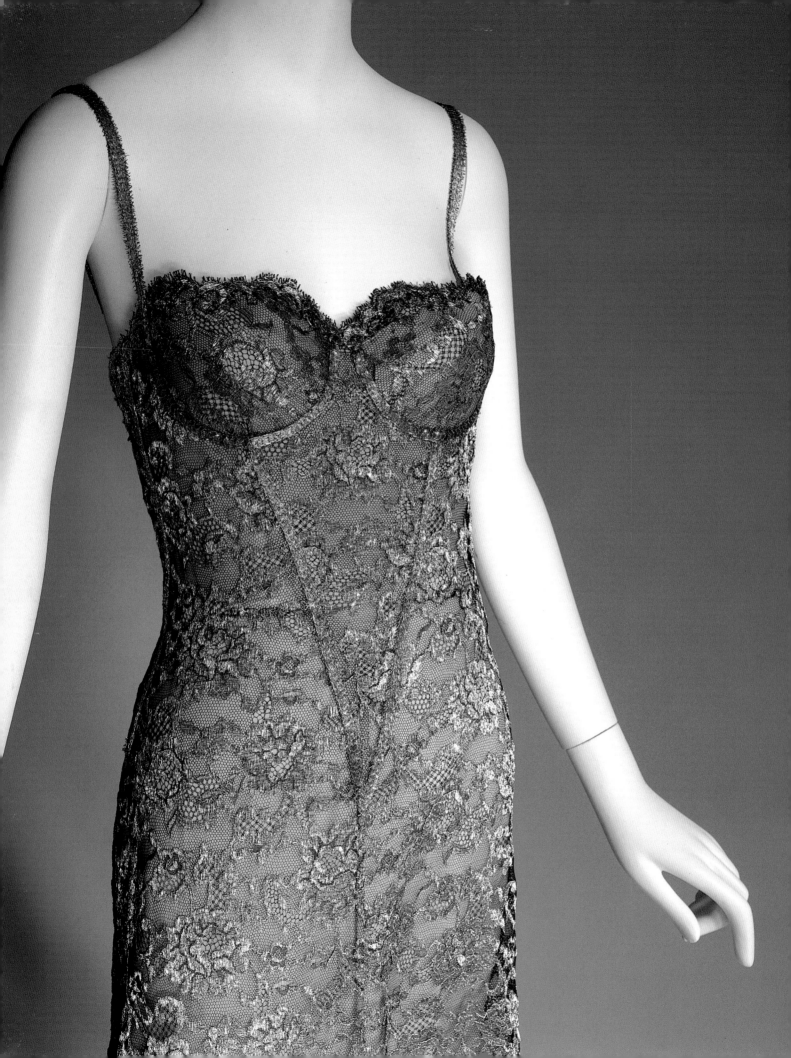

SUPERMODELS WERE THE BIGGEST NEWS in fashion in the 1990s. Linda Evangelista, in particular, became the icon of a new era because she seemed both contemporary and classically elegant. She was a true chameleon, and every time she changed her hair color it made headlines. In 1990 Peter Lindbergh photographed a brunette Evangelista as a reincarnation of Ava Gardner, evoking "fifties glamour for the nineties." By early 1991 "la nuova Linda Evangelista" had gone short and platinum. "Blond is glamour," stated Italian Vogue (January 1991), it is the ultimate "feminine color." Then, in October Evangelista was featured again on the cover of British *Vogue*, where she "personifie[d] the fiery Fifties redhead."

Claudia Schiffer, Christy Turlington, and Cindy Crawford were some of the other supermodels of the decade. As photographer Holge Scheibe put it, The Barbie doll was the "role model of generations of Cindys, Lindas, and Christys, the embodiment of BLOND, SEXY & LONG-LEGGED." With her long blonde hair and voluptuous figure, Schiffer actually posed in Italian *Vogue* (July 1994) as "the real Barbie."

The most famous black model of the decade was Naomi Campbell, who was featured on the cover of *Time* magazine illustrating an article on beauty and money: "More glamorous than movie stars, the supermodels of the '90s earn spectacular loot for their spectacular looks." And they were worth it, too, because top models could "make consumers buy." Racial prejudice was much less of an issue than in the past, and a number of "ethnic" models had successful careers. Some, like Asian-American model, Jenny Shimizu, were unusual in other respects also. A tough-looking lesbian with a tattoo, Shimizu was a cult figure in fashion circles. More unusual still was Kristen McMenamy, a *jolie laide* who was featured frequently during the brief fad for grunge.

The most controversial model of the nineties was the slender Kate Moss, who reigned as the "waif" of 1993. Although she appealed to many of Calvin Klein's younger customers, Kate Moss was also savagely criticized for being too thin and thus allegedly promoting anorexia and other eating disorders. She was on the cover of *People* with a headline, "Skin and Bones." According to the text, "Supermodel Kate Moss is the ultrathin symbol of the underfed waif. Is a dangerous message being sent to weight-obsessed teens?"

111 Calvin Klein slip style evening dress in silver metallic chantilly lace over beige chiffon, Spring 1992. The Museum at F.I.T., New York, Gift of Kelly Klein, 94.143.1. Photograph by Irving Solero.

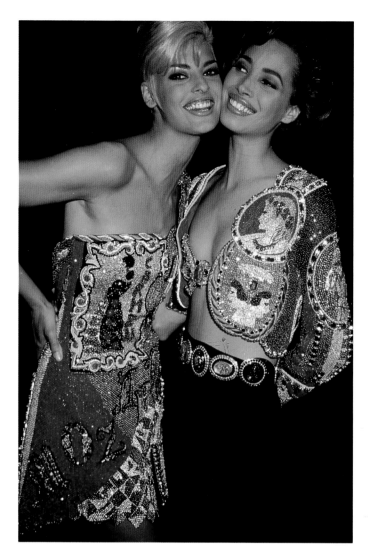

112 (*above left*) Linda and Christy in Versace, 1992. Photograph © Roxanne Lowit.

113 (*above right*) Kate Moss in Prada, 1995. Photograph © Roxanne Lowit.

Harper's Bazaar tried to explain that the waif look was a natural reaction to the ultravoluptuous and muscular "Glamazon" models of the 1980s, but posters depicting Moss continued to be defaced with graffitti saying "Feed Me!"

So "fashion killed the unloved waif" (as Amy Spindler of the *New York Times* graphically put it), and "magazine editors, not designers, twisted the knife." Pale and skinny were out, red lips and stilettos were in. The towering white-blonde Nadja Auermann appeared simultaneously on the covers of *Vogue* and *Harper's Bazaar* looking like a glamorous android.

By emphasizing the importance of fashion models, am I implying that fashion itself was in trouble in the 1990s? It is always difficult to identify the fashions of a decade while it is still in progress, and early attempts to characterize nineties style already seem flawed. In retrospect, we can see that it is much too simplistic to interpret the nineties primarily as an austere and

repentant response to the "greedy" eighties, but this was often how it seemed in the early 1990s.

Consider, for example, how American *Vogue* heralded "the triumph of grunge . . . in the repentant '90s." Grunge began as a cheap vernacular style, a part of Seattle youth culture, associated with bands like Nirvana and Pearl Jam. Characterized by loose, layered clothes, such as checked flannel shirts, long loose dresses, and heavy boots, grunge looked as though hippies and punks had merged their wardrobes. The film *Singles* helped publicize the look, which was then picked up by hip designers like Anna Sui and Marc Jacobs.

Soon fashion periodicals like *Vogue, Harper's Bazaar,* and *Women's Wear Daily* began promoting the look avidly, publishing major articles on the subject. Readers were urged to adopt a "street fashion that mixes rough-and-tumble work clothes with waifish thrift-shop finery." For those not accustomed to wearing second-hand clothes, a few instructions were in order: Just take a retro-style floral dress (by Ralph Lauren or Calvin Klein) and accessorize it with Doc Marten boots, long underwear, a flannel checked shirt (you can cut the sleeves off) or a big stretched-out sweater, and perhaps "a post-Punk nose ring."

Unfortunately for the fashion industry, there was considerable consumer resistance to paying top prices for such shabby-looking clothes. Indeed, from the beginning a few journalists, for example Michael Gross, saw grunge as essentially a media-created fad ("an example of fashion's lemmings going over a cliff en masse"). Nevertheless, the fad lasted long enough to influence some of the Euopean collections, as designers like Dolce and Gabbana and Gianni Versace featured a version of psychedelic grunge.

"Oh, my God! Versace's doing grunge," exclaimed one reporter at the Milan menswear shows in spring 1993. Pressed to explain, he asked, "what *do* you call it when someone wraps a sweater around their waists?" "Where I grew up," replied an editor sitting nearby, "we called it wrapping a sweater around your waist." By this time, however, using "grunge" as a buzzword was the kiss of death. After grunge died, unlamented, it was replaced by the monastic look, which featured long dark clothes and religious accessories such as crosses.

"Piety on Parade: Fashion Designers Seek Inspiration in Religious Clothes," announced a front-page article in the *New York Times*. Calvin Klein was inspired by priests' robes; Geoffrey Beene did a hooded cape and coat

114 Grunge fashion by Anna Sui, 1992. Photograph © Roxanne Lowit.

like a monk's cowl. "We are in a period of being more humble, of spending less, of being more frugal," argued jewelry designer Robert Lee Morris. But Katell le Bourhis, director of the Musée des Arts de la Mode et du Textile, pointed out that while these clothes might look "simple and plain," they cost "the same price as the extravagant ones."

Designers seemed to be confusing purity of line – no ruffles – with spiritual purity. As Amy Spindler noted, there was also "the underlying tension of waif-like virginal models being cast into the decadence of a material world." After all, in nineteenth-century brothels prostitutes had often been asked to dress up as nuns.

By late 1993 fashion had shifted again "from the convent to the cathouse" (as *Women's Wear Daily* put it). "There was that first rush to buy the long black skirt," said Nicole Miller, but then most customers stopped buying. Hence "the new glamor" of 1994 – more pejoratively referred to as the "power slut" look.

Fashion's new mantra was "Strong and Sexy." The new look was one of "steely femininity" and "hard-core glamor." According to *Vogue* (May 1994), "From Paris . . . to New York . . . women are trading in grunge and minimalism for . . . the hard-edged . . . stance of a Helmut Newton photograph." Or as *Harper's Bazaar* put it, fashion's new woman was adopting "a killer arsenal of old-fashioned female weaponry." Upswept eyeshadow. Dark red nail polish. Vinyl glossy lipstick. Sexy spike heels. Extreme Beauty.

Some designers recognized, uneasily, that the fashion pendulum was swinging too far too fast. As Donna Karan put it, "Grunge, they said, was the death of fashion. Then monastic was the death of fashion. Now this. Fashion links on to something so hard and . . . exaggerates it and frightens the customer." The comic strip "Cathy" showed a malicious saleswoman gloating, "Comfy is out! Glamour is in!" Within a short time the "dressed to kill" look would disappear – although like a vampire it proved to have more than one life.

"Fashion Returns to the Classics," declared *Time* (April 1995): "After years of driving women away with gimmicks and excess, the latest turn in fashion is – surprise! – back to elegant, wearable clothes." At Chanel, Lagerfeld talked about a "new tendency for beauty to combat ugliness." Versace said "I dressed Claudia Schiffer and Madonna like my mother used to dress." In place of his usual ultra-sexy clothes, Versace made what *Time* called "pretty, practical clothes" – like pink suits. So was everyone happy? Only a few weeks later retailers were complaining to *Women's Wear Daily* that modern women did not want to wear pink.

What was happening to fashion? Contrary to popular belief fashion was not dead, but the fashion system did appear to be undergoing a profound and often traumatic transformation. To use a political metaphor, the Empire of Fashion had become Balkanized. Fragmented into many small "style tribes," few people still obeyed the traditional Czars of fashion. Indeed, the

115 Chanel suit by Karl Lagerfeld with cropped jacket, short skirt, boned corselet in pink textured tweed and white cotton logo T-shirt, Spring 1994. The Museum at F.I.T., New York, Gift of Chanel Inc., 94.80.1. Gianni Versace light blue wool twill suit, Spring 1995. The Museum at F.I.T., New York, Gift of Gianni Versace, 95.77.1. Photograph by Irving Solero.

116 Tom Ford for Gucci white matte jersey full-length evening shift with matching contour belt with large hardware "buckle," Fall 1996. The Museum at F.I.T., New York, Gift of Gucci, Inc., 97.30.1. Photograph by Irving Solero.

new creations of the great designers were increasingly regarded as irrelevant by the vast majority of consumers, although admittedly, some designers had devoted followers.

The fashion industry as a whole seemed in bad shape, drifting like a boat without a rudder. Lacroix's failure to maintain his initial stardom seemed indicative of a more widespread malaise. The feverish spending on expensive consumer goods characteristic of the 1980s came to an end as a deepening recession resulted in faltering retail sales. But as the economy rebounded sales failed to pick up. Manufacturers and retailers increasingly adopted strategies for wooing reluctant customers, including frequent sales and an emphasis on less expensive "diffusion" lines. Certain companies, such as The Gap, sucessfully weathered the recession by promoting "real clothes" (i.e. basic separates), but when other manufacturers followed suit, the market quickly became glutted.

Among young people there was still considerable interest in clothing as an expression of identity, but they tended to create their own anti-fashions, based on local or musical subcultures. These street styles then became the source of inspiration for fashion designers, but as the failure of grunge proved, it was not easy to commercialize street style. Nevertheless, it is possible to identify several major sources of inspiration for contemporary fashion.

Retro is controversial. Already in the 1970s Marylou Luther, the fashion editor of the *Los Angeles Times* complained that designers "seem to be as afraid to face the future as they are to let go of the past." Many people today also complain "Why don't designers do something new?" Why do they keep recycling the fashions of past decades and centuries? But perhaps this is naive. Certainly retro styles are ubiquitous throughout popular culture – in architecture and graphic design, for example, as much as in fashion.

117 Advertisement courtesy of Gucci.

118 (*following page*) Kate Moss in John Galliano, 1994. Photograph © Roxanne Lowit.

Nor does retro necessarily signify a mass flight into nostalgia. Indeed, the evidence indicates that most fashion trendsetters have very little sense of history. The actual historical past is essentially irrelevant; it exists only to be cannibalized. Designers, stylists, photographers, and club kids all ransack the past for usable images, which are then ripped out of context and ruthlessly stripped of most of their original meaning. A few observers, like Jamie Wolf, have suggested that "retro babble" actually signifies "absolutely nothing at all" – beyond the fact that "fashion is based on change . . . *which* change, exactly, is unimportant."

John Galliano, Jean-Paul Gaultier, and Vivienne Westwood are three of the most inventive designers of the 1990s. If they look back at the fashions of the past, as they often do, it is not for lack of ideas. One year Galliano is inspired by the French Revolution, and another year by Jacques Fath; in each case it is not a question simply of recycling the past, still less of trying to return to an earlier era. A key principle of contemporary postmodern art has been the juxtaposition of incongruous objects, images, and materials. Avant-garde fashion designers use retro in this spirit.

Moreover, as Vivienne Westwood points out, "If anyone is trying to be modern, it's a cliché." In the past people thought in terms of "progress," they believed that fashion would evolve until it reached an ideal form. Some people envisioned the future of fashion as culminating in nudity, others looked backward to "timeless" classical simplicity, or forward to space-age uniforms, but all such fashion futurism now looks completely démodé.

Modernism is just one period style among many. In retrospect, we can see why Courrèges was called the Corbusier of the 1960s couture. Yet even Courrèges was inspired by the geometry of Balenciaga. Courrèges's fashions inspired the costumes worn in the movie 2001, but to repeat this look as we move into another millenium is just as much retro as copying the fifties couture.

Ethnic influences have always been a part of western fashion, but over the past few decades the mixture of "exotic" styles has become both more intense and more eclectic. The Turkish-born Rifat Ozbek, for example, has often used Middle Eastern elements in his work, but in 1990 he made a splash with his sexy African-inspired collection, which drew, in fact, not only on pan-African nationalism, but more specifically on the Rastafarian style of the Caribbean. This, in turn, brings up the question, Why does fashion draw on certain ethnic looks and not on others?

World historical events in the former USSR and Eastern Europe had essentially no impact on fashion. The collapse of the Communist bloc will probably ultimately result in these nations' integration into the international fashion system, but this will be a longterm development. Nor have events such as the Gulf War been significant in fashion terms. This should not be surprising, however, since (with a few exceptions such as the French Revo-

119 (*previous page*) Carla Bruni in Dolce and Gabbana, 1994. Photograph © Roxanne Lowit.

120 (*facing page*) Vivienne Tam full length T-shirt dress in nylon mesh knit with multiple photo prints of Mao, 1995. The Museum at F.I.T., New York, Gift of Vivienne Tam, 95.82.6. Photograph by Irving Solero.

lution) political events seldom have a profound impact on fashion; the biggest influences on fashion today are cultural. It is significant, therefore, that Ozbek's use of Rasta-inspired style evokes reggae music.

Because music is the most important influence on youth culture, and because African-Americans are extremely important in popular music, black street style has been one of the most important influences on the clothing of young people of all races. This strong black aesthetic is popularized through music videos, as well as the fashion pages of magazines like *i-D* and *The Face*. The singer Neneh Cherry, for example, was featured wearing a little black dress accessorized with "rap star gold." In an essay on rapwear, Diane Cardwell of the *New York Times*, explained how style cults and musical genres interact: the survivalist B-Boy, the gangsta, the Nubian grunger, and the Nubian cowboy all have their own looks and sounds.

Is it exploitation when defiant black street styles (such as the "homeboy" look) are copied by white designers? Certainly, the look has spread even to the upper limits of the couture, as Lagerfeld put his Chanel models in rappers' chunky gold chains, big gold earrings, and the kind of skin-tight shorts worn by New York City bicycle messengers. The influence moves both ways, however. Some rappers have mixed baggy shorts and baseball caps by Home Boy with combat boots by Chanel. "We have the Chanel combat boots now, which are more upscale," explained one performer. "They're also really easy to dance in."

Some critics worry about the ramifications of street styles within the black community. The often hostile lyrics of rap music and the sartorial connections with prison garb seem to valorize drug dealers and gangstas. Clothing companies like Boiy Krazi have made blue denim "prison suits" printed with big inmate numbers. Expensive street fashions can themselves lead to crimes: if you wear gold jewelry or an expensive jacket, you have to be able to defend it. In the United States young people have actually been killed for their clothes. Yet "cool" style has positive associations as well, because of its connections with self-respect and pride.

Other ethnic styles have caused controversy, too. When French *Vogue* went to Brooklyn to photograph Jean-Paul Gaultier's collection of Hasidic fashions, many Jews complained. The Islamic community has also experienced problems with western fashions. Not long ago, fashion journalists routinely used pejorative terms, such as "Jap" and "coolie," to characterize Asian-inspired styles. This is no longer true, but Far Eastern influences continue to be extremely important in contemporary fashion. Jean-Paul Gaultier's use of Central Asian, Chinese, and Mongolian themes was highly praised, as was Galliano's exquisite version of *japonisme*.

The body, sex, and gender continue to be central issues in the cultural construction of contemporary fashion. In her 1985 essay, "Sorrow and Silk Stockings: The Woeful State of Femme," lesbian Marcia Pally argued that

"Popular styles don't lie midway between masculinity and femininity, they fall – rush – toward butch. Where cock is king, go for the codpiece. It's not surprising that gay lib produced a butch uniform, feminism a tailored one." Women and men alike wanted to look powerful, but the styles that signified power evolved over time. By the 1990s the ultra-femme style of the so-called "lipstick lesbian" had become widely adopted by many young gay women. So had the tough look of the "leather dyke." Straight women also increasingly mixed clothing symbols of masculine power (like Levi's and leather jackets) with symbols of feminine sexual power (like high heels, corsets, and lingerie).

The result was the emergence of fetish fashion as one of the most significant styles of the 1990s. In *Fetish: Fashion, Sex, and Power* I describe how and why clothes have become progressively more kinky. It is important to stress that this is not just a sporadic fad; for the past thirty years, the iconography of sexual "perversion" has increasingly influenced both high fashion and street style.

Versace's "bondage" collection of 1992 was only the most notorious example among many. Some women regarded the look as exploitative and misogynistic. Others saw it as positive Amazonian statement. Versace himself insisted that "Women are strong." Was it "Chic or Cruel?" asked the *New York Times*. Did the fashion degrade women or empower them? "It could go either way," said Holly Brubach. "Either the Versace woman is wielding the whip, or she's the one who's harnessed and being ridden around the room wearing a collar and a leash."

Harper's Bazaar playfully captioned one photograph of a Versace outfit, "Heavy metal, light bondage. The straps and stilettos of the dominatrix will not be denied." The modern woman was being presented with an image of herself that evoked Michelle Pfeiffer's Catwoman or *The Avengers'* Emma Peel.

Designers like Versace were not responsible for this look, which had been percolating up from street style for decades, where black leather and rubber functioned symbolically as organic armor. Throughout the 1980s London's goths, pervs and neo-punks had worn fetish fashion, so had gay "leathermen" and "leather dykes." Although most feminists hated fetish fashion, the style owed as much to the women's movement as it did to the movement for sexual liberation.

121 Fetish fashion by Vivienne Westwood. Photograph courtesy of Vivienne Westwood.

122 Fashion from Versace's Bondage collection, 1992. Photograph © Roxanne Lowit.

123 (*facing page*) Moschino rayon/spandex "bra dress," 1994. The Museum at F.I.T., New York, Gift of Moschino, 94.106.1. Photograph by Irving Solero.

The growing popularity of fetish fashion is also directly related to the charisma of deviance. Long pathologized and demonized, both the "pervert" and the "bad girl" have been reconceptualized as exemplars of radical, transgressive sexuality. Sexual fetishism, cross-dressing, and sadomasochism have influenced the work of many designers. Thierry Mugler's leather corsets, for example, are often decorated with spikes or what appear to be nipple rings.

124 Donna Karan dress in neon pink "scuba" neoprene knit, 1994. The Museum at F.I.T., New York, Gift of Donna Karan, 94.126.1. Photograph by Irving Solero.

125 (*facing page*) Jean Paul Gaultier nylon/spandex hooded jumpsuit, 1966 (detail). The Museum at F.I.T., New York, Museum Purchase, 96.66.1. Photograph by Irving Solero.

Tattooing and body piercing have also moved from the fringes of the sexual subculture to the center of youth fashion. Twenty years ago it was deeply shocking when Robert Mapplethorpe got his nipples pierced. But in 1995 many tattooed and pierced men and women walked down the runway at Jean-Paul Gaultier. These designers are important because they subvert conventional ideas about masculinity and femininity, the normal and the perverse.

The "fashionization" of materials like rubber is evidence of the convergence of fashion and fetishism, but there is another, equally important sub-text. *Women's Wear Daily* calls it the "Industrial Revolution." Certainly, the industrial materials "once reserved for . . . scuba gear and surgical gloves have now made it to the runways." Molded plastic, rubber, vinyl, and other

127 Azzedine Alaia high-heeled ankle boots in leopard printed ponyskin with black platform sole and heel, 1991. The Museum at F.I.T., New York, Gift of Azzedine Alaia, 92.34.1. Photograph by Irving Solero.

high-tech materials have increasingly been incorporated into second-skin dresses and other innovative fashions. Technological advances are, in fact, one of the few ways that fashion can be truly modern.

Techno styles utilize industrial materials, or they express what might be called an industrial aesthetic. The aesthetic issue is perhaps more interesting, because it expresses cultural values as well as technological advances. The Italian design company Prada is a cult favorite among "fashionistas" world-wide, and the black nylon Prada knapsack was a style icon of the 1990s. The popularity of Reebok sneakers is also a testimonial not only to advances in shoe construction, but also to a desire to identify oneself as an active and street-wise individual.

Not only actionwear but also uniforms have profoundly influenced fashion. In her book *Sex and Suits*, Anne Hollander argues that the man's suit is the quintessentially "modern" style of dress – for women as well as men. It can be a business suit: the German designer Jil Sander, for example, draws on menswear prototypes, creating "classic" clothing "with a twist." It can be a military uniform. Prada, Gucci, and Dolce and Gabbana have all exploited the erotic appeal of sartorial militarism.

While most designers favor the authoritarian look of officers' uniforms, street style draws on a more anarchic image of military style, epitomized in the image of a war-battered Tank Girl. And if the cyber-punk look is too messy, one can always wear a worker's uniform. The Mao suit, for example, exerts a continuing stylistic influence – especially on the most opulently austere clothes. Designers like Helmut Lang have taken the less-is-luxe aesthetic to a powerfully sophisticated state – to the point where a simple floor-length T-shirt can be all the clothes a body needs.

126 (*facing page*) Azzedine Alaia black wool suit with fitted "peplum" jacket and narrow ankle-length skirt, worn with leopard pattern stretch chenille knit bodyusuit, 1991. The Museum at F.I.T., New York, Gift of Azzedine Alaia, 92.34.1. Photograph by Irving Solero.

At the dawn of the twenty-first century, several designers were acknowledged by their peers to be the most influential figures in fashion. Other emerging talents have also begun to create the fashions of the future.

Helmut Lang was born in 1956 in Vienna and became famous first in 1994, when his "Trash and Elegance" collection included a dress made of fused rubber and lace. His intensely modern, urban aesthetic encompasses both men's and women's clothes. Drawing on vernacular garments, such as narrow trousers, three-button jackets, and clingy tee-shirts, Lang aimed to create "the sort of anonymous status that the truly knowing admire. If you have to ask, you don't get it." Lang's "downbeat elegance" set the tone for avant-garde street style in the 1990s. His "Radical Couture" collection, for example, combined stark minimalism, high-tech fabrics, and such unconventional details as diagonal sashes and negligée straps. His strategically slashed garments were widely copied, as was his use of transparent fabrics. In 1998 he moved to New York. "I don't believe that fashion evolves on its own," says Lang; "There are more radical social changes behind it." He insists, "What I do is about now, it's about the lives we lead."

Miuccia Prada first became famous in the mid-1980s for her black nylon backpack. Soon her bags and quirky shoes were followed by a ready-to-wear collection, a secondary line called Miu Miu, a menswear collection, and in 1998 the immensely influential Prada Sport. "I never actually decided to become a designer. Eventually, I found that I was one." Following her instincts, she succeeded in achieving both cult status and mass appeal. Even when she made "ugly clothes from ugly materials," she said, "they end up looking good anyway.".

John Galliano graduated from St. Martin's College of Art and Design in 1984 with a stunning collection, "Les Incroyables," inspired by the French Revolution. It took some time, however, before he found financial backing. Since 1997, he has been designing for the House of Dior in Paris, where he has created numerous spectacular collections, often inspired by the long ago or far away. As he put it in 1998, "My role is that of a seducer." Despite many successes, notably his beautiful bias-cut gowns, Galliano's romanticism and historicism seem antithetical to current trends, and there have been repeated rumors that he was about to be fired.

Meanwhile, avant-garde fashion continues to evolve. The revolutionary Japanese designers Yohji Yamamoto and Rei Kawakubo of Comme des Garçons are still designing clothes that ignore outworn conventions of status and sexuality. Both of them are interested in developing new materials, which will undoubtedly provide a basis for future fashions. The Japanese avant-garde also gave birth to so-called Deconstructionist Fashion.

Born in Belgium in 1957, Martin Margiela showed his first collection in 1989 and immediately achieved cult status as the most notorious creator of "Deconstruction Fashion" or *la mode destroy*. Margiela has unravelled old army socks and made them into sweaters, recut second-hand black leather coats

into ball dresses, and designed beautifully tailored jackets with exposed linings and frayed edges. "I love the idea of recuperation," says Margiela. "I believe that it is beautiful to make new things out of rejected or worn things." In 1997 he was hired by the luxury house Hermès, which recognized that Margiela's radical reinvention of clothing seemed to point toward a new future for clothes.

Like Margiela, Ann Demeulemeester has given Belgian fashion a reputation for serious, introverted, and quietly intense clothing. Inspired by the musician Patti Smith, she creates poetic clothes, mostly in a palette of black, white, and gray. She is best known for having perfected a way of designing clothes that look as though they are about to slip off the body, but which are held in place by an internal harness system. Her best-known styles include falling-off white shirts, hip-slung trousers, and asymmetrical suits.

The relationship between art and fashion is hotly contested, but it has made unexpected celebrities of the Dutch duo Viktor and Rolf. "Fashion doesn't have to be something people wear," they say. "Fashion is also an image." Hussein Chalayan is another designer who is also a conceptual artist. In 1993 he graduated from Central St. Martin's College of Art and Design. One of his collections was based on Islamic veiling, while another featured a motorized airplane dress made of one hundred percent fiberglass and coats with attached head-rests.

Finally, in the realm of avant-garde fashion that is also high fashion, the name to conjure with is Alexander McQueen. Born in 1969, McQueen worked as a tailor's apprentice on Savile Row before graduating from Central St. Martin's College of Art and Design in 1992 with a collection entitled "Jack the Ripper Stalking His Victims." Subsequent collections included "Nihilism" (1994), "The Birds" (1995), and the notorious "Highland Rape" (1996), which showed women in bloodied, torn clothing. The creator of low-slung trousers called "bumsters," McQueen was appointed creative director of the couture house Givenchy in 1996, replacing John Galliano, who moved to Dior. Whereas Galliano is a consummate romantic, McQueen has described his aggressive approach to fashion as "eclectic verging on the criminal." His first collection for Givenchy was in Greek style, featuring gold rams' horns. Meanwhile, he continued his own collection with a spectacular Gothic show, "The Hunger." Despite raised eyebrows, McQueen has brought a signature style to Givenchy that is simultaneously sexy and strong, while his own label is more emotional and personal.

Some observers argue that the end of fashion is approaching. Even designers sometimes express a lack of confidence. Thierry Mugler once said, "The future of fashion? It has none. The trend is no fashion. We are getting nakeder and nakeder." Frankly, these predictions seem unlikely. Like language, the decoration of the body seems to be a defining characteristic of the human race.

SELECT BIBLIOGRAPHY

Alsop, Susan Mary. *To Marietta from Paris, 1945–1960* (Garden City, New York: Doubleday, 1975)

"Armani: On the Loose," *Gentlemen's Quarterly* (September 1979)

Ballard, Bettina. *In My Fashion* (New York: Donald McKay, 1960)

Becket, Marjorie. "Paris forgets this is 1947," *Picture Post* (September 27, 1947)

Bertin, Celia. *Paris à la Mode* (London: Victor Gollancz, 1956)

Boyd, Ann. "Leather Forecast," *The Observer* (September 17, 1978), p. 41

Bricker, Charles. "Looking Back at the New Look," *Connoisseur* (April 1987)

Carnegy, Vicky. *Fashions of a Decade: The Eighties* (New York; Oxford; Sydney: Facts on File, 1990)

Castle, Charles. *Model Girl* (Seacaucus, New Jersey: Chartwell Books, 1977)

Charles-Roux, Edmonde, et al. *Théâtre de la Mode* (New York: Rizzoli, in cooperation with The Metropolitan Museum of Art, 1991)

Cosgrove, Stuart. "The Zoot Suit and Style Warfare," in Angela McRobbie, ed., *Zoot Suits and Second-Hand Dresses* (Boston: Unwin Hyman, 1988)

Coughlan, Robert. "Designer for Americans, Jacques Fath of Paris Sells U.S. Women Wearable Glamour," *Life* Magazine (October 1949)

De Marly, Diana. *Christian Dior* (London: B. T. Batsford, 1990)

Dariaux, Geneviève-Antoine. *Elegance* (Garden City: Doubleday, 1964)

Davis, Fred. *Fashion, Culture and Identity* (Chicago: University of Chicago Press, 1992)

Deutschman, Paul E. "How to Buy a Dior Original," *Holiday* (January 1955), pp. 44–7

Dior, Christian. *Christian Dior et Moi* (Paris: Bibliothèque Amiot-Dumont, 1955)

Donovan, Richard. "That Friend of your Wife Named Dior," *Colliers* (June 10, 1955), pp. 34–9

Dryansky, G. Y. "Armani, The Man of the Moment," American *Vogue* (August 1984)

DuCann, Charlotte. *Vogue Modern Style* (London: Century, 1988)

Fleury, E., ed. *Hommage à Christian Dior* (Paris: Musée des Arts de la Mode, 1987)

Gaines, Steven. *Simply Halston: The Untold Story* (New York: Putnam, 1991)

Gleik, Elizabeth. "Skin and Bones. How Thin Is Too Thin?" *People* (September 20, 1993)

Grignaffini, Giovanna. "A Question of Performance," in Gloria Bianchino et al., eds., *Italian Fashion* (New York: Rizzoli International, 1987)

Groom, Avril. "Dressing for Dinner and Disco," *The Daily Telegraph* (November 13, 1978)

Gross, Michael. *Model: The Ugly Business of Beautiful Women* (New York: William Morrow, 1995)

Hebdidge, Dick. *Subculture: The Meaning of Style* (London: Routledge, 1993)

Howell, Georgina. *In Vogue: Six Decades of Fashion* (London: Allen Lane, 1975); rev. edn., *In Vogue: Seventy-Five Years of Style* (London: Condé Nast Books, 1991)

Howell, Georgina. "The '80s. The Past Decade Saw Fashion Expand by Clinging Tightly to Well-Toned Bodies," British *Vogue* (January 1990)

Janowitz, Tama. "Off the Street Chic," American *Vogue* (September 1987)

"The Lady or the Vamp," *The Daily Mirror* (October 23, 1978)

"Legs Go Back on Show," *The Daily Telegraph* (October 23, 1978)

Melly, George. *Revolt into Style* (Oxford: Oxford University Press, 1989)

Merriam, Eve. *Figleaf: The Business of Being in Fashion* (Philadelphia and New York: Lippincott, 1960)

Nims, Jacqueline. "Ritzy Rags and Reagonomics: Money, Culture and the Conspicuous Look in Reagan's America" (New York: Fashion Institute of Technology, M.A. Thesis, 1995)

Nonkin, Leslie Jane. "Fear of Power Dressing," American *Vogue* (September 1986)

Orth, Maureen. "Kaiser Karl: Behind the Mask," *Vanity Fair* (February 1992)

Ostier, André. "Jacques Fath Recalled," in Ruth Lynam, ed. *Couture: An Illustrated History of the Great Paris Designers and their Creations* (Garden City, New York: Doubleday, 1972)

Pearlman, Jill. "70s Sound Style," American *Elle* (March 1991)

Polhemus, Ted. *Street Style: From Sidewalk to Catwalk* (London and New York: Thames and Hudson, 1994)

Poneman, Jonathan, "Grunge and Glory," American *Vogue* (December 1992)

Roberts, Eleanor. "Fath Brings Paris Chi-Chi to Boston," *Boston Post* (December 18, 1953)

Rubinstein, Hal. "Isn't it Romantic," *New York Times* Magazine (June 13, 1993)

Rudolph, Barbara. "Beauty and the Bucks," *Time* (October 7, 1991), p. 38

Spindler, Amy. "How Fashion Killed the Unloved Waif," *New York Times* (September 27, 1994), p. B13

Spindler, Amy. "Looking Back: All the Bustle over Retro," *New York Times* (November 15, 1994), p. B11

Steele, Valerie. *Paris Fashion* (New York: Oxford University Press, 1988)

Steele, Valerie. *Women of Fashion: Twentieth-Century Designers* (New York: Rizzoli, 1991)

Steibel, Victor. "Rise and Fall of the New Look," *Leader* Magazine (April 16, 1949)

Taylor, Lou. "Paris Fashion, 1940–1944," in Juliet Ash and Elizabeth Wilson, eds., *Chic Thrills: A Fashion Reader* (London: Pandora, 1992)

Taylor, William. "Crime? Greed? Big Ideas? What Were the '80s About?" *Harvard Business Review* (January/February, 1992)

Thurman, Judith. "A Cut Above: Giorgio Armani's Cool, Cool Elegance," *Connoisseur* (August 1988)

Veillon, Dominique. *La Mode sous l'Occupation* (Paris: Payot, 1990)

Wilson, Elizabeth, and Lou Taylor. *Through the Looking Glass: A History of Dress from 1860 to the Present Day* (London: BBC Books, 1989)

Wolfe, Tom. *The Bonfire of the Vanities* (New York: Bantam, 1990)

Worthington, Christa, "The Rise and Fall of Azzedine Alaia," *Women's Wear Daily* (October 17, 1986), pp. 1, 6

X, Malcolm (with Alex Haley). *The Autobiography of Malcolm X* (New York: Grove Press, 1965)

"YSL choisit le prêt à porter: cette photo explique sa décision," French *Elle* (June 9, 1971)

INDEX